QUOTABLE
SAN FRANCISCO

HISTORIC MOMENTS IN MEMORABLE WORDS

TEXT BY TERRY HAMBURG, IMAGES BY RICHARD HANSEN

Foreword by Carl Nolte, *San Francisco Chronicle*

THE
History
PRESS

Published by The History Press
Charleston, SC
www.historypress.com

First published 2021

Manufactured in the United States

ISBN 9781467147200

Library of Congress Control Number: 2020948645

Contents

CONTENTS

Foreword

There's only one thing you can say for sure about San Francisco—it's a place people talk about. It's "Everybody's Favorite City" according to the tourist industry. It's also the city some people love to hate. When a prominent California Republican wanted to find the worst thing he could say about the opposition candidate, he said, "Kamala Harris wants to turn the entire United States into San Francisco."

That's the story of the city. A lot of people love the place and a lot don't. But everybody has an opinion.

In this book, Terry Hamburg and Richard Hansen offer up two centuries of comments and quotes about San Francisco—everything from a Spaniard who thought it was the worst place in California to an Englishmen who thought there was nothing in the world like San Francisco.

San Francisco was an instant city—born in an amazing gold rush, raised in boom times, crushed by fire and earthquake and born again. Hamburg and Hansen serve up instant history with the freshness of eyewitness accounts.

What did people think at the time? "Its growth appears to be magic," said James Wyld. "The city is one vast garbage heap," wrote Joseph Middleton. Both quotes come from the same year, 1849.

Within thirty years, San Francisco had the world's largest hotel, the wicked Barbary Coast, millionaires, bandits, vigilantes, even an emperor.

"East is east and west is San Francisco," said O. Henry. "A mad city," commented Rudyard Kipling, who came to see what the fuss was all about.

It all came crashing down in a disastrous earthquake in 1906. Hamburg and Hansen quote a letter written at the time: "Dear papa and mama, A terrible thing has happened. San Francisco is no more."

And the ditty by Larry Harris, "From the Ferry to Van Ness you're a godforsaken mess...but the damndeast finest ruins, nothing more and nothing less."

The city, of course, came back. It always has.

Hamburg and Hansen quote presidents, poets, movie stars, politicians and ordinary citizens—even Twiggy, the famous model: "I'm just mad for San Francisco. It looks like London and Paris all stacked on top of each other."

And perhaps the best quote of all: "San Francisco is forty-nine square miles surrounded by reality," courtesy of Paul Kantner of Jefferson Airplane.

It's the talk of the town. You can quote me.

—Carl Nolte

Preface

In 1969, the San Francisco Board of Supervisors officially announce "I Left My Heart" as the city song. Such a lovely ballad, but it is an ode to tourists who visit the city and dream to return for another adventure. For those born or adopted San Franciscans, there is only one true anthem, belted out by a feisty Jeanette MacDonald no less than eight times in the 1936 movie *San Francisco*. It tells the venerable yearn-to-return tale of a native who leaves home for whatever and wherever and realizes that there are no greener pastures than the foggy charm of Baghdad by the Bay.

It only takes a tiny corner of
This great big world to make a place you love
My home up on the hill
I find I love you still
I've been away but now I'm back to tell you

San Francisco
Open your golden gate
You let no stranger wait outside your door

San Francisco
Here is your wandering one
Saying I'll wander no more
Other places only make me love you best
Tell me you're the heart of all the golden west

San Francisco
Welcome me home again
I'm coming home
To go roaming no more

1
Humble Origins

There, when this bay comes into our possession, will spring up the great rival of New York.

—John C. Calhoun, 1844, secretary of state, pointing to a speck on a map, later to be called San Francisco, some 2,500 unexplored miles away

Bold and prophetic words, indeed. But at the time, it is frontier pie in the sky. The spot is one of the most remote places on earth—a grueling six-month sea odyssey or land trek from the eastern United States across treacherous unknown terrain brimming with hostile native Indians and deadly weather. That this tiny, isolated hamlet port confined by sand dunes as far as the eye could see would in a mere generation be called the "Paris of the Pacific" is the most improbable of fairy tales.

The lack of irrigable land, fresh water, timber and pasturage makes San Francisco the worst place for a town in California.

—Don Pedro de Alberni, Spanish soldier and ninth governor to Mexican California, 1776

The Bay of San Francisco is well adapted for a naval depot, or a place for whalers to recruit at. There is no place where a natural site for a city can be found throughout the whole bay; and it appears extremely difficult to select one where the locality would permit of extensive artificial improvement.

—*Capitan John Wilkes, American naval office and explorer, 1844*

With the approval of Mexican authorities, the first resident of what will be San Francisco takes his native wife and three children to establish a trading settlement in 1835 at Yerba Buena Cove, so named for the indigenous plant, meaning "good herb." Located about a mile from Mission San Francisco de Asís, from which the city soon derives its name, Capitan William Richardson buys hides and tallow so coveted in the eastern United States from the local hacienda rancheros. Without this resource, the early town might not exist, much less sprout. Decisively, the pioneer lays out Foundation Street, but it takes a full year for another trailblazing mercantile entrepreneur to appear. A third trading enterprise joins the party. By 1844, there are a dozen houses and fifty residents in the upstart community.

Within three months of the 1846 American declaration of war with Mexico, Captain John Montgomery boldly lands with 70 sailors and marines and marches to Yerba Buena Plaza to take possession of the village in the name of the United States. His ship is the *Portsmouth*, and the plaza assumes its name. At that moment, Yerba Buena consists of 73 Mexicans and Indians along with 48 inhabitants of Anglo-American or non-Spanish descent. There are no paved or officially named streets. The historic plaza is a bare clay patch devoid of trees or grass—a mud hole in winter and a dustbowl in summer. The population suddenly triples two months later when some 240 Mormons land at the port. This has a profound effect on the fledgling settlement. These are enterprising folk who lead a building and business boom. Their leader, Sam Brannan, quickly establishes the first newspaper in the state, the weekly *California Star*.

1847. It's the boondocks, but a boondocks with amenities: over a dozen general stores and groceries, butchers and bakeries, two hotels, printing offices and wood mills, an apothecary, a watchmaker, a shoe store and even a cigar merchant. There are numerous saloons—the exact number unknown because they go in and out business so frequently—and a couple of ten-pin bowling alleys, a popular sport imported from the Old World to the New. And people keep trickling in, some merchant seamen deserting their vessels in the hope of a better life. The city is officially renamed San Francisco,

after the mission a mile away. By the end of 1847, the census jumps to eight hundred. The first school opens. This is the lay of the town when James Marshall stumbles upon gold nuggets along American River at the Sutter Sawmill at Coloma, 120 miles to the northeast. Despite efforts to keep the large deposits a secret, word spreads like a virus, and overnight San Francisco becomes a virtual ghost town.

The whole country from San Francisco to Los Angeles and from the seashore to the base of the Sierra Nevada resound to the sordid cry of gold! GOLD!! GOLD!! while the field is left half-planted, the house half-built, and everything neglected but the manufacture of shovels and pickaxes.

—The Californian, *May 29, 1848, ceasing publication for lack of readers and reporters to report local stories that are not happening*

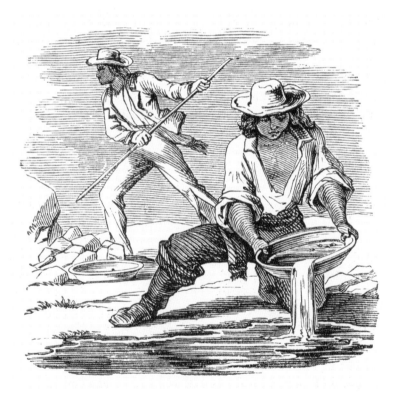

Gold is so plentiful and near the surface in the early days that a pick and pan, sometimes augmented by sluicing techniques, can produce a small fortune in hours. It is called "placer mining" after the Spanish word for shoal or sand bar.

In retrospect, history always looks like destiny. At the moment gold is discovered, few envision or expect the dominant role San Francisco will play in this momentous story. But the stars are aligning.

The pre–gold rush village is hardly imposing. It is initially centered on the northern part of the curving mile-long Yerba Buena Cove. Shore waters extend from Clark's Point at what are now Bush and Battery Streets down to Rincon Point near First and Harrison, comprising parts of the current Financial District and Chinatown as well as Jackson Square. What will eventually become the main thoroughfare of the city, Market Street, consists of unstable, perilous sand dunes up to eighty feet high. Walking the short distance from Portsmouth Plaza to the future Union Square is a treacherous trek. Wharves are hastily assembled by merchants to accommodate incoming vessels. All manner of materials are tossed into the waters below as the cove and adjacent marshlands turn into landfill.

Impressive, even booming, compared to nearby communities, fledgling San Francisco remains a modest trading outpost that could hardly entertain pretentions of becoming a great metropolis. In fact, as many observe and warn, it is far from the ideal place for a major settlement. Immediately to the west, the steep eastern ridges of Nob and Russian Hills block expansion. And farther to the west and south, stretching seven miles to land's end at the Pacific Ocean, sits a desert of rolling, formidable and largely unexplored sand dunes. As late as 1870, a San Francisco map labels the area that now constitutes the Sunset and Richmond districts as "Land of Fog: Uninhabitable." The local water supply is poor—the Pacific Ocean and Bay consist of undrinkable salt water. Easily accessible timber for construction is far from adequate, which requires residents to transport water, fuel and goods to the site. Then there is the climate. Compared to the rest of the Bay, the city weather is distinctly colder. The howling winds carry daily fog and biting swirls of dust and sand. Several other locations around the Bay would seem make better settlements, such as the Contra Costa—"Opposite Coast"—and Benicia.

San Francisco does have a natural harbor, but it sits more than one hundred miles from the active gold fields. Sacramento and Stockton, located on the Sacramento and San Joaquin Rivers, are closer to the mining action and are better candidates as gates of entry. What gives San Francisco a critical advantage is the faster clipper ship, developing quickly in the 1840s and soon to be the standard for cargo and passengers. That vessel cannot navigate the shallow waters of gold country rivers. More accommodating, San Francisco Harbor becomes the logical "default" port of transfer for people and materials to the Promised Land. All this maritime

traffic depends on a miraculous 1.7-mile fortune of nature connecting the Pacific Ocean to inland California—what was proclaimed as the "Golden Gate" by Captain John Frémont in 1846.

A confluence of fortune flows into San Francisco. It is the end of humble origins and the start of Great Expectations.

2
Instant City

POPULATION OF SAN FRANCISCO
1848: 800
1849: 20,000–25,000
1852: 34,776
1860: 56,802
1870: 149,473

In the course of a month or a year there was more money made and lost…
more sudden changes of fortune, more eating and drinking, more smoking,
swearing, gambling, tobacco chewing, and more profligacy…than could be
shown in any equal space of time by any community of the same size on
the face of the earth.

—Edmond Auger, French gold hunter, 1849

Skepticism abounds about the Paul Bunyan–sized gold stories trickling out of California. President James Polk is presented with 230 ounces of California gold, setting the cautious politician on his heels and prompting an official proclamation of the find that unleashes the largest mass migration in American history. Those who travel in the first great wave are dubbed "49ers." No wonder there is a rush. At a September 1848 meeting in San Francisco, the price of gold is fixed at $16 an ounce—a one-pound nugget is worth $8,000 in today's value.

By the autumn of 1849, some ten thousand frenzied adventurers have disembarked in San Francisco by sea after enduring a sardine-packed,

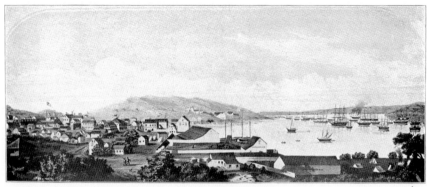

SAN FRANCISCO IN 1849
From an old drawing

Rustic San Francisco just before all hell breaks loose.

stomach-wrenching six-month ordeal. As many as five hundred ships are deserted at anchor in the Bay, never to be sailed again. Not only are the passengers seeking fortune but also the crews, since there are no exports to give ships nautical ballast for a journey anywhere else. Local resources are scare, so abandoned vessels provide lumber or serve as temporary businesses and residences. Those hearty adventurers who travel by ship to San Francisco are called "Argonauts." In Greek mythology, Jason led a group of sailors—*nauts* in Greek—aboard a ship named *Argo* in search of the fabled Golden Fleece, thus Jason and the Argonauts. In the twentieth century, the phrase morphs into sailors star trekking to outer space, as in "astronauts" and "cosmonauts." Many a visitor stays at the Argonaut Hotel at Fisherman's Wharf in San Francisco.

> *San Francisco is unique, a thing without parallel, one that admits of no comparison, for there is nothing like it in the histories of cities.*
>
> —*Dr. William McCollum, 1848, visiting from England*

The land odyssey surpasses the sea route in sheer numbers but presents its own unique journey through hell. In spite of the obstacles, by early 1850 some twenty-five thousand mostly young men descend upon San Francisco. The average age is perhaps twenty-five. What is today called "The City" flexes its metropolitan muscles overnight. Rome wasn't built in a day. But San Francisco was. In his classic study of urban development, Gunther

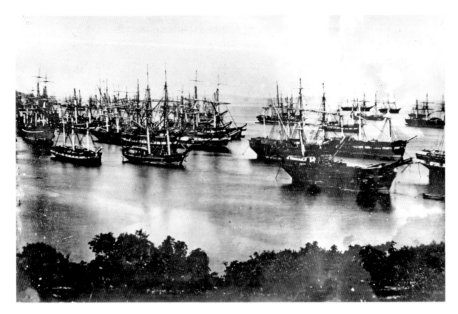

Nautical traffic jam in San Francisco harbor, 1849. These ships never sail again, and their lumber is harvested to help build the early city.

Barth calls it a rare "instant city" that virtually bursts into existence "full blown and self-reliant." The invading entrepreneurial army is wildly diverse. Even a decade after the initial gold rush, two-thirds of the city's population is born outside the United States.

> *Of the marvelous phases of history of the Present, the growth of San Francisco is the one which will most tax the belief of the Future. Its parallel was never known, and shall never be beheld again.....Every newcomer in San Francisco is overtaken with a sense of complete bewilderment. The mind cannot immediately push aside its old instinct of values and ideas of business, letting all past experiences go for naught.....As in the turn of dissolving views, there is a period when it wears neither the old or not the new phase, but the vanishing images of the one and growing perceptions of the other are blended in painful and misty confusion. One knows not whether he is awake or in some wonderful dream.....Never have I had so much difficulty in establishing, steadfastly, to my own senses, the reality of what I saw and heard.*
>
> *—Bayard Taylor, 1850. Hired to cover the gold rush by Horace Greeley, editor of the* New York Tribune *who would later immortalize the words*

"Go West, young man," the young poet and writer becomes the most widely read author of the early gold rush. His two-volume correspondence essays Eldorado: Adventures in the Path of Empire *is a runaway best seller in the United States and Great Britain.*

San Francisco is an odd place; unlike any other in creation & so it should be; for it is not created in the ordinary way, but hatched like chickens by artificial heat.

—*J.K. Osgood, 1849, in a letter to a friend*

Its growth appears to be magic. There is nothing similar on records; one may say without exaggeration that it has been inaugurated in one moment by some superhuman power, or sprung like one of those ambulating towns do spring the day before a fair.

—*James Wyld,*
A Guide to the Gold Country of California, *1849*

MUD AND MADNESS

This Street is Impassable, Not Even Jackassable

—*sign at the corner of Clay and Kearny Streets in San Francisco, circa 1850*

The city is one vast garbage heap.

—*Dr. Joseph Middleton, diary, 1849–51*

There is a price to pay for instant city magic. Conditions are especially harsh for the first wave of miners who return to San Francisco in late 1849 to wait out the winter rains pummeling the gold fields one hundred miles to the northeast. Simultaneously, disembarking by the thousands from an armada

of ships in San Francisco Bay, are neophytes ready to join the fray. What passes for streets are uneven trails between buildings that often meander into muddy, even surging ravines when hit by heavy rains. Few affordable accommodations are available. Prices for everything keep soaring. There are no sewers, and clean drinking water is scarce. Alcohol is a convenient, plentiful and welcome substitute. Cholera lurks. The first outbreak is in 1850.

> *Cholera again visited the city of the fall of this year* [1852]; *though its ravages were slight. However much may be said of the general healthiness of the place, little praise can be given to the very dirty state in which the greater part was allowed to remain—and nearly the same may be said of its condition in 1854. The streets were thickly covered with black rotten mud. These were the proper dunghills of the town, and were made a depot for all kinds of rubbish and household sweeping, offal* [animal waste] *and filth....Rats—huge, fat, lazy things, prowled about at pleasure, and fed on the dainty garbage...Sickening stenches pervaded every quarter.*

—Annals of San Francisco, *1855, the first published history of the city*

A Street-scene on a rainy night.

Such hardships are enough to drive a soul to madness. And they do. In the early years of the gold rush, it is well reported that there are more suicides in California in proportion to population than any other state. After physical disease, suicide is the second leading cause of death.

San Francisco is an enterprise run mad. The Forty-Niners were drawn from the pulpit, the bench, they all rush—giddy, mazed—into this one vortex. Happy the few who escape unharmed.

—*Daniel B. Woods,* Sixteen Months at the Gold Diggings, *1851*

In no part of the world are poverty and affluence so nearly mingled in the same cup. Nowhere is fortune so fickle, nowhere do so many fall in a day from wealth to wants. Such transition naturally disturb the mental balance.... [Some] *have not possessed strength of mind to enable them to encounter poverty and disappointment, and who have just enough intelligence to perceive that their lives are worthless to themselves and to society.... Perhaps the most potent cause of insanity in California is the excessive indulgence in intoxicating drink.*

—*Benjamin E. Lloyd, historian,*
Lights and Shades in San Francisco, *1878*

The 49ers are described then and now as a rough-and-ready lot, but they often turn out to be less so than their reputation. Most Americans cannot afford to book ship passage or arrange transportation by land to such a far-off place and still have the grubstake to finance a mining adventure where a shovel and pan might cost $35 ($1,000). A typical fortune-seeker comes from a middle-class family and is well educated.

Perhaps two-thirds of the immigrants to the country, since the spring of '49, have been young men of this age (20–25), have been nurtured in a lap of luxury; surrounded by a host of kind friends and relatives, and where their domestic relations have been most happy and many who were in such circumstances as to ask nothing of dame fortune.... They arrive here, one half of them, already worn down and debilitated by sickness; then comes the change of scene; change of living; change of climate; change of country

and indeed, everything which tends to about a complete revolution in the whole system and constitution.

> *—Dr. Wake Bryarly, 1851, visiting physician for the Sacramento State Hospital, which was the first hospital in California established specifically for the mentally ill as well as regular patients*

The most excitable and unsettled people have been attracted hither from all parts of the world, bringing with them a temperament favorable to the development of insanity. And the circumstances to which they are exposed are inimical to the exercise of self control.

> *—Benjamin E. Lloyd, historian, 1878*

Noah's Ark

As a community San Francisco is made up of elements a little, just a little, heterogeneous. It is a great menagerie, a sort of Noah's ark in which all living things seem to have or two representatives.

> *—Wasp magazine, 1879. The weekly San Francisco publication is infamous for wicked and acerbic satire.*

Take a sprinkling of sober-eyed earnest, shrewd, energetic New England businessmen; mingle with them a number of rollicking sailors, a dark band of Australian convicts and cutthroats, a dash of Mexican and frontier desperadoes, a group of hardy backwoodsmen, some professional gamblers, whiskey dealers, general swindlers…and having thrown in a promiscuous crowd of broken-down merchants, disappointed lovers, black sheep, and professional miners from all parts of the word.…Stir up the mixture, season strongly with gold fever, bad liquors, gambling, quarrels, pistols, knives, dancing and digging and you have something approximating to early California society.

> *—George E. Parson, 1870, biographer of James Marshall, the sawmill operator who first discovered gold in Northern California*

From first boots off the boats, the gold rush is attracting the most diverse population ever to occupy such a small patch of land. With a tsunami of immigrants, residents are forced to adapt to immediate circumstances. Tradition be damned. And besides, whose tradition are we talking about, anyway? That variety of cultures and frenzied pace of life produces innovation and improvisation. The pressure to develop a semblance of social order overnight encourages unorthodox behavior. Prejudice be damned, as well—or at least suspended. Most folks are too preoccupied with the pursuit of wealth and tension-releasing pleasure to indulge those passions. San Francisco diversity nurtures—imperfectly, and not without setbacks—a unique social and ideological tolerance.

> [The 49ers include] *the people of the many races of Hindoo land, Russians with furs and sables, a stray, turbaned, stately Turk or two, and an occasional half-naked shivering Indian, multitudes of the Spanish race from countries of the Americas, partly pure, party crossed with red blood—Chileans, Peruvians, and all with different shades of the same swarthy complexion....* [They were] *black-eyed and well-featured, with moustaches, and their eternal gaudy scrapes of clothing or darker cloak.... Spaniards were more dignified, polite, and pompous...the Englishmen fat, conceited, and comfortable, pretending to compete in shrewdness with the subtle Yankee. Germans, Italians and Frenchmen all were gay, easy, principled, philosophical.*
>
> —Annals of San Francisco, *1855. The Anglo authors also describe the "Chinese, Jews, Negros, Australians, and Japanese" in even more vivid and opinionated stereotypes, best left to private consumption.*

The thriving gambling dens and saloons encourage a bold Star Wars mixing of races and ethnicities in whirls of recreation and recklessness. Whatever cultural prejudice immigrants carry from their homelands can be blown to the San Francisco Bay winds in liquor-fueled soirees. This degree of cross-cultural fraternization is not common at the time anywhere else in America. Practice may not make perfect, but practice makes tradition. It engenders a unique practical equality in a country that is already celebrated for egalitarianism.

> *Ours was a big general cell, it seemed, for the temporary accommodation of all comers whose crimes were trifling. Among us there were two Americans,*

two "Greasers" (Mexicans), a Frenchman, a German, four Irishmen, a Chilean…all drunk.

—Mark Twain's 1870 imaginary letter home from one Ah Song Hi, a Chinese immigrant on his 1850s gold rush adventures. Samuel Clemens lands in San Francisco in 1864 as a young man and works at several newspapers prior to becoming a traveling correspondent for the Alta California. *The real Tom Sawyer is a volunteer San Francisco firefighter who befriends the young Mark Twain. In telling the writer of his adventures in the West during his migration from New York City to California, he inspires the famous book and main character. Tom Sawyer rests at Cypress Lawn Cemetery, nine miles south of the city, where many other notable San Francisco souls reside. Twain's style of writing—vernacular, satirical and casual—is characteristic of a budding national revolution in art and letters that introduces a fresh, far-western frontier perspective to counterbalance a staid, Old World tradition of New England writers such as Ralph Waldo Emerson who had led an intellectual movement that molded America's first generation of literary greats. San Francisco becomes the national epicenter of this new writing.*

Americans and Europeans, Mexicans and South-Americans, Chinese and even negroes, mingle and dissipate together, furnishing a large amount of business for the police.

—Frank Soule, journalist, 1855

A catastrophic crop failure in southern China that coincides with new burdensome taxes on already impoverished citizens precipitates a mass migration to California. Over twenty thousand Chinese immigrants inundate the old customs station in 1852—eight times the number from the previous year. An alarmed California state government quickly imposes a second Foreign Miners Tax, upping the levy to three dollars per month. There is a logic to the tax: if you come to the United States just to make a fortune and leave without being naturalized, you should pay for that privilege. It is applied to the Chinese, Mexicans, Chileans, Hawaiians, Peruvians and Argentines. With a barely functioning government and highly mobile population, the tax is seldom collected. Especially in the early gold rush years, it is commonly believed and often true that the average immigrant to San Francisco, from

Colored population—Greaser, Chinaman, and Negro.

This illustration appears in *The Annals of San Francisco*, 1855. The authors are Anglo patricians, and their book text reflects the common prejudices of the era, especially among elites. They are equal opportunity critics, however, sparing no one from their acid satire.

Missouri to Manchuria, is there to make a fortune and return home. This perception is most focused on the Chinese and feeds hostility.

Of all the ethnic groups roaming the early streets and gold fields of San Francisco, the Chinese are the most "foreign" and insular—apparently resistant to cultural integration. What comes to be called "Chinatown," an area concentrated around Sacramento Street, is the most densely packed section of humanity in San Francisco—and perhaps the country.

Commentators are bewitched, bothered and bewildered by the Chinese.

> *Go where the visitor will, and he meets natives of the Celestial Empire, and subjects of the uncle of the moon, with long painted queues or tails, very wide pantaloons bagging behind and curiously formed head covering— some resembling inverted soup plates, and fitting to the scalp as the scalp does to the Celestial cranium it covers.*
>
> —San Francisco Herald, *1852*

They will divide the rooms into numerous diminutive compartments by unsightly partitions and the smoke and rank odor their open fires and opium discoloring the celling and walls enders the whole building offensive…so that the expense of renovating it would not be offset by the rental renewals receipts for six months or more.

—Benjamin E. Lloyd, 1878. However inaccurate, this is a common perception. All can agree, however, that the Chinese are a most industrious people.

The national habits and traits of the Chinese character, to which they cling with uncompromising tenacity in this country, are strikingly distinct from all other nations.…They are constitutionally haughty and conceited and believe themselves to be superior to us all respects.…The Chinese are more objectionable than foreigners because they refuse to have dealing or intercourse with us. Consequently there is no chance of making any thing of them either in the way of trade or labor.

—Hinton Helper, Land of Gold, *1855*

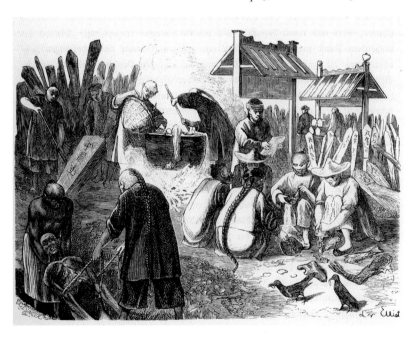

A Chinese funeral ceremony in San Francisco. The Chinese want their remains delivered to local ancestral lands for final burial. The practice at the time is to remove and cleanse the bones before transport.

LAWS OF SUPPLY AND DEMAND

The population of the city in 1850—in flux and difficult to calculate—quickly bounds to about twenty to twenty-five thousand. The previous year, some seventy-five thousand passed through on the way to the gold fields. They return to San Francisco to cash in, restock and revitalize, spending money like drunken Argonauts. Perhaps the largest entrepreneurial vacuum in history begins to be filled. That goods must be imported to a remote region turns San Francisco into a clinic on supply and demand in an unregulated marketplace.

A resourceful resident and Mormon leader named San Brannan seizes the day and becomes the state's first millionaire. Upon word of the gold discovery and before the onslaught of outside adventurers, he accumulates as much mining equipment as can be found and arranges to acquire more, cornering the early market. To promote his wares, Brannan saunters up and down Montgomery Street on May 8, 1848, with a large bottle of gold shavings, announcing to San Franciscans that is "gold from the American River." The merchandising spectacle is the first concrete proof residents have of the find. Brannan then builds a store next to Sutter's Fort, where John Marshall first discovered gold, and another in nearby Sacramento. At the height of the early gold frenzy, the Fort Sutter store is the only supply depot between gold field lands and San Francisco. The establishment turns enormous profits, on exceptional days as much $5,000 ($150,000). There is no mention of any security arrangements to protect the gold/cash-only business revenue, but it likely resembles a frontier version of Fort Knox.

1849 PRICE LIST FROM SAM BRANNAN'S SACRAMENTO STORE

($1=$30+)

Beef	$0.50 a pound
Mutton	$1.00 a pound
Veal	$0.75 a pound
Pork	$1.00 a pound
Chicken	$16.00 each
Mackerel	$1.00 a pound
Coffee	$0.55 a pound
Tea	$5.00 a pound
Flour	$0.75 a pound
Sugar	$0.65 a pound
Potatoes	$1.00 a pound

Onions	$1.00 a pound
Eggs	$0.85 each
Molasses	$4.00 a gallon
Fruit	$0.50 each
Hard Bread	$0.75 each
Shovels	$25.00 each
Pans	$10.00 each
Pick Axe	$25.00 each
Shirts	$40.00 each
Boots	$40.00 a pair
Socks	$10.00 a pair
Hats	$10.00 each
Underwear	$15.00 a pair
Horses	$150.00 each
Mules	$100.00 each
Saddles	$50.00 each
Rifle	$75.00 each
Pistol	$50.00 each
Knife	$10.00 each
Ammunition	$10.00 a box
Dynamite	$100.00 a box
Haircut	$1.50
Shave	$1.00
Bath	$2.00
Laundry	$0.50 a piece
Billiards	$1.00 a game
Lodging, a blanket on the floor	$1.00 a night

Scurvy abounds in the early gold rush due to paucity of vitamin C, absent in the typical miner diet of coffee, tea, biscuits, bread and cheese. Even the most resilient can crumble under a conspiracy of symptoms like fatigue, muscle weakness, joint aches and leg rashes. The demand for fruit with its scurvy-preventing nutrients hits a peak in 1849, when apples are as rare as women and can fetch an extravagant $5 ($150) each. Fruit mongering is a dangerous profession.

There is restaurant cuisine in those early days, however limited and dear. Edward Gould Buffo is one of the first journalists to write about the gold rush. A breakfast of bread, cheeses, butter, sardines and two bottles of beer with a friend comes to staggering $45 ($1,300). He pays the bill, but there is

no mention of a tip. Game is rare. In this case, the chicken *does* come before the egg. Those laying the precious commodity are more valuable alive, given that a single yolk might fetch $1 ($30). The most available bird is the curlew, a tall native wading species with a distinctive ascending two-note call and slow gait that makes it easy to locate and dispatch. Roasted or boiled to order, the delicacy will set you back about $30 ($100).

Who can afford such outrageous prices? Local miners who have already struck it rich—and great fortunes can be extracted in hours. Others may pool resources to buy equipment and goods. Many arrive with money. Some pioneers are smart or lucky enough to walk off the boat with goods to sell. A prescient gentleman arriving in 1849 brings 1,500 copies of New York City newspapers and hawks the months-old print at $1 ($30) each in two hours. Another fellow in 1851 finds an unexpected bounty in toothpicks. He has brought a supply for himself and friends but quickly discovers his product commands $0.50 ($15) for a pack of twelve.

The lofty prices prevail during 1849 and 1850 and then slowly recede as resourceful suppliers fill the entrepreneurial vacuum. It hardly happens overnight. Supply chains before railroads are cumbersome and unpredictable. There is no Panama Canal. The riches unearthed daily buoy up extraordinary prices, creating an atmosphere of reckless abundance— witness the gambling parlors where thousands of dollars are won or lost nightly over the flip of a single card.

It sounds almost incredible now, the many stories that are told of the manner in which persons would waste the gold dust in those early times but it was the truth, nevertheless. In front of Mr. Howard's store, on Montgomery street, from the sweepings of the floor a man got over fifty dollars [$1,500] in one day. Another instance occurred in the City Hotel. The man who did the sweeping would save the sweepings in a barrel, until full; and on washing it out he obtained over two hundred dollars [$6,000] in gold dust.

—*John Brown*, Reminiscences and Incidents of the Early Days of San Francisco, *1857. John Brown is an example of the rugged, free-spirited character who makes his way to infant San Francisco. In his own words: "In introducing myself to the Public, I wish to say that I was born in the City of Exeter, Devonshire, England. While still very young, I left home to serve as an apprentice to my Uncle, on the packet ship 'England.' I ran away after the third trip, and shipped for Havana, going thence to Philadelphia, which ended my sea-faring life. From Philadelphia, I went to*

New York, where I remained a few months, then started for the West, going as far as Cincinnati. Leaving the latter place, to make my home among the Cherokees....I remained with the Cherokees until May, 1843, when I started for California, arriving in the winter of the same year." True...exaggerated… apocryphal? These stories are the soul of early San Francisco.

Despite the amazing high cost of living and the extradinary opportunites for frittering away money, everyone in early San Francisco was supremely confident that he would soon be able to return home with an incalucuable amount of gold. Everything was conceived on a vast scale and here was always plenty of cash available for any schemed that be proposed, no matter how impossible or bizaarre it seemed.

—Annals of San Francisco, *1855*

Those who pursue commercial goals make more money in the long run than gold prospectors. From livery stables to ladies of the night, "mining the miners" is the road to success. Such entrepreneurs establish national brands that thrive to this day.

DOMINGO GHIRARDELLI HAS A miner supply store in Stockton and San Francisco. Both burn down in 1851. He embraces chocolate in 1852 and hits the sweet spot. Ghirardelli's Chocolate Factory occupies four different sites before the company takes over the Pioneer Woolen Mills on North Point Street—the present site of Ghirardelli Square.

LEVI STRAUSS opens a San Francisco branch of the family New York City cloth business in 1853. His customers are miners who are always complaining that their pants fall apart in the rigors of gold digging. Strauss experiments with durable canvasses and applies for a patent to fashion riveted trousers. Miners, cowhands, lumberjacks and railroad workers make the pants legendary. Soon, he uses a durable cotton, known as denim.

In 1981, the company moves its corporate headquarters to what is now called Levi Strauss Plaza in the Embarcadero. It pays $46,532 in 2001 for a pair of denim trousers it made in the 1880s—at the time the oldest known. In 2018, a pair of Levis goes to an anonymous buyer from Asia for almost $100,000; it was originally purchased 125 years earlier by an Arizona Territory storekeeper who stashed them in a trunk after a few wears. The

auction house conducting that sale has since revealed that a pair of 501 jeans manufactured in the 1880s sold for $60,000 to a Japanese collector, and another pair, from 1888, went for six figures.

HENRY WELLS AND WILLIAM G. FARGO take the young American Express Company—designed to transport goods and valuables between New York City and Buffalo to various points in the Midwest—and expands its operation in 1852 to banking and express shipping to California. The Wells Fargo Museum at 420 Montgomery Street is on the site where the first San Francisco office opened.

ISADORE BOUDIN establishes a commercial bakery in 1853 where he produces the renowned sourdough bread that quickly becomes synonymous with San Francisco itself. The unique tangy flavor of the local loaf can be attributed to the spores, fungi and bacteria in the microclimate—and virtually nowhere else. Miners acquire a love for the special flavor, taking various sourdough starters on their travels. Those who land in the 1890s Alaskan gold rush are called "sourdoughs." Boudin Bakery continues to use its original starter at Fisherman's Wharf, where the story of sourdough is told in the Boudin at the Wharf Bread Museum overlooking a working bakery.

JAMES A. FOLGER arrives in San Francisco in 1849 as a teenager and purchases a stake in a coffee mill company before leaving to find gold. He carries along samples of coffee and spices, taking orders from grocery stores along the way. Upon his return to San Francisco in 1865, Folger becomes a full partner of the Pioneer Steam Coffee and Spice Mills. In 1872, he buys out the other partners and renames the business J.A. Folgers & Company.

PHYSICS AND ECONOMICS DICTATE that what goes up, must come down. Gold production soars to new heights in mid-1853, fueling an already extravagant speculative spirit. As in most financial feeding frenzies, a wild high is a harbinger of a dramatic change in fortune. The boom deflates as quickly as it began. The gold rush has seemed invincible. The downturn hits the city hard, both physically and psychologically—the first widespread dislocation in the heretofore constantly expanding economy. Overnight, there is doubt about the future. Immigration to California in 1855 is cut in half from the previous year.

The young city is stunned by the quick economic downturn. Thousands of discouraged miners abandon their dreams. Some return to the eastern states; others migrate inland or to Southern California and seek work or entrepreneurship in agriculture. Real estate is the most significant source of

profit after gold. As capital for investment dries up, there is a precipitous fall in real estate prices that dominos into a decimation of individual fortunes. Almost one-third of the San Francisco's approximately one thousand business structures collapse, most into bankruptcy. Warehouses, shops and office buildings lay vacant. Housing sites that cost $15 in 1847 and command $8,000 two years later fall back overnight to $100. Gold does continue to be extracted for many years, but at reduced levels. The economy gradually recovers in the 1860s. However, San Francisco is treading less certain waters before being blessed again by the mineral gods.

The whole town is for sale…and there are no buyers.

—William T. Sherman, 1858, on a business trip to the city. The military officer would soon become a heralded Northern general in the Civil War.

DANTE'S INFERNO

A perfect storm—hastily built wood structures pulled from abandoned ships, tents made from whatever is available and intoxicated outdoor cooking—is begging to ignite. It does, likely aided by arson. From Christmas Eve 1849 to June 1851, six fires devastate major parts of the city and consume countless buildings and mostly unknown lives. The collective events are regarded at the time as the most destructive set of fires ever in an American city. It has one beneficial effect—like most disasters, the events inspire new and improved construction.

The San Francisco city seal, adopted in late 1852, pays tribute to the city's resilience in the face of fires by featuring a phoenix—the legendary bird arising from flames. It is a harbinger of the devastation and recovery from the 1906 earthquake and fire. The seal undergoes changes over the years, but the phoenix remains.

I went home scarcely suspecting that in a few hours half of this city I had been admiring would be nothing more than a pile of ashes.…The cry of "Fire!" so terrifying for the city of San Francisco built of wood and canvas echoed in the air. More than once I had heard the clamorous and insistent call of the fire bell because conflagrations were common in San Francisco. But the one I was to witness was monstrous, a huge inferno that

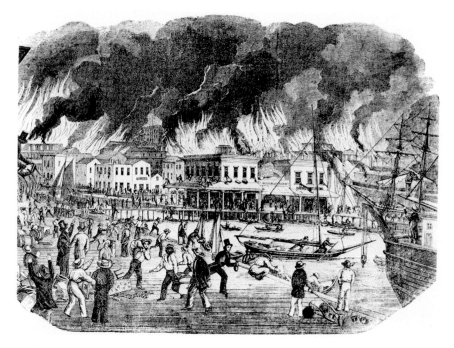

San Francisco ablaze in 1850.

would consume 300 buildings....Alcohol and wood! The most voracious fire could not have sought a more potent combination. With each new rum, brandy or grog ship it devoured, the fire doubled in intensity.

—*Theophile de Rutte, Swiss businessman, 1849, describing the fire that swept through the city on Christmas Eve*

Mr. Thomas Maguire, the proprietor of the "Jenny Lind Theatre," on the plaza, which was a most valuable building, now lost again—a sixth time, by fire! But it is needless to particularize losses, where every citizen may be said to have burned out several times, and to again and again lost his all! With sigh or a laugh, according to the temperament of the sufferer, he just began once more to raise his house, stock it with new goods, and arrange his future plans...like the often persecuted spider with its new web, to create still another town, another fortune.

—Annals of San Francisco, *1855*

The first officially organized volunteer fire departments in the city are created after the 1849 Christmas Eve conflagration. Three years later, fourteen private volunteer engine companies have been established along with three hook and ladder brigades. The only paid personnel is a city fire chief. These groups are part of a long tradition of American volunteer fire companies composed of leading citizens who take great honor in their membership—a source of political and economic status. Competition among these companies for uniforms, equipment and station houses is intense, including a mad dash to fires to see who can douse the flames first. Volunteer firemen, in uniform, participate in parades and all public celebrations.

As always, ladies love a man in uniform. Brought to the budding city by her aristocratic parents as an eight-year-old, Lillie Hitchcock Coit becomes a firefighting booster—and a young public heroine. Inspiring citizens to help volunteer firemen put out a blaze in 1858, the teenager is anointed the "mascot" and honorary member of Knickerbocker Engine Company No. 5. Soon she is riding along with the stalwarts as well as attending their parties and banquets. This relationship continues throughout her life. Heir to the Coit estate, "Firebell Lil" wills one-third of that fortune "to be expended in an appropriate manner for the purpose of adding to the beauty of the city which I have always loved." Her friend and architect Arthur Brown,

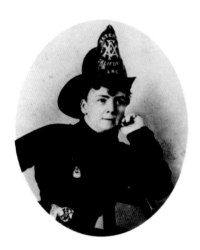

Lillie in one of her many firefighter hat poses.

buried adjacent to the mausoleum that he designs for her at Cypress Lawn Cemetery, is chosen to realize her gift and designs Coit Tower to resemble a fire hose nozzle. There are historians who question if the artifact is indeed a nozzle. But all agree that it is difficult not to see a Freudian allegory. When the art director of the 1958 film *Vertigo* asks Alfred Hitchcock why he wants Coit Tower to appear prominently in the protagonist's living room window, he responds, "Because it is a phallic symbol." Tourists (and locals) climb to the top for amazing views.

Firemen begin earning salaries on December 3, 1866. Merry Christmas.

LAW AND DISORDER

San Francisco in 1851 is the nearest approach to criminal anarchy that an American city has yet experienced.

—Herbert Asbury, The Barbary Coast, *1936*

Mayhem reigns in the Wild West. The mining camps one hundred miles from San Francisco are even more violent and disorganized than the city, but the per capita urban murder rate during the 1850s is still five times the current level. It is a port—and a uniquely grab-it-and-leave-it port—that attracts a transient population less likely to conform to traditional norms. San Francisco's notorious reputation for street crime draws immediate national attention. The public tends to see much of the early person-on-person assaults as justified by self-defense or payback vengeance or too ambiguous to adjudicate. Informal vigilance groups often dispense "instant justice" before civil authorities can intervene. Those charged with policing do not exist officially until August 1849.

GANGS OF SAN FRANCISCO: THE DUCKS AND THE HOUNDS

The upper part of Pacific Street, after dark, is crowded by thieves, gamblers, low women, drunken sailors, and similar characters....Unsuspecting sailors and miners are entrapped by the dexterous thieves and swindlers that are always on the lookout, into these dens, where they are filled with liquor— drugged if necessary, until insensibility coming upon them, they fall an easy victim to their tempters....When the habitues of this quarter have a reason to believe a man has money, they will follow him for days, and employ every device to get him into their clutches....These dance-groggeries are outrageous nuisances and nurseries of crime.

—San Francisco Herald, *1850*

The most notorious of the notorious are the notorious Sydney Ducks. Of the some eleven thousand who emigrate from Australia to San Francisco by mid-1851, as many as 20 percent are ex-convicts originally sent to penal colonies there from Great Britain. Sydney-Town, located on the waterfront at the southern edge of Telegraph Hill, is well known for its

dive bars, dangerous gambling dens and violent robberies. The denizens are suspected of many crimes, the most dastardly of which is arson for the purpose of looting and burglary. In fact, many accuse the Ducks of setting some or all of the deadly fires that sweep through San Francisco in the early 1850s. The First Vigilance Committee lynches three of its members in 1851 and deports twenty-eight more. Gangbangers foolish enough to stay or return are routed for good by the Second Vigilance Committee in 1856.

The Hounds—euphemistically calling itself the San Francisco Society of Regulators—is a nativist/anti-foreigner ragtag army whose preferred target is Hispanics, especially Chileans arriving in great numbers from an experienced mining culture. Gang revenue comes from extortion of foreigners. That activity quickly expands into a full-fledged criminal enterprise when it accosts city residents as well, using looting and arson as enforcement tools. The anti-foreign message is not entirely unpopular, but as usual, the roughnecks overstep their dubious credibility and face demise. When on July 15, 1849, the Hounds attack a Spanish "shantie town," robbing and killing several immigrants, public opinion and city officials turn against them.

> *There is great excitement among property holders, and organized parties patrol the town nightly under arms.*
>
> *—Charles Winslow, a physician who migrates from Boston to San Francisco, in a letter to his wife on July 19, 1849, of events that occurred on July 15. The doctor proves instrumental in founding an emergency volunteer police department that instantly deputizes 230 men to arrest the Hounds. Most of the gang has fled the city by this time, and its influence abruptly ends.*

The San Francisco Police Department—already planned and likely accelerated because of the chasing of the Hounds—is founded one month later. Consisting of a chief and thirty-five officers to protect twenty thousand residents, it does not always get rave reviews in the early years.

> *As for the police, I have only one thing to say. The police force is largely made up of ex-bandits, and naturally the members are interested above all in saving their old friends from punishment. Policemen here are quite as much to be feared as the robbers; if they know you have money, they*

will be the first to knock you on the head. You pay them well to watch over your house, and they set it on fire. In short, I think that all the people concerned with justice or the police are in league with the criminals. The city is in a hopeless chaos, and many years must pass before order can be established. In a country where so many races are mingled, a severe and inflexible justice is desirable, which would govern with an iron hand.

—Albert Bernard de Russailh, 1851. The Frenchman comes to San Francisco in search of gold and keeps a journal of his observations.

As late as 1871, San Francisco has only 100 police officers—1 for every 1,445 inhabitants. New York City has 1 for 464, London 1 for 303. Crime and disorder mushroom. Leading citizens scramble to find additional secure jail space. In October 1849, at a cost of $8,000 ($250,000) the brig *Euphemia*, abandoned in San Francisco Bay at the foot of Battery Street, is purchased and converted into a floating county jail that holds 25 prisoners, some of whom are booked as "unruly"—a code word for mentally unstable. After the Broadway Jail opens in 1851, the vessel is buried in landfill as the city expands. It is uncovered during a 1921 construction project.

We should remember that those little boys whom we see wandering about the street ragged and dirty, spending the day time watching opportunities for theft…those drinking, swearing loafing children, most of them become so from the force of circumstances.

—San Francisco Herald, December 1856

Other cities experience juvenile delinquency problems, but not to the extent as San Francisco—a society with few women or stable families or traditional institutions in the midst of unprecedented temptations for bad behavior lurking on every street corner.

ARMED TO THE TEETH

Weapons are de rigueur, even haute couture, west of the Mississippi, and especially in San Francisco. Gun control means knowing how to shoot straight.

Most of the citizens if not all go around armed. I myself venture out evenings with a cane which through it looks perfectly harmless…will be found to contain a sword two and half feet long.

—*clergyman Francis Prevaux, 1851, writing to his parents*

Several doorkeepers were in attendance, to whom each man as he entered delivered up his knife or his pistol, receiving a check for it, just as one does for a cane or umbrella at the door of a picture-gallery. Most men drew a pistol from behind their back, and very often a knife along with it; some carried their bowie-knife down the back of their neck, or in their breast; demure, pious looking men, in white neck collars, lifted up the bottom of their waist coat and revealed the butt of a revolver; others, after having already disgorged a pistol, pulled up the leg of their trousers, and distracted a huge bowie-knife from their boot, and there were men, terrible fellows, no doubt, but who more likely to frighten themselves than anyone else, who produced a revolver from each trouser pocket, and a bowie knife from their belt. If any man declared that he had no weapon, the statement was so incredible that he had to submit to be searched; an operation which was performed by the doorkeepers, who, I observed, were occasionally rewarded for their diligence by the discovery of a pistol secreted in some usual part of the dress.

—*J.D. Borthwick, journalist, reporting on his attendance at a "no-weapons" San Francisco masquerade ball in 1852*

Alcohol consumption in San Francisco is hard and heavy from the earliest days. Not just served in saloons, the drinks flow nonstop in brothels and gambling houses. Liquor and weapons prove to be a deadly combination. Of the first twenty official murders recorded in the San Francisco police blotter, ten appear to be directly associated with intoxication:

5. Drinking Tent (saloon)
7. Saloon affray
9. Brothel (saloon)
12. Brothel (saloon)
13. Drunk fight
14. Saloon dispute
15. Drinking Saloon

17. Brothel (saloon)
19. Gamble dispute
20. Gamble dispute

Half the victims are "bladed." The other half go to their maker by "gun." The remaining Top Twenty meet their "official" fate by:

Misunderstanding
Riot
Trussed
Robbery
Robbery
Stabbed 24 times
Headless floater
Quarrel in the street
Ship dispute
Impromptu duel

Although not specially linked to drinking, it is a fair assumption that the stench of liquor permeated most of these crime scenes as well. The majority of "perps" are listed as "fled" or "never identified." It will take some years before the inclination to take the law into your own hands abates. In the meantime, sensational assassinations and assassination attempts define first-generation San Francisco.

PERHAPS THE MOST DANGEROUS profession in the early city is journalism. A no-holds-barred crusading editor gets into a long, vitriolic and very personal verbal battle with another editor who happens to sit on the Board of Supervisors. In 1856, James King of William reprints articles reporting that Supervisor James Casey has served time in New York's Sing Sing Prison for grand larceny.

"Are you armed, sir?" asks Casey as he accosts King in the late afternoon on a busy street. "Draw and defend yourself!" Without waiting for a response, he fires one shot at King, who dies six days later at age thirty-four. Fifteen thousand show up for a funeral procession that a bystander describes as "a spectacle never before witnessed in San Francisco." There will be more such spectacles.

IS THERE A GREATER insult than for someone to call your mother a whoremonger—in other words, a brothel keeper? To add insult to injury, you are labeled a bastard—in the literal sense, another slander on your mother. Charles de Young, anticorruption crusader and cofounder and editor of the *San Francisco Chronicle*, who had proclaimed political enemy Isaac Kalloch a serial adulterer, is tangling with the largest minister in the city—both in weight and congregation size—and a candidate for mayor in 1880. Furious at the counteraccusations, de Young concocts a dastardly plan: enlist a youngster to entice an unsuspecting Kalloch to a coach to speak to a "young lady," whereupon de Young leaps from the vehicle and shoots his adversary at point-blank range. Kalloch, with plenty of natural insulation to stop a bullet from reaching vital organs, survives and goes on to win the election.

In this drama, the pen is not mightier than the sword. Released on bail, de Young confronts his karma one night when Kalloch's son, full of liquid courage, marches into the *Chronicle* offices and shoots him dead at his desk. Again, a lavish San Francisco funeral procession for the thirty-nine-year-old victim as a jury finds the young Kalloch acted under duress and is acquitted, sparking public outrage that is mild compared to the editorial outrage.

de YOUNG REDUX. THIS time it is Charles's brother Michael de Young publishing no-holds-barred articles that accuse Sugar King Claus Spreckels of using slave labor on his Hawaii plantations and bilking stockholders. By 1884, son Adolph Spreckels has had quite enough. In venerable San Francisco tradition, he aims to assassinate the editor, but his aim is off. Entering the *Chronicle* offices, Spreckels does manage to shoot de Young in the elbow and shoulder and would have dispatched his adversary with a third shot had it not been slowed by a bunch of children's books de Young happened to be clutching prior to the fracas. In a frantic chaos of scuffles with employees, Spreckels is shot and subdued. Everyone survives. In venerable San Francisco tradition, the aggrieved assailant is acquitted by a jury.

> *Those de Young girls are nice, but we've been never been close since my husband shot their father.*[*]
>
> —*Alma Spreckels, circa 1925, the wife of deceased Adolph Spreckels, speaking of the daughters of Michael de Young*

[Mr. Terry is] *a dammed miserable ingrate.*

—*Senator David Broderick, 1859*

THESE ARE FIGHTING WORDS that cry for a public retraction, which is not forthcoming. Not technically an assassination, a bloody rose by any other name is still a bloody rose. And this duel is tantamount to an assassination. Duels are technically against the law, and the initial tete-a-tete is stopped by police intervention. Soon after, the encounter occurs with all the trappings of formal aristocratic protocol. Broderick never has a chance against the more gun-skilled former California Supreme Court justice David Terry, who picks the duel weapon, practices with it and has experienced seconds. Broderick accidently fires the hair trigger. His one permitted shot drills the ground. Now it is Terry's turn. Per rules, he gets all the time he wants to aim and fire at a defenseless Broderick, who must remain motionless. The return round scores a direct hit to the lungs. It is the last major contest of this gentlemanly sport in the United States. The burial of the popular Senator Broderick is another spectacular city funeral procession. That the antislavery Broderick is slain by the proslavery Terry further inflames an impending Civil War–divided city. One critic of the historic duel calls it "polite slaughter." In 1998, the pistols used in that duel fetch $34,500 at a San Francisco auction.

GUNS MAY BE THE preferred method of dispatching an enemy, but the ancient and trusty knife is a close second. When a commodities broker loses a package of gold, Charles Sutro finds and returns it, but only after a few days. The broker is angry at the delay and, during a name-calling confrontation, nearly severs Sutro's lower lip. Later the same day, the attacker happens to encounter the victim's uncle Adolph Sutro—who will go on to develop vast city arboretum spaces, build an incomparable public bath and serve as mayor. Aware of the incident, Adolph mutters an epithet as the two walk by each other. He recalls what follows: "Mr. King passed me and sprang around and said, 'You call me a scoundrel?' He then cuts with a knife a ghastly wound from the ear down to the mouth. There were fifty persons standing about, but it was done so suddenly that I doubt in any person witnessed it."

The rest of the story: Adolph Sutro's life-long signature whiskers are grown to cover the scars.

WHEREAS it has become apparent to the citizens of San Francisco, that there is no security for life and property, either under the regulations of society as it at present exists, or under the law as now administered; Therefore the citizens, whose names are here attached, do unite themselves into an association for the maintenance of the peace and good order of society…and do bind ourselves, each unto the other, to do and perform every lawful act for the maintenance of law and order…but we are determined that no thief, burglar, incendiary or assassin, shall escape punishment.

—*First Committee of Vigilance declaration on June 13, 1851,*
in the Daily Alta California

The Committee of Vigilance disbands by September, only to return in 1856. The 1856 version, a reaction to the murder of journalist James King of William, boasts a membership of six thousand, the largest vigilante group in American history. It operates parallel to and in defiance of the duly constituted city government that actively opposes the movement. Members are propertied middle/upper-class "rebels" who are protecting their stake in new social order while claiming to save the city from itself.

The interrogation and incarceration of suspects—often denied formal due process—is conducted at vigilante buildings. The group targets disreputable boardinghouses, suspect ships and undesirable immigrants. Its militia parades often and with abandon. The 1856 organization hangs four people, including James Casey (the assassin of journalist James King of William) on the day of his victim's funeral. The disposition of other detainees is as follows:

1 whipped, a common punishment at that time
14 deported to Australia, whence they came
14 ordered to leave California pronto
15 transferred to public authority, likely to their relief
41 "discharged"

After the second relinquishment of power in 1857, its tombstone might have read: Keep the Order or We'll Be Back. And the committee does return in 1878 during a nationwide depression that sparks local labor unrest and virulent anti-Chinese sentiment. The Vigilance Committee is credited with rescuing the San Francisco Chinese community from destruction by angry white mobs.

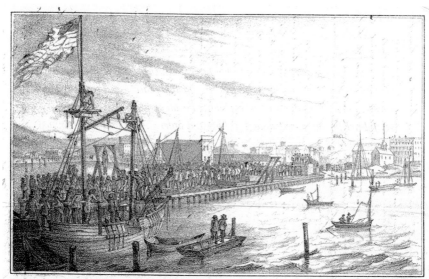

JAMES STUART HUNG BY THE VIGILANCE COMMITTEE ON MARKET ST. WHARF, ON THE 11ᵗʰ OF JULY 1851. — IMMENSE MULTITUDE PRESENT. — 500 OF THE VIGILANCE COMMITTEE ON DUTY AT THE EXECUTION. — His confession & evidence proved him guilty of the murder of Chas. Moore, Sheriff of Yuba County, — of the murderous assault & robbery of Mr. Jansen in this city, & of the Captain of the brig Jas. Coskie in this harbor — of the robbery of the Custom house at Monterey — Besides numerous other robberies & murders. No criminal was ever more daring or successful — more reckless or cold blooded. He was a Sydney convict, transported for life "for forgery. His last words were "I die resigned — my sentence is just."

VIEW TAKEN FROM THE STORESHIP BYRON.
Foot of Market St. Wharf San Francisco.

Publ. & Lith by Justh Quirot & Cᵒ Calif. Corn. Montg. Sᵗ S.F.

In American history, there has never been a group comparable to the Committee of Vigilance—in terms of patrician influence, relative restraint and voluntary relinquishment of power or how it shapes the political agenda.

THE LEGEND OF THE "gentleman outlaw" is a cocktail of mythology, dime novels and a dash of reality. San Francisco provides the ideal shaker.

BLACK BART: THE FACT

Madame, I am not here for your money. I'm here for Wells Fargo money.

—Charles Boles, aka Black Bart, 1875, *responding to a terrified young lady offering her purse in a daring stagecoach robbery*

Between 1875 and 1883, a polite, even gallant, nonviolent criminal robs twenty-eight Wells Fargo stagecoaches in Northern California and Oregon. Although armed with a shotgun, he never fires a shot, touches a victim or

takes anything from a passenger. It is later revealed that the weapon is empty. His dress is dapper—a clean long linen duster coat and bowler hat, accented by a flour sack head disguise with cut-out eyeholes. In a letter to his wife, he expresses anger and contempt for Wells Fargo agents. He leaves this poem at the scene of one of his crimes:

I've labored long and hard for bread,
For honor, and for riches,
But on my corns too long you've tread,
You fine-haired sons of bitches.

—Black Bart, 1877

This literary cursing never appears in his speech. In fact, the chief interrogator after his capture describes Boles as "extremely proper and polite in behavior. Eschews profanity."

In a hasty retreat after suffering a wound in his final robbery, he leaves behind a San Francisco laundry–marked handkerchief. A gentleman's habit leads to a gentleman's demise. A search of ninety city laundries finally turns up the identification. Charles Boles served as a first lieutenant in the Civil War Union army. He assumes the name Black Bart from a fictional newspaper series of a Wells Fargo stagecoach robber who dresses in black and sports long, unruly black hair and a bushy black beard—ironically, the opposite of the real Black Bart. When arrested, Boles describes himself as a mining engineer who lives beyond his means in San Francisco and robs stagecoaches whenever he needs money to pay his debts.

Here I lay me down to sleep
To wait the coming morrow,
Perhaps success, perhaps defeat,
And everlasting sorrow.
Let come what will, I'll try it on,
My condition can't be worse;
And if there's money in that box
'Tis munny in my purse.

—Black Bart, 1878

No, gentlemen, I am through with crime.

—Charles Boles, upon walking out the prison gates, answering a question from a horde of reporters. Wells Faro presses charges only on the final robbery. Boles serves six years in San Quentin, reduced to four for good behavior, presumably including an absence of profanity. He then vanishes never to be seen again. Hollywood could not resist the story. In 1948, Black Bart stars dashing Dan Duryea in the lead and voluptuous Yvonne De Carlo as a totally fictional love interest.

PALADIN: THE FICTION

Have Gun—Will Travel is set in 1870s San Francisco. "Paladin" lives the high, elegant life of a gentleman at the exclusive Carleton Hotel, indulging in tailor-made clothes, extravagant food, beautiful women and the most cultured of cultural events as he serves as president of the San Francisco Stock Exchange Club. To finance this lavish lifestyle, Paladin is a surreptitious gun for hire—a "soldier of fortune" his theme song declares—who dons an all-black outfit as he ventures to the hinterland to solve problems, usually with a gentleman's conscience but prepared to do what a man has to do. After dispatching or neutralizing his foes, Paladin returns to the good life in San Francisco. His secret collaborator and enabler at the hotel is a resourceful Chinese concierge. The show runs for seven years.

SIN CITY

The Sabbath in California is kept, when kept at all, as a day of hilarity and bacchanalian sports, rather than as a season of holy mediation or religious devotion. Horse-racing, cock fighting, cony-hunting [rabbit]*, card-playing, theatrical performances, and other elegant amusement are freely engaged in this day.*

—Hinton Helper, 1855. Gold rush San Francisco elicits torrents of criticism. Some is tongue-in-cheek à la Mark Twain; other is part of a still generally optimistic look at budding American California. But Hinton Helper, a travel writer, is one of those who loathes and ridicules the much-

heralded promise of a new world on the West Coast as a "hoax." He claims there is precious little fertile land, terrible weather, inadequate ports and a gold rush–spawned moral depravity in government, business and culture that can never be overcome. He strongly advises against immigration, warning: "The present condition and future prospects of California actually portend much poverty and suffering."

The importance of the dollar and the might of an ounce are studied, sought for in every possible way. In short the social man is lost in the money-seeking gold-hunting selfish acquisitive miner and conniving millionaire.

—*Peter Decker,* Life in the Mines, 1850–1851

San Francisco quickly earns a reputation as the most wicked and licentious city in the country, flaunting the devil's trifecta of gambling, drinking and womanizing—a reputation that clings to this day. A young male population, thousands of miles from their hometown and "civilization," fueled by testosterone, sudden wealth and abundant liquor could and did whatever they wanted.

Among so many temptations to err, thrust prominently in one's way, with any social restraint to counteract them, it was not surprising that many men were too weak for such a trials, and to use an expressive but not very elegant phrase, went to the devil.…The human nature of ordinary life appeared in a bald and naked state, and the passion of men, with the vices and depravities of civilization, were indulged the same which characterizes the life a wild savage.

—*J.D. Borthwick, journalist, 1857*

I have seen purer liquors, better segars, finer tobacco, truer guns and pistols, larger dirks [daggers] *and bowie knives, and prettier courtesans here, than in any other place I have visited; and it is my unbiased opinion that California can and does furnish the best bad things that are obtainable in America.*

—*Hinton Helper, 1855*

In 1853, the *Christian Advocate* counts 573 establishments selling liquor, 48 houses of "ill-fame" and 46 gambling dens to service a population of some 35,000—perhaps the highest per capita in history for these "sin" categories. And this survey surely misses many of the more informal and transitory of those businesses. There are 2 churches.

The fabled "Barbary Coast" becomes a symbol for "sin city" and remains a San Francisco fixture and the major public red-light district until the 1920s. The area—defined by the Embarcadero in the east, Grant Avenue and Chinatown to the west, on the south by Clay and on the north by Broadway—is filled with narrow crisscrossing alleys that resemble a labyrinth Kasbah. Crusty sailors give the district its colorful name in the early 1860s, borrowed from the North African Barbary Coast, where local pirates launch raids on nearby towns and vessels, looting treasure and kidnapping locals for indentured servitude on sea.

The Barbary Coast is the haunt of the low and the vile of every kind. The petty thief, the house burglar, the tramp, the whoremonger, lewd women, cutthroats, murderers, all are found here. Dance-halls and concert-saloons, where bleary-eyed men and faded women drink vile liquor, smoke offensive tobacco, engage in vulgar conduct, sing obscene songs and say and do everything to heap upon themselves more degradation, are numerous. Low gambling houses, thronged with riot-loving rowdies, in all stages of intoxication, are there. Opium dens, where heathen Chinese and God-forsaken men and women are sprawled in miscellaneous confusion, disgustingly drowsy or completely overcome, are there. Licentiousness, debauchery, pollution, loathsome disease, insanity from dissipation, misery, poverty, wealth, profanity, blasphemy, and death, are there. And Hell, yawning to receive the putrid mass, is there also.

—Benjamin E. Lloyd, historian, 1878

It is a unique criminal district that for almost 70 years was the scene of more viciousness and depravity, but which at the same time possessed more glamour, than any other of vice and iniquity on the American continent.

—Herbert Asbury, historian, 1937

Shanghai Kelly's Saloon, open for business today at the corner of Polk and Broadway Streets, is named after a real character who makes his living as a "crimp," filling orders from ship captains who need crews but cannot enlist them voluntarily. A common method of involuntary recruitment is to drug or ply the victim with liquor in a saloon or brothel. The unfortunate soul wakes up the next morning on board a ship sailing the ocean blue. The term *shanghaied* refers to the distant port of Shanghai in China. The slang and deed did not originate in San Francisco, but it becomes legendary for the practice during the gold rush, when it is near impossible to find men willing to sign up as merchant seamen to leave such an exciting and potentially lucrative place.

Shanghai Kelly regularly dispatches "runners" to arriving vessels and offers free liquor to entice the unwitting to his saloon/brothel. Needing to fill an especially big order, the master crimp concocts a daring plan: charter a paddlewheel steamer and invite anyone to jump aboard and celebrate his birthday with endless free drink and food. Once they are drugged, he delivers ninety men to three awaiting ships. But how to explain returning to shore with an empty boat? In his haste to profit, Kelly has likely not thought that far ahead and now hopes to sneak in "under the fog." As luck would have it, he stumbles upon the *Yankee Blade* run aground. Kelly graciously rescues the crew and steams back to the city, no one the wiser.

> *Gambling was a peculiar feature of San Francisco at this time. It was the amusement—the grand occupation of many classes—apparently the life and soul of the place.*

—Annals of San Francisco, *1855*

You didn't quite strike it rich in the mining camp, but you gather more than enough to spur you on—many times what you could have earned as a ranch hand back in Missouri. Now you need a respite from the backbreaking toil, constant over-the-shoulder vigilance and paucity of comfort. You trek the one hundred miles back to San Francisco to cash in and indulge in a little rest and relaxation. The hotel and food prices are shocking. It wasn't like this a year ago. You might sleep in an overpriced tent at the outskirts of town on a cold, damp dirt floor with the autumn rains beating overhead and trickling in. Or an outdoor boardinghouse.

Enticingly close are gambling saloons that beckon with fireplaces, gas lamps, music, liquor and women. Sounds of old-time rhapsodies and scents

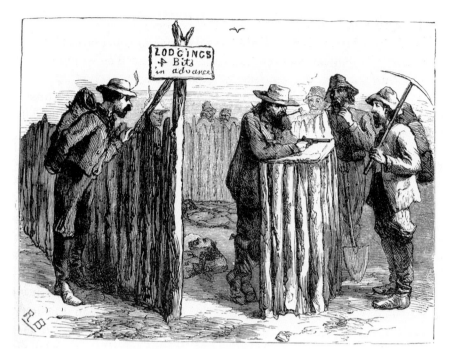

A cheap place to rest one's head in San Francisco without losing it.

of perfume float by. You haven't seen the fairer sex in…you can't remember when. So you run or drift to the lights like moths to a flame. Those flames are the social centers of San Francisco. The addiction seems to afflict everyone, from day laborers to judges. The popularity of gambling in the West can be attributed in part to the DNA of those who left the relative safety and comfort of the East to seek fortune on the unknown frontier. These hardy souls were natural-born gamblers, unafraid of risk and failure.

The earliest gambling "houses" are improvisations consisting of little more than large tents. Men crowd onto barrels or shipping crates and test their luck. It doesn't take long for entrepreneurs making hand-over-fist profits to set up more inviting habitats that become the first solid and comfortable structures constructed in the city. By 1850, hundreds of dens with a wide range of architecture and amenities dot San Francisco. Gambling is not a sport for the faint of heart. Thousands of dollars can be lost in seconds. The cavalier attitude is fed by plentiful gold finds in those early years.

He rode up to the barroom window (which was very large) and said he was going to ride through. I informed him if he did so, it would be a very dear

ride. He asked how much it would cost him. I made the figures rather high thinking it would keep him from coming through: $500 [$15,000]. The words were hardly out of my mouth when he threw a bag of dust through the window to me, "Weigh out your $500 and take enough out for a basket of wine," and before I could pick up the bag he and his horse were through the window.

—*John Henry Brown, 1850, manager of the City Hotel*

One Rufus Lockwood becomes an instant local legend when the lad, likely under the influence of multiple stimulants, skips an unknown number of $20 gold pieces (today's value $600+ each) across San Francisco Bay as he probably skipped flat stones back in his old swimming hole a couple of year prior.

GAMES PEOPLE PLAY

FARO. The most popular early gambling card game, where players bet on the order in which cards will appear after shuffled.

MONTE. A notorious game of Spanish origin in which three or four cards are dealt face-up and players bet that one of them will be matched before the others as the cards are dealt from the pack one at a time.

VINGT-ET-UN (TWENTY-ONE). Introduced to the United States through the French community of New Orleans, the game evolves into blackjack.

ROUGH ET NOIR. A complex French game in which two rows of cards are dealt and designated as red and black, and players bet on which row will have a count nearer thirty-one and on whether the first card of the winning row will be of the color for that row.

POKER. Whatever its historic origins, American-style poker is defined by betting on outcomes. It flourishes by 1800 on paddlewheel pleasure boats plowing the Mississippi River region. A staple of pioneer and gold rush gambling farther west, the most common games are straight (five cards, one draw) and stud (mix of cards face-up and face-down). The "wild card" is introduced around 1875.

ROULETTE. A gentleman's gambling amusement in Paris, the New World game follows the path of poker from French New Orleans up the Mississippi River and then out west. Frontier roulette is often played with makeshift spinning wheels. Accusations of fraud and cheating on riverboats leads to a transformation of the games where freestanding wheels are placed on top of tables, not embedded or attached to other structures or devices.

San Francisco officials are aware of and alarmed at the gambling dens. Throughout the gold rush and after, they enact anti-gambling laws that are both ridiculed and ignored. The statutes do discourage investment in lavish establishments that might be raided, but—as with all morality legislation—the forbidden practice goes underground, often in exclusive gentlemanly settings.

THEN THERE IS LIQUOR—AND MORE LIQUOR

No place in the world contains anything like the number of mere drinking-houses in proportion to the population, as San Francisco. This, perhaps, is

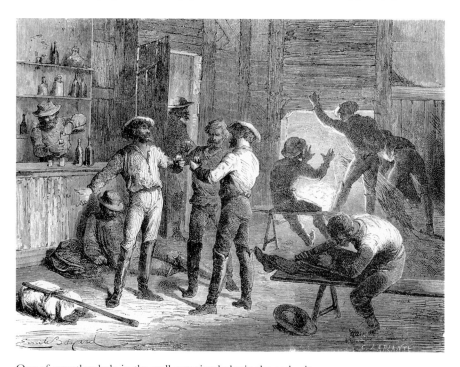

One of countless hole-in-the-wall watering holes in the early city.

the worst feature of the city. The quantity of ardent spirits daily consumed is almost frightful.

—*Frank Soule, journalist, 1855*

Californians do not seem happy unless they either taking a drink or treating their friends and acquaintances with them. That they find themselves provided with them in the gaming halls is merely what they consider themselves entitled to expect.

—*W.R. Rae, English journalist, 1871*

There are countless consumer scarcities in the early gold rush days, but spirits are always available, if not always at reasonable prices. Alcohol accompanies and fuels all types of excessive behavior, from gambling to prostitution to murder. By default, the saloons become the early social centers of the town. More than in any other American city, they serve as meetinghouses, political clubs, concert halls and even civic centers.

It is compounded of the shavings of cherub's wings, the glory of a tropical dawn, the red clouds of sunset and the fragments of lost epics by dead masters.

—*Rudyard Kipling, poet, 1889, on pisco punch*

Perhaps the most prominent drinking establishment is the Bank Exchange & Billiard Saloon, opened in 1853 in the spot where the Transamerica Pyramid now stands. Everyone who is anyone hobnobs there among the pretentious oil paintings, marble floors and extravagant gas lamps. Legend has it that the infamous pisco punch was invented at the place, although the powerful Peruvian brandy that served as its main ingredient has been available in the area since the 1830s. The Exchange's cocktail version is so potent that a customer is required to walk around the block and reenter before being served a third round. Few make it back for the trifecta.

Alcohol consumption has a long and treasured place in American cultural and political history, reaching back to early colonial days when local fresh water is regarded as impure and suspected of causing many a common aliment. Various forms of distilled spirits are a welcome substitute.

This ardent group of praying protestors, circa 1849, may represent the majority of "nonprofessional" women in San Francisco at the time.

In wine there is wisdom, in beer there is freedom, in water there is bacteria.

—*attributed to Benjamin Franklin, circa 1770*

Alcohol is also a caloric substitute for isolated settlers. With little infrastructure to transport grains and fruit, farmers use excess crops to distill liquor, like spruce beer, hard cider and rum. In *Taverns of the American Revolution*, Adrian Covert describes colonial and post-Revolutionary America as a "functioning alcoholic." To what extent does this eighteenth-century attitude and practice extend to the gold rush? The drinkers of San Francisco are the offspring of those older souls, removed but generation or two. And also removed from traditional conventions.

> *Very many also continue the habit of occasionally taking a daily "drink" or two while most of the inhabitants take many more "drinks" than they would perhaps care to confess.*

—Annals of San Francisco, *1855*

GENDER MATTERS

You have no idea how few women we have here, and if one makes her appearance in the street, all stop, stand, and look. The latest fashion to carry them in their arms (the streets are incredibly muddy). This we see every day.

—*lawyer John McCracken, 1849, in a letter to his sister*

Brawny, stalwart men, with shaggy beards and unshorn locks, would press forward to get to the tiny soft hand [of a baby], *and some would even snatch the child from its mother's arms, and toss it up, or kiss it, in an ecstasy of joy.*

—*Benjamin E. Lloyd, historian, 1878*

Every man thought every woman in that day a beauty. Even I have had men come forty miles over the mountains, just to look at me, and I was never called a handsome woman, in the best day, even by most ardent admirers.

—*from the diary of a Sacramento woman, circa 1850*

The gender imbalance is a subject of marvel to every observer then and since. *The Annals of San Francisco* estimates that a mere 700 women are among the presumed 25,000 people who arrive in the city during the first two years of the gold rush. Most of the early calculations hover around 50:1. Has such a disproportionate sex ratio ever existed in history during times of peace, or even in war? At one point, San Francisco likely has more prostitutes than women who are not prostitutes. According to one source, at the end of 1849, the city population is about 20,000, of which 1,100 are women and 700 of those are prostitutes.

The world's oldest profession thrives in such an environment. Most of the men arriving in San Francisco are in their twenties—a time of raging testosterone—and deprived of traditional sexual relations for at least six or more months. The *Annals of San Francisco* reports that in 1850 some 2,000 women descend, "many of whom were of base character and loose practices." Other writers describe them as "working girls" and "harlots."

Most of these female immigrants come from Mexico and South America with the same motivation and pluck as the men—to make as much money as possible in the shortest time and depart. Many gravitate to the Barbary Coast because there are few alternatives. But as quickly the sea winds will carry them, more "professional" ladies arrive from the eastern United States and Europe, along with savvy madams. Brothels mushroom in this fertile soil. The level of service and cost quickly escalate. Some of the houses are conspicuously opulent, beyond anything young male adventurers—now flush with gold—ever conjured up in their wildest back-home fantasies.

The first celebrated parlor house was that of the "Countess," who arrives from New Orleans in the summer of 1849 with a "stable" of beautiful and cultured young ladies. Obtaining a two-story frame building on Washington Street across from the town center at Portsmouth Plaza, Irene McCrady announces the opening of her establishment with an elegant reception conveyed by engraved invitations to the city's most prominent citizens, including the clergy. The Countess, adorned in stunning evening gown and jewels, escorts guests through a lavishly furnished reception room to a luxurious parlor. Piano music accompanies the fine champagne and light supper. Guests who choose to stay past midnight pay $96 ($3,000) to partake of the private entertainment. The Countess becomes the mistress to a successful gambler who runs the famed El Dorado Gambling Hall & Saloon.

The only aristocracy we had here at the time were the gamblers and prostitutes.

—Caleb T. Fay, local politician, 1849

See yonder house. Its curtains are of the purest white lace embroidered, and crimson damask. Go in. It is a soiree night. The lady of the establishment has most polite invitations…to all the principal gentlemen of the city, including the collector of the port, mayor alderman, judges of the county, and members of the legislature. A splendid band of music is in attendance. Away over the Turkey or Brussels carpet whirls the politician with some sparkling beauty, as fair as frail; and the judge joins in and enjoys the dances in the company of the beautiful but lost beings, whom, to-morrow he may send to the house of correction.

—Annals of San Francisco, 1855

These "parlors" are an East Coast adaptation. Since the development of an affluent nouveau riche in New York City a century earlier, such establishments flourish there. The transplantation to the western pool of riches is restrained only by the time it takes to get from there to here. A San Francisco customer has an opportunity to indulge in elegant seclusion and comfort and luxury available to few in the world. Yes, the ladies are the draw, but the regal furnishings, unrushed companionship, fine liquor and food, attentive service and live music may be as important as the carnal pleasures, assuming you could remember those pleasures in the morning. What you do not forget is the nasty climate, rude accommodations and violent milieu you may have escaped to enter that fleeting moment of paradise. French or French-looking women in particular are an immediate hit, especially compared to the South American choices. The *Annals*, a harsh critic of the practice, concedes that the French ladies of the night improve the style and sophistication of the city. Even the men, the writers observe, dress better to impress such females.

> *The French woman…had the charm and novelty, that Americans were irresistibly drawn to by their graceful walk, their supple and easy bearing, and charming freedom of manner, qualities, after all, only to be found in France.… But if the poor fellows had known what these women had been in Paris, how he could pick them up on the boulevards and then for almost nothing, they might have been not been so free with their* [extravagant] *offers.*
>
> —*Albert de Russailh, journal writer, 1852*

In the first few years, the French presence is "underground," but only formally. Soon *nymphs de pave* stroll the fashionable streets and enter the stores to purchase the best that money could buy, or boldly solicit.

> *Someone has remarked that in Eastern cities the prostitutes tried to imitate in manner and dress the fashionable respectable ladies, but in San Francisco the rule was reversed—the latter copying after the former.*
>
> —*Benjamin E. Lloyd, historian, 1878*

Deference was paid by all classes to the female form, even though its dress covered corruption; nor was it very damaging to any man's reputation...to be seen in conversation with a public woman.

—*Hubert Howe Bancroft, historian, 1884*

Women at all levels of this industry become part of the wider entrepreneurial culture that "mines the miners," a less-oft told tale of the gold rush. The most uniformly successful San Francisco immigrants are not those who dig for gold. The restaurateurs, bankers, merchants and purveyors of "sin" garner the most reliable assets. Prostitutes as a group are soon some of the wealthiest residents of city. The most prominent madams become as powerful as they are legendary—the most successful American businesswomen of the era. In 1854, the Board of Alderman (Supervisors) votes to outlaw the practice, a proclamation that has a minor effect on the most notorious places but is, in the words, of a contemporary observer, "utterly impractical in operation."

There is something very attractive to men about a madam. She combines the brains of a businessman, the toughness of a prizefighter, the warm of a companion, the humor a tragedian. Myths collect about her.

—*John Steinbeck, novelist, circa 1940*

[Society] *without woman is like an edifice built on sand. Woman, to society, is like the cement to the stone. The society has no such cement; its elements float to and fro on the excited, turbulent, hurried life of California immigrants."*

—*James Wyld*, A Guide to the Gold Country of California, *1849*

We do not wish to say, or even imply, that San Francisco is the wickedest and most immoral city in the world but it has not yet overcome the immoral habits contracted in the days when the inhabitants were nearly all males, and had nothing to restrain them from engaging in the most vicious practices; when there were no mothers to chide their waywardness and say in winning tones: "My son go not in the way of evil" and fewer virtuous sisters to

welcome brothers home, and by their loving kindness and noble lives, to teach them to cease from sinning.

—*Benjamin E. Lloyd, historian, 1878*

It is a unique situation in American history, especially in the early years. Thousands of young men, unshackled from family and moral moorings, travel to the ends of the earth where strangers will likely never see you again and neither care nor remember what you do. Relatives and friends are thousands of miles away. San Francisco is the original "Las Vegas: what happens here stays here." Many pioneers plan to leave as soon as they make their fortune. Many stay. But in this far-off land, traditional social norms dissipate, and reputation seems to have little long-term value. Down the hatch and let the devil take tomorrow.

Gold Rush California was primarily a man's world, at least until the mid-1850s and yes, it could be wild, free, unconstrained, exuberant.

—*Kevin Starr, historian, 2005*

Til Inconvenience Do Us Part

Among the early acts of the new State of California is a radical law in 1851 that allows either a husband or wife to separate on the grounds of incompatibility and petition for a court-appointed referee rather than go to public trial. The District Court in San Francisco is known as the most liberal in this regard. There are 269 marriages in San Francisco during 1856 and 72 applications for divorce—ranking as the number one per capita divorce rate in the country. Most are initiated by women.

Marriage among us seems to be regarded as a pleasant farce—a sort of "laughable afterpiece" to courtship. . . . The divorces which are granted here are in a tenfold ratio the number in any other part of the Union of equal population.

—San Francisco Chronicle, *1866*

3
Paris of the Pacific

POPULATION OF SAN FRANCISCO
1870: 149,473
1880: 233,959
1890: 298,997
1900: 342,737

San Francisco is a delicious combination of wealth and wickedness, splendor and squalor, vice, virtue, villainy, beauty, ugliness, solitude and silence, rush and row; in short San Francisco is just San Francisco, and that's all there is to it.

—*George Griffith, British writer and explorer, circa 1901*

Gold builds San Francisco. Silver establishes it. By the 1860s, the golden goose is laying far fewer eggs. The celebrated city remains a one-hit wonder, hugging an isolated sliver of the Pacific coast, entertaining seemingly farfetched great expectations to be the dominating metropolis of the West ready to stand building-to-building and port-to-port with the great cities of America. But a silver lining glints in the horizon. As with the gold rush, no one sees it coming.

GROWING PAINS

From the vast accumulation of sand in these regions, I am led to conclude that the original name of this territory was Sand Francisco.

—Dr. Abraham Dunshunner, geologist, 1855

How and where will the budding metropolis develop from here? The so-called Outside Lands—stretching to the Pacific Ocean and physically comprising about half of the present-day city—is largely undeveloped until the 1930s. In the nineteenth century, it is regarded as uninhabitable desert. Twenty years after the gold rush, upstart and ambitious San Francisco falls into limbo. It has glaring shortcomings, perhaps none more apparent than the lack of public parks and recreation areas. The "instant" city is a dense urban jungle suffering warehouses and smoky factories and boxy structures with little in the way of civic buildings or monuments or museums to offset the grim overtone. In the midst of this hodgepodge, many neighborhoods remain dingy, even barnyard rustic.

People have forgotten that San Francisco is not a ranch, or rather, that it ought not properly to be a ranch. It has all the disagreeable features of ranch, though. Every citizen keeps from ten to five hundred chickens, and these cackle all day and all night: They stand watches, and the watch on duty makes a racket while the off-watch sleeps. Let a stranger get outside of Montgomery and Kearny from Pacific to 2nd Street and close his eyes, and he can imagine himself on a well-stocked farm, without any effort, for his ears will assailed by such a vile din of gobbling of turkeys, and crowing of hoarse voiced roosters, and cackling of hens, and howling of cows, and whinnying of horses, and braying of jackasses, and yowling of cats, that he will be driven to frenzy.

—Mark Twain, 1868

They will see it, as very new, yet they will feel it very old. Civilizations is better organized here in some respects than in any city outside of Paris; some of it looks as transplanted from a city of Europe; others are in the first stages of rescue from the barbaric.

—Samuel Bowles, journalist, circa 1875

Come on down! Bring the children! It's the best public entertainment in San Francisco at the time.

San Francisco is wonderfully picturesque. Viewed from afar, every steeple and building on its many hillsides conspicuous and effective, but it is shabby, irregular and dirty within, and only passably elegant in very limited quarters.

—*J.G. Oakley, businessman, 1886*

Woodward's Gardens fills the early entertainment and parks void. That it could attract as many as ten thousand people on holidays in the 1880s shows how dearly residents crave an escape from industrial pollution and drab concrete. When Woodward's Gardens welcomes the world's most famous bear, Monarch—the last known captured grizzly—more than twenty thousand people attend his public introduction.

The amusement complex occupies two large city blocks bordered by Mission Dolores, Valencia and Thirteenth and Fifteenth Streets. It contains the largest zoo on the West Coast, some of the animals wandering free. Patrons stroll in an aviary, watch dancing kangaroos and bears and join in daily seal feedings. There are museums and an art gallery with hundreds of paintings, including replicas of master works. The gardens boast one of first aquariums in the world. Add to that Japanese acrobats, a live display of Native American Indians in a replica village, the largest roller-skating rink on the West Coast, Sunday hot air balloon jaunts, a thrill-seeker boat ride— and you have an early "Disneyland." No wonder Robert B. Woodward is called the "Barnum of the West." The park closes in 1891, in part due to the popularity of Golden Gate Park. Today there is no trace and hardly a memory of the place that for over a decade was the major amusement park of San Francisco. Unlike other commercial "gardens" in the city, Woodward bans the sale of alcohol, following the rule in his popular hotel. These may well be the only teetotaler public venues in the city.

Another escape from urban life before Golden Gate Park is "Land's End" at the western Pacific Ocean edge of the city. It is a happening place as early as the 1860s when the soon-to-be legendary Cliff House restaurant debuts. The problem is getting there. Early on, when only a horse and carriage toll road can reach the location, it is the playground for the city's nouveau rich to hobnob with visiting U.S. presidents. After a period of decline where shady politicians and other nefarious characters become the habitués, it is rehabilitated by wealthy neighbor Adolph Sutro, who transforms the place in 1886 into a family-friendly hospitality spot. A decade later, he opens the immensely popular public Sutro Baths next door. Advances in public

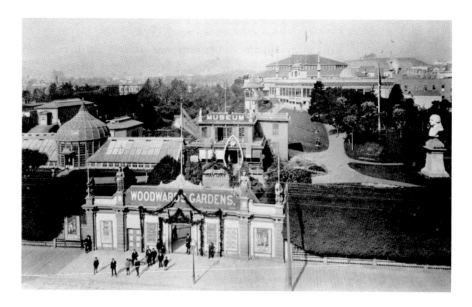

transportation in the 1880s make the trip to Land's End affordable for the working and middle classes who flock there, especially on weekends.

The frolicking seals on Seal Rock and a glimpse of the island are fun, but the place begs for more formal entertainment and the vacuum is quickly filled by a succession of ventures, including daring-do individual acts—one popular performer who swims and performs aquatic stunts with his hands and legs tied attracts ten thousand spectators on a single day. In 1884, the "Gravity Railroad" roller coaster becomes the first amusement ride. In the same year, a spectacular new indoor playground for the middle-class debuts, featuring dining, variety shows, boxing matches and a dance floor and promenade that can accommodate two thousand guests. The Ocean Beach Pavilion is "the best appointed pleasure resort on the Pacific Coast," the owner proclaims.

The southern end of the Pavilion is seventy-four feet long. At its elegantly made counters can be obtained, from skilled barkeepers, the choicest refreshments, as all the liquors are furnished by the well-known establishment, A.P. Hotaling & Company, including the celebrated J.H. Cutter whisky. The ruling price of drinks will be ten cents.

—San Francisco Chronicle, *1884*

Travel to the end of the continent. The Golden Gate is in background.

In 1896, Adolph Sutro builds a magnificent new Cliff House—a seven-story Victorian chateau below his estate on the bluff of what is aptly named Sutro Heights. He is also purchasing large tracts of adjacent "desert" land and turning them into forests and arboretums. The Cliff House survives the 1906 earthquake only to succumb to fire the following year. It is rebuilt as a more modern and modest structure, and although renovated a few more time, the basic 1909 reconstruction remains today.

More than any other enterprise, it is the Sutro Baths, opened in 1896, which transforms Land's End into the playground of San Francisco. The world's largest indoor swimming pool installation is built for the ordinary citizens of the city and provides luxurious amenities that only the wealthy could have afforded at the time. It is quickly nicknamed the Pleasure Dome.

SUTRO BATHS BY THE NUMBERS

6: saltwater pools
7: water slides
30: swinging rings
25,000: customers that can be accommodated per day
517: private dressing rooms
40,000: for rent towels that can be washed per day

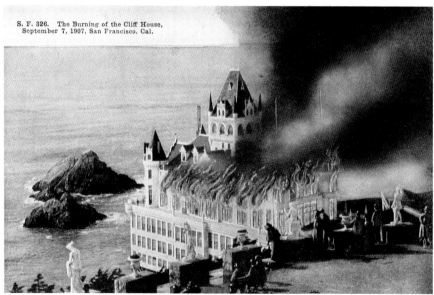

S. F. 326. The Burning of the Cliff House,
September 7, 1907, San Francisco, Cal.

20,000: for rent bathing suits that can be washed per day
2,700: capacity for the Amphitheatre
25 cents: Cost to use bathing accommodations and go into the water
2 cents: entry to the complex as a spectator

The facilities showcase a free museum featuring stuffed birds and animals, Egyptian mummies, paintings and statuary. Potted plants are everywhere. When the family of Woodward's Gardens auctions off the venue's abundant collection of artifacts in 1894, it is grabbed by Sutro, who displays the pieces at his Cliff House restaurant and later at the baths. A pair of major rail lines, one established by Sutro, service the baths every day. Without an affordable way of traversing the San Francisco desert to the Pacific, the affordable amenities mean little. Sutro provides both. Success follows.

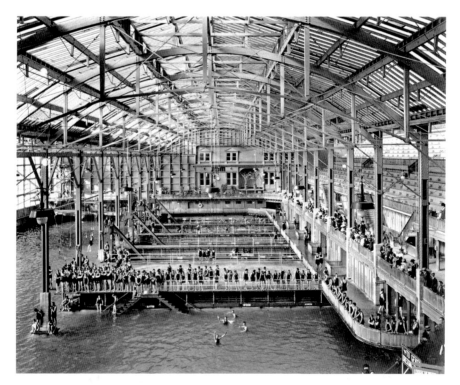

There is nothing like this communal bathing spectacle since…ancient Rome? The wildly popular Sutro Baths, called the "Pleasure Palace," defines popular public recreation in San Francisco at the turn of the century.

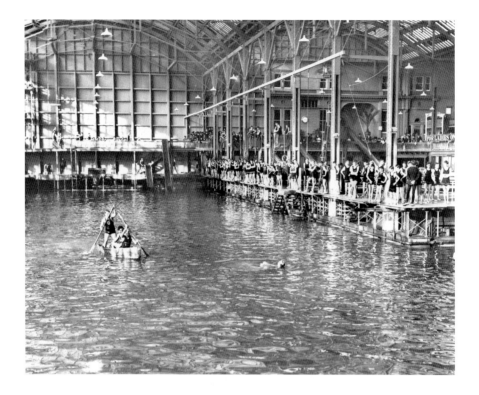

The Pleasure Dome suffers an ignominious demise. As celebrated as the venue had become, its popularity gradually declines, especially during the 1930s Depression. The Sutro family converts the enterprise into an ice-skating rink and eventually sells to developers that plan a high-rise apartment complex. While in the process of demolition in 1966, a spectacular fire destroys what is left of the Sutro site. In the aftermath, that residential plan is abandoned. What remains today are the remains—an array of curious, almost eerie ruins you can view from the road above or descend and explore up close.

CONQUERING THE DESERT

A grand Park within the reach of every citizen would do more in preventing dissipation and vice than half the sermons preached, half the moral lectures and teachings given to children and to men.

—Alta Daily California, *1855*

The problem with a Grand Park is the Grand Desert. An 1870 city map labels the area that is today the densely populated Richmond and Sunset Districts as "The Land of Fog—Uninhabitable." Another map dubs it the "Great Sand Bank." Most of the so-called Outside Lands are also technically outside because the territory is not officially part of the city until the federal government sells it to San Francisco in 1866. Whatever potential the vast area holds is a gamble, and few developers are willing to roll the dice. At the time, it is envisioned for cemeteries, racetracks, orphanages and dairy farms.

Of all the elephants the city of San Francisco ever owned, they now own the largest in Golden Gate Park, a dreary waste of shifting sand hills where a blade of grass cannot be raised without four posts to keep it from blowing away.

—Santa Rosa Press Democrat, *1873*

The skepticism and derision that greet this decision [to buy land for a large San Francisco park] *can only be understood when one realizes just how windswept and inhospitable the park site, and all of western San Francisco, was. Great sand dunes covered most of it. Roads were almost non-existent. The incessant breeze blew sand so violently that it was difficult for a horse to face west. And plants would not take.*

—*Gary Kamiya,* Cool Gray City of Love

The Golden Gate Park we celebrate and enjoy today has an inauspicious and controversial beginning. Every great city in the late nineteenth century Western world boasts parks, many featuring a grand, dominating expanse. San Francisco consults Frederick Law Olmsted, the nation's anointed urban landscaper, who pontificates that "a park gives a city a soul." He inspirits New York City with Central Park, but when Olmsted is asked to replicate his eastern gem in the West, he declares San Francisco's Outside Lands so barren and sandy that the park envisioned there is fantasy. Instead, he proposes three smaller parks in three other locations. Thinking big, city fathers reject his scaled-down version in favor of the present Golden Gate Park. The initial problem is the "squatters" who are well versed in old Spanish pueblo law regarding boundaries and land transfers—and formidable negotiators.

THE SAND DUNES OF GOLDEN GATE PARK BEFORE THEY WERE CONVERTED INTO A GARDEN
View from the old Seal Rock House, taken in 1865. The work of reclaiming the sand dunes was not begun until the seventies

The vast undeveloped and perilous sand dune terrain between the far reaches of civilization inching its way to "Land's End" at the Pacific Ocean, circa 1915. Sloat Boulevard is at the bottom.

The purchase price eventually rises to a lofty $25 million in today's value, which is widely ridiculed as "a joke" or "not worth a button."

The first superintendent, William Hammond Hall, faces the daunting task of how to tame this forlorn desert wilderness. Many experiments to root vegetation and plants are tested with varying degrees of success. There is some progress, however physically modest. By the mid-1870s, well-to-do equestrian and carriage traffic streaming to the roads are joined by bicyclists and strolling pedestrians. Most of Golden Gate Park remains more vision than reality until John McLaren steps up from assistant to full superintendent in 1890. He is, without exaggeration, a miracle worker, nicknamed the "Wizard of Golden Gate Park." Wealthy businessmen in the Bay Area had McLaren landscape their estates, and historians describe his reign "as spectacular years when Nature was brought under control." Through ingenuity and experimentation, McLaren is able to turn windswept sand dunes into grass, trees, gardens and lakes admired by the world.

If it were possible I would like to take Golden Gate Park home with me. True, we have lovely parks in Paris, but your Golden Gate has—how do you say?—extraordinary contours.

—Jean Cherioux, French statesman visiting San Francisco, 1987

Aye, then, we'll plant it ott.

—John McLaren, circa 1900, on his strategy for dealing with "stookies"—his word for monuments. He despises statuary in Golden Gate Park, regarding it as rude distraction from the pastoral setting he strives to create. The ones he cannot forbid become the victim of dense plants and vegetation designed to hide them from view. After his death in 1943, the lost pieces are gradually uncovered, exposing a treasure-trove of art. He secrets a commemorative statue of himself authorized by the city in a box, which is discovered and placed in the park after he passes.

Wild game is coming.

—the verbal code, circa 1900, McLaren's gardeners (who eventually number four hundred) whisper to warn that the superintendent is

approaching to inspect. Relishing his nickname "Boss Gardner," he quickly garners a reputation as a no-nonsense, nose-in-your-details taskmaster who will not hesitant to scold an employee in public or imperiously fire him on the spot. There is other wild game in today's Golden Gate Park. The deer and the buffalo continue to roam. The buffalo can be found in an enclosed field next to Spreckels Lake.

MANNA FROM HEAVEN (AGAIN)...MORE PRECISELY, THE EASTERN SLOPE OF MOUNT DAVIDSON, A PEAK IN THE VIRGINIA RANGE OF NEVADA

The mineral gods smile once again on San Francisco. The spectacular silver boom that begins in the 1860s and continues unabated for almost twenty years shapes the city as profoundly as gold. During that time, the modern equivalent of $75-plus billion is extracted from the Comstock Lode. Singlehandedly, San Francisco bankrolls, manages and reaps the bounty of this industry. It consolidates the city as the Wall Street of the West. Silver enterprises produce the first true generation of San Francisco megamillionairess, and a breathtaking economic expansion ensues. Great downtown buildings and Nob Hill mansions are financed by silver money, including legions of restaurants, theaters, hotels and grand retail establishments. The influx of capital at the peak of silver extraction transforms the historic old city and spills into the surrounding areas. In 1869, the transcontinental railroad connects the metropolis to the nation. A new record is set in 1876 when a New York to San Francisco run is done in an amazing three days, eleven hours and twenty minutes. By the mid-1870s, a second "instant city" is emerging.

The wheat, gold, wool, wine and fruit must yield precedence to the metal of the Comstock. By the boldness in which she invested her capital, and her power in attracting those who had made fortunes elsewhere without her help, San Francisco became the owner of nearly everything worth owning in the silver mines, which were then worked mainly for her benefit.

—*John Hittel,* A History of the City of San Francisco, *1878*

[San Francisco is] *the child of the mines. They gave it its first start: They have generously…nourished it ever since. The have called into existence a very large manufacturing interest, giving employment to tens of thousands of men. They have stimulated every branch of trade and internal commerce quickened every pulse of industrial life. Nearly all our finest buildings have been erected of the profits of mining enterprises. Every pound of ore that is taken out of the earth, from Alaska to Arizona, pays tribute here. A man makes his fortune in the desert of Nevada or Idaho. But he is pretty sure to spend it in San Francisco.*

—*Samuel Williams,* San Francisco Evening Bulletin, *1875*

Even the gambling tables languished. People invested all they had, all they could borrow, beg, pawn, or steal, in [silver mining] *stock. No one talked of anything else; and many women, known as Mudhens, sold stock on the curb. Everybody assumed that one spot of earth at least had enough for all, and this day one year hence he would be handling money by the bushel and proclaiming that never in this life would he do another stroke of work.*

—*Gertrude Atherton, novelist and journalist,* California: An Intimate History, 1914, *on the silver mania of the 1870s*

The fledgling metropolis begins to emerge as a world-class city in this period. John McLaren, the redoubtable superintendent of Golden Gate Park, takes on the challenge to transform two hundred undeveloped acres of his domain as the site for an 1894 Midwinter Fair that intends to showcase the mild winters and attract new residents. With two and a half million attendees, San Francisco proclaims the event a huge success. The occasion is used to announce to the world the "official" opening of Golden Gate Park, an achievement not yet complete but still touted as the equal of New York's Central Park.

[Golden Gate Park] *is the only park on earth having a sea front.*

—*Southern Pacific Railroad promotional pamphlet,* California for Health, Pleasure and Profit, *1895*

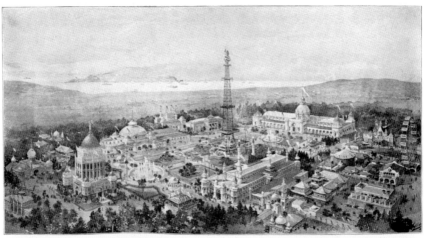

GENERAL VIEW OF MIDWINTER EXPOSITION, IN GOLDEN GATE PARK, 1894

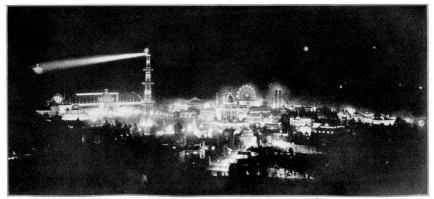

ELECTRICAL EFFECTS AT MIDWINTER EXPOSITION IN 1894

San Francisco has no rival. For long distances her bay is spoken of as "the bay" and she is not merely the greatest city, but "the city."

—Henry George, noted American economist and journalist, 1880

America had never seen anything like the explosive growth of San Francisco....To the country's astonishment, San Francisco laid claim [in 1870] to being one of the ten largest cities in the United States. It was said that you could ask for a ticket to "the City" at any railroad depot in the West and the manager would hand [you] a passage to San Francisco.

—Charles Adams, Magnificent Rouges of San Francisco

The first Ferry Building, constructed in 1875. The wood structure topped by a clock dominates the bustling Embarcadero at Market Street until replaced by the present Ferry Building in 1898.

San Francisco is the only populated area from the Canadian border to the Mexican border that is known as "The City!"

*—Chester MacPhee, realtor and member of
the Board of Supervisors, circa 1925*

East is East, and West is San Francisco.

—O. Henry, legendary short story writer, circa 1900

"NOTHING SEEMED IMPOSSIBLE"

The title of a William Ralston biography epitomizes the city's "boosterism" at this opportune time. A young man arrives in the city with modest means and soon becomes the greatest local developer in a remarkable urban transformation that captures the world's attention. "Billy" Ralston realizes that the silver bonanza provides an opportunity to achieve the

PALACE HOTEL, BEFORE THE FIRE

At the time, the 755-room Palace Hotel is the largest in the nation and boasts a grand interior courtyard that can accommodate multiple horse guests and carriage processions. It is the tallest building in San Francisco for over a decade. Destroyed by fire in the 1906 earthquake, the structure is rebuilt, reenvisioned and reopened as the New Palace Hotel in 1909.

most ambitious of dreams, but if only he leaps through the window while it remains open. In short order, he establishes multitudes of businesses in San Francisco from carriage and furniture factories to a woolen mill and sugar refinery. He builds the first dry dock, the Palace Hotel (at the time the largest in the world), the renowned California Theatre and the powerful Bank of California. Other developers scramble to follow in his footsteps.

Opened in 1874 as the first commercial bank in the state, the Bank of California is the second-richest such institution in the nation and welcomed by local businessmen who prefer to deal with locals rather than the dreaded eastern establishment. Unfortunately, not all of Ralston's investments are wise, and when his gamble on several silver mines fails, there is a run on the Bank of California, forcing it to shut down temporarily in 1875. The board of directors fires Ralston. The next day, his body is found floating dead during his regular Bay swim. Accident or suicide? There is no definitive answer then or now. William Ralston is gone at age forty-nine.

The Emporium, touted as the "The Grandest Mercantile Building in the World," debuts on Market Street in 1896—a seven-story columned façade design that features a bandstand and restaurant. The first and second floors host the department store; the California Supreme Court occupies the third. A huge ground-floor rotunda is covered with a spectacular stained-glass dome towering one hundred feet above. The venture is celebrated as a miracle of modern everything.

At first called "Hallidie's Folly," a young engineer has the last laugh—all the way up the hill and to the bank. Few dare to reside on top of the steepest (Nob and Russian) hills because the journey is cumbersome and slow, even dangerous on horse-drawn wagons and carriages. It is especially perilous for the animals, which might endure injury and even death when pulled to the unforgiving pavement. A love of animals helps motivate Andrew Hallidie to adapt his invention of wire rope for the mining industry to the rough streets of San Francisco. The first cable car descends the Clay Street Hill at 5:00 a.m. on August 2, 1873. Hallidie picks that early hour so no one will be injured lest the debut fail and the vehicle plummets out of control. His gripman peers down the steep slope from Jones Street and refuses to operate the machinery, so Hallidie grabs the handle and negotiates the car smoothly down the hill and back up. Hallidie Plaza near the Powell and Market Street cable car turntable and the Hallidie Building in the financial district are named after the innovator.

Nobody seems to think of building a sober house. The prevailing style is what might be called the delirious Queen Anne. Of the craziness that ever decorated so efflorescent, floriated biliousness and flamboyant a city, I think San Francisco may carry off the prize....I am not sure but this riotous run of architectural fancy is just what the city needs to redeem its otherwise harsh nakedness.

—Noah Brooks, New York Times *journalist, in an 1883 letter to his wife*

By 1890, there are eight privately operated cable car lines climbing the steep hills of San Francisco, creating a real estate boom as new areas open to development, most specifically for the nouveau riche who rush to occupy the high ground and conjure up gargantuan mansions. An extravagance now common in New York City is a revelation to San Francisco. One of the Big Four transcontinental railroad barons, Leland Stanford boasts a fifty-room castle. Neighbors include his transcontinental railroad colleagues Mark Hopkins, Collis Huntington and Charles Crocker, who luxuriates in 12,500 square feet fronted by a 172-foot façade and 76-foot tower that occupies almost a city block. When an undertaker who owns a corner of the block refuses to sell his modest cottage to the mogul, Crocker constructs a 40-foot-high wall to block his view of the property. It becomes known as the "spite fence."

Those palaces on the Nob Hills of these United States are the toadstools of the decay that is going on in this Republic today.

—William Greenwood, political writer, 1895

There are uglier buildings in American than the Crocker home on Nob Hill, but they are built with public money for a public purpose; among the architectural triumphs of private and personal taste it is peerless.

—Ambrose Bierce, novelist and journalist, circa 1880

[It looks] *likes a packing crate painted white.*

—Gertrude Atherton, 1880, on the Leland Stanford residence

By 1880, Nob Hill, with capped Greek Temples, medieval castles and baroque cuckoo clocks, was the social Olympus of San Francisco.

—Frances Moffat, 1977, San Francisco Chronicle *society page editor. Where does Nob Hill derive its name? Most likely, "nob" is a contraction of the Hindu word* nabob—*used by provincial governors in India before the British take colonial possession. The new rulers broaden the definition to include any rich or important person, and eventually shorten it to "nob."*

"THE TERRIBLE '70S"

(A chapter title from Gertrude Atherton's book A California History, 1936)

In the midst of a breathtaking expansion of wealth, San Francisco is hit with an international calamity known as the "Great Depression"—so-called until the Great Depression of the 1930s claims its moniker. The 1870s downturn is regarded as the first modern global economic crisis. Unemployment becomes an Atlantic states export to the West Coast. Most of these California immigrants are desperately seeking work, adding to a growing pool of laid-off San Franciscans that is further swelled by Chinese entering the local labor market. Between and 1865 and 1869, ten thousand Chinese laborers are the backbone of the Central Pacific workforce during the construction of its part of the transcontinental railroad. After completion, many migrate to San Francisco's Chinatown in an economically treacherous time. The outsiders are all-too-convenient scapegoats for the hard times and high unemployment. It is the most troublesome symptom of economic malaise that grows increasingly vitriolic, at times fomented by ad hoc leaders of the city's large Irish working class. The ideology of free labor and anti-capitalism is merged with anti-Chinese sentiment.

When the Chinese question is settled, we can discuss whether it would be better to hang, shoot, or cut the capitalists to pieces. In six months we will have 50,000 men ready to go out…and if "John" [the Chinese] don't leave here, we'll drive him…into the sea.…We are ready to do it.…If the ballot fails, we are ready to use the bullet.

—*Dennis Kearney, popular San Francisco "sandlot" orator and labor organizer, 1877. A militant socialist organizer and charismatic agitator who once urged laborers to be "thrifty and industrious like the Chinese," he soon begins to denounce Chinese immigrants as the cause of white workers' economic woes. He warns railroad owners they have three months to fire all Chinese workers or "remember Judge Lynch." Kearney becomes known throughout California for racially charged speeches where he shouts the slogan: "The Chinese must go." When the economy recovers, his influence evaporates, and he fades from the popular scene.*

It was greatly augmented by disappointed miners from the camps and labourers out of work, men lured from distant homes by the hope of great wealth in the land of gold, then saw themselves on the verge of starvation while the splendid mansions of speculators…rose along the heights of the city, and the newspapers reported their luxurious banquets.

—*James Bryce, British historian and politician, circa 1880, on the rise of the San Francisco Workingman's Party in 1877. Dennis Kearney is one of its leaders.*

If an anti-Chinese mob should get control for a few hours, the destruction of San Francisco might be the result.

—*John Hittel, historian, 1878*

A gang sacks twenty Chinese laundries in July 1877. The Third Vigilance Committee—officially anointed the Committee of Public Safety but commonly known as the "Pick-Handle Brigade"—is quickly formed. Within two days, the now aging leaders who had created the committees of 1851 and 1856 mobilize four thousand citizens into patrolling battalions, each man armed with a hickory pickax handle attached by a leather thong. A call for martial law is backed by the governor and U.S. Navy. San Francisco splinters into armed camps: the committee, the state militia, unemployed workers and the Chinese who vow to protect their property by any means necessary. The state militia stops rioters from destroying a major woolen mill that employs Chinese. The committee jumps in to prevent the burning of docks where Chinese immigrants usually arrive. But a mob sets fire to

a nearby lumberyard and then attacks first responders. Dozens of police charges finally rout the rioters, leaving four dead and fourteen wounded. Smaller fires and riots break out in other parts of the city; they are met and suppressed by the Pick-Handle Brigade. Three days later, the California governor telegraphs the secretary of the navy that the danger has passed.

Unlike in previous economic downturns, 1870s San Francisco has the confidence to survive without a soul-searching challenge to its status and stability. The economy is more diversified, the banking industry remains solid and the infrastructure and port are well established. So when the nation recovers and basks in prosperity a decade later, the city by the Bay is prepared to take on the world. The stage is set for advanced boosterism—a drive led by civic leaders to propel San Francisco into a dynamic, expanding metropolis that creates fortunes for its people as it rises to West Coast dominance, ready to be compared to and compete with the great American cities of the East… and indeed the world.

CULTURE HIGH AND LOW

A San Francisco girl am I, and only plain at that;
I've been to Monte Carlo, and have played at baccarat
In Paris, London and Berlin and far away Moscow
I must admit they're very fine, but give me dear 'Frisco.

By 1853, planked streets are conquering mud and sludge, making thoroughfares accessible to new theaters popping up everywhere. The Jenny Lind (1851) and Adelphia (1850) set the stage for the early stage. The grand California Theatre debuts in 1869 and overnight becomes the leading venue for drama and opera. San Francisco soon boasts a reputation as the premium show business destination outside of New York City. Impressive for an upstart city thousands of miles from "civilization."

> *A new phase is coming over the theatrical in California. Nothing will do now but the stars and even then they must be of the first magnitude. The Californians are as good judges of acting as can be found anywhere; and they care not a fig for the opinion of New York or London.*

> —Pioneer Monthly *magazine, 1854*

The form of the program was nearly identical in each, generally beginning with a minstrel first part, followed by an olio [variety acts] and concluding with an afterpiece, which all too often was based on an immoral story and its lines bristled with poorly concealed smut.…The quality of the performances was always excellent, for many of the country's best stars have graduated from the old San Francisco melodeons and variety halls.

—*newspaper review of Gilbert's Melodeon, 1865*

Of all American audiences that of San Francisco is the most critical and exacting.

> —*Sarah Bernhardt, 1887. The French actress is the most celebrated stage personality of the era across Europe and American.*

So-called high culture is part of San Francisco from its earliest days. Opera performances and Shakespeare flourish alongside "coarser" entertainment. City residents cannot get enough Shakespeare. In the first decade of the gold rush, twenty-two of the Bard's thirty-eight plays are performed to packed venues. This should not be surprising. The expense of traveling to California, especially by ship, usually prohibits those of modest means. As young and adventurous as the early mix of male pioneers are, many come from educated middle class backgrounds. Cut adrift from family, community and the conventional company of ladies, entertainment becomes a highly valued diversion. The crass and refined coexist, but they do not necessarily draw from a different demographic. A patron may attend Shakespeare one night and a ribald burlesque the next. It is just one irony in a multitude of ironies that constitute San Francisco then and now.

San Francisco is naturally and temperamentally a musical city.

> —*Walter Damrosch, New York symphony conductor, 1901*

I will sing in San Francisco if I have to sing in the streets, for I know that the streets of San Francisco are free.

> —*Luisa Tetrazzini, 1910*

Before the 1906 earthquake, some five thousand operatic performances take place in the city, encouraged in part by a large Italian immigrant population. The famed international opera star Luisa Tetrazzini, threatened with an injunction against singing in a San Francisco theater during a contract dispute, opts to perform a Christmas Eve downtown outdoor performance in 1910 to a crowd estimated at 250,000. The population of the city at that time is a little over 400,000. The head chef of the prestigious Palace Hotel where Tetrazzini often stays is believed to have created the recipe known as Chicken Tetrazzini in her honor: poultry or seafood and

mushrooms in a butter/cream and parmesan sauce flavored by wine or sherry, served over pasta and garnished with parsley.

The Comstock silver riches create a new class of wealthy patrons and a new era of grand theaters. The elite is eager to demonstrate that haute culture accompanies haute cuisine and haute couture. World-class drama and opera are in ever-greater demand as "stars" from the East Coast and Europe beat a path to the city. Some attribute this arts boom to a shifting demographic of more—and more "respectable"—women. Women comprise 40 percent of the population by 1870 compared to less than 10 percent in the early 1850s. Theater and opera program bills are brimming with advertisements for upper-end merchandise and services such as gourmet restaurants, French fashion, jewelry, fine chocolates, perfumes, pianos and fencing lessons.

At the other end of the spectrum, the infamous Barbary Coast retains its reputation as source of lowbrow diversion and pleasure.

> *Every city on earth has its special sink hole of vice, crime and degradation.... San Franciscans will not yield the palm of superiority to anything to be found elsewhere in the world...and they will point triumphantly to the Barbary Coast, strewn from end to end with the wrecks of humanity, and challenge you to match it anywhere outside of the lake of fire and brimstone..*

> —*Colonel Albert S. Evans,* A la California: Sketch of Life in the Golden State, *1873*

Modern popular journalism comes into its own in this period. San Francisco has a vivid, vitriolic and, in the early days, violent press tradition. In 1887, the young son of a wealthy California senator begins a newspaper genre and a personal legend by taking control of his father's little-read *San Francisco Examiner*. Overnight, William Randolph Hearst dramatically increases circulation via a sensational style of news dubbed "yellow journalism." He boasts that the *Examiner* is the "Monarch of the Dailies."

> *Hearst routinely invented sensational stories, faked interviews, ran phony pictures and distorted real events.*

> —*Martin Lee and Norman Solomon,* Unreliable Sources

Hearst's primary and able rival for the mainstream audience is Joseph Pulitzer's *New York World*. Cut from the same pulp, they create daily drama

and sensational headlines to sell newspapers—now hawked from the street corners—even if the truth has to be stretched or details fabricated. These editors are sometimes credited with starting the Spanish-American War of 1898. When renowned graphic artist Frederic Remington cables his boss from Cuba in 1897: "There is no war," William Randolph Hearst famously responds: "You furnish the pictures and I'll furnish the war."

A MAD CITY WITH PERFECTLY INSANE PEOPLE

Eccentricity is honed to a fine art in San Francisco. It becomes a cottage industry.

> *San Francisco took to their collective bosoms one of the most delightful groups of eccentrics ever gathered. Of course, success breeds competition and as in Florence of old or as in Paris of the past generation the success of one artist stimulated others to creativity. These characters of San Francisco were artists in their own strange way. Each had a definite and individual personality and strove for recognition with their eccentricities of mannerism and appearance.*
>
> —*Robert Ernest Cowan*, Forgotten Characters of San Francisco

> *Being desirous of allaying the dissensions of party strife now existing within our realm, I do hereby dissolve and abolish the Democratic and Republican parties, and also do hereby decree the disfranchisement and imprisonment, for not more than 10, nor less than five, years, to all persons leading to any violation of this our imperial decree.*
>
> —*Emperor Norton, the quintessential San Francisco eccentric, 1869*

The improbable Emperor Norton is a wildly popular and celebrated character who "rules" San Francisco as the self-proclaimed emperor of the United States and protector of Mexico after he loses his fortune and apparently his sanity in a speculative rice venture. Some snicker he is crazy like a fox; however his street career begins, he does indeed appear to morph into his bizarre alter ego. Mark Twain pitied him. The legend begins when once heralded businessman Joshua Abraham Norton retreats to isolation after a

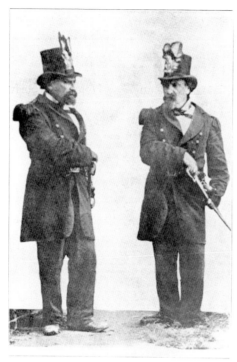

EMPEROR NORTON, A STREET CHARACTER OF EARLY DAYS
Photographed in 1875

Left: The Emperor in full royal regalia.

Below: Bummer and Lazarus receive elaborate funeral ceremonies. The mourners portrayed here paying last respects include prominent San Franciscans. The Emperor is on the left tossing a tribute rat, for which the dogs' preference and prowess are legendary.

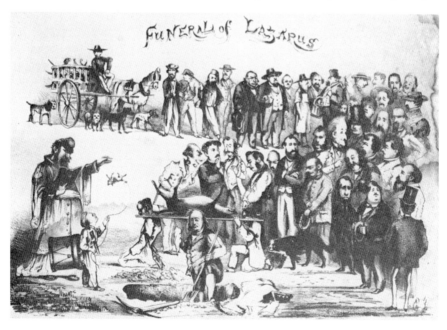

ruinous loss only to reemerge in 1859, announcing his title to the citizens of the city. Roaming the streets in an extravagant regal costume, the Emperor is treated with feigned deference and good cheer. His special "currency" is honored at many establishments, while his official proclamations—such as the order to dissolve the U.S. Congress and numerous decrees calling for a bridge connecting San Francisco to Oakland—are widely discussed, if only with levity. Upon the Emperor's death in 1880, thirty thousand line the streets for the funeral procession, representing one in seven residents. His Majesty has as his companions two street dogs named Bummer and Lazarus that are also accorded gracious treatment. Each year on the day of his burial, a group of devotees don full Emperor attire to commemorate his life by parading from his grave to a local watering hole.

It's a tea pot of a town always boiling over.

—*Martha Hitchcock, mother of Lillie Hitchcock Coit, circa 1890*

Lillie is—in classic San Francisco tradition—both elite and quirky, "the reigning madcap heiress" one historian calls her. As a teenager, she becomes a local celebrity and champion of San Francisco's volunteer firefighters. Daughter of a prominent physician and wife of the "Caller" of the Stock Exchange, she relishes puffing on cigars, donning trousers, posing in western garb and guns and sneaking out at night disguised as a dude to gamble in male-only establishments. One of the best-known local eccentrics, she is a lifelong booster of San Francisco's firefighters and leaves a gift in her will that funds Coit Tower.

Material success does not compromise San Francisco's nonconformist ethos. The city remains unorthodox, rebellious and libertine—a curious cocktail of cosmopolitanism and frontier temperament. Even when civic maturity promotes conformity and more social stratification, there is always eccentricity and restiveness, led by an elite that remains a different breed than elites elsewhere.

[San Franciscans] *are not hypocrites, who pretend to high qualities, which they do not possess. In great cities of the old world, or even in those of the pseudo-righteous New England States, there may be quite as much crime and vice committed as in San Francisco, only the customs of the former places a throw a decent shade over the grosser, viler aspects.*

—Annals of San Francisco, *1855*

As we have little hereditary wealth and most of your great fortunes have been made…within a brief time, by bold investments or speculations, and not by occupations requiring much erudition or refinement, so the millionaires and their families are in some cases ignorant of many fashionable usages. Nowhere else will such bad manners be found in families possessing so much wealth.

—*John Hittel, historian, 1878*

Innovation, open-mindedness and irreverence become part of San Francisco's DNA. The international Bohemian movement finds a welcome home here, which becomes its subculture heartland. The *American College Dictionary* defines a bohemian as "a person with artistic or intellectual tendencies who lives and acts with no regard for conventional rules of behavior." Later, this milieu will breed the hipsters, beatniks, hippies, counterculture and "adult" entertainment industry—all incepted or flowering in San Francisco. That robust spirit is born in the gold rush. Freedom from societal restraint, disdain for common opinions, even reckless abandonment all serve as traits that deliver survival and success at the time.

Their individualism and strength descended to their off spring and with it came also their spirit of Bohemianism with the result there has always been a recognized refusal to be bound down by conventional rules and regulations, especially when those rules and regulations bore the hall mark of hypocrisy.

—*The* Wasp, *spouting its typical iconoclastic commentary, 1917. The San Francisco magazine also laments at the time that authentic Bohemianism is quickly disappearing.*

The word referred to a tribe of penniless artists seen around the seedier districts of Paris and New York. They drank to excess, contracted venereal diseases. They shivered to death in drafty garrets, toiling over masterpieces would never be printed. But in Bret Harte hands, "Bohemianism" became more than just a byword for wild living. It came to present a creative alternative to the mundane and the mercenary in life, a way to overcome California's crude materialism.

—*Ben Tarnoff,* The Bohemians, *2014. Bret Harte was one of the most widely read fictional and essay writers on the gold rush.*

I never saw so many well-dressed, well-fed, business-looking Bohemians in my life.

—*Oscar Wilde, 1882, on the occasion of his first visit to Francisco. The famous playwright and flamboyant bon vivant is one of many avant-gardes who identify with San Francisco. He is driven from English Victorian society in the 1890s when his homosexual identity is uncovered, but his works survived and thrived in the United States.*

In this club were no amateurs spoiling canvas because they fancied they could handle oils without knowledge of shadows or anatomy—no gentlemen of leisure ruining the temper of publishers and an already ruined market with attempts to write....Most hosts were working, or had worked, for their daily bread with pen and paint.

—*Rudyard Kipling, poet, 1889. Kipling is writing about the famed San Francisco Bohemian Club. It begins as a so-called haute boheme of well-off artists and intellectuals enjoying their elite company separate from philistines—high and low—but eventually morphs into an establishment bulwark with members like William Randolph Hearst and Richard Nixon. Bohemianism as a cultural way of life is more commonly practiced on the streets of San Francisco, then and now.*

It's an odd thing, but anyone who disappears is said to be seen in San Francisco. It must be a delightful city and possess all the attractions of the next world.

—*Oscar Wilde, circa 1895. His quip is oft quoted. But what does it mean? Perhaps those who have wanderlust, face a crisis of identity, suffer existential angst or simply yearn to escape oppressive conditions of any kind join a cultural diaspora to a far-off place with a reputation for hospitality, diversity, tolerance and enough back alleys to hide your anonymity and keep your secrets. Get lost in San Francisco—and find or reinvent yourself.*

Although no one ever accuses the local business elite of bohemianism, many recognize the city's independence and resistance to conformity. If you can beat 'em, join 'em.

San Francisco is fed on the intoxicants of a gold rush, developed by an adventurous commerce…isolated throughout its turbulent history from the home lands of its diverse people and compelled to the outworking of its own ethical and social standards, welcoming people to a place that has evolved an individuality beyond any other American city.…Here is not thralldom to the past, but a trying of all things on their merits, and a searching of every proposal or established institution by the one test: Will it make life happier?

—1900 San Francisco Chamber of Commerce publication

San Francisco is a mad city…inhabited by perfectly insane people whose women are of remarkable beauty.

—Rudyard Kipling, 1889

The erotic excesses of the 1880's and 1890's continued the much publicized erotic frolics of the '49ers. San Francisco is an adult playground, not just for the local folks but also for the tourists who flock to the city because of its reputation. Prostitution is such a big business by the turn of the century that literally thousands of San Franciscans depended on it for their livelihood.

—Charles Lockwood, historian, 1978

Both the seedy and the grandiose traditions of the "oldest profession" thrive in San Francisco. The Barbary Coast does a brisk and around-the-clock business. Consumer demand leads to enterprises like the three-story Nymphia that debuts in 1899 with 150 "cribs" (semi-private rooms) on each floor. Two city police patrolmen stationed outside will enter only if they hear gunfire or screams for help. Drunken fistfights in and around the establishment are left to fate. At the other end of the erotic spectrum, parlor house madams compete for the most sumptuous surroundings. The distinctive red light in the porch alerts an elite carriage rider to the destination where he is typically greeted by a Black maid, escorted to the parlor to meet the madam and plied with fine champagne. Musicians never stop playing, and neither do the ladies.

The interior abodes of some of these "abodes of sin" are rich and costly, and many are furnished in style superior to the private dwelling of most citizens.

—Benjamin E. Lloyd, historian, 1878

San Francisco is only eighteen inches above hell. Treat lightly, brother.

—Reverend W.W. Case, 1895

Mary Blake [comely opera singer performing in Barbary Coast dance halls]*: "I'm going stay."*
Father Mulligan: "You're in probably the wickedest, most corrupt city, most Godless city in America. Sometimes it frightens me. I wonder what the end's going to be."

—San Francisco, *1936, depicting the Barbary Coast and the Great Earthquake, script by Anita Loos*

You'd think 'twould be a godly town,
This city namesake of a saint,
But on rather close inspection,
I've concluded that it ain't.

—San Francisco booklet A to Z, *1903*

San Francisco—guardian of the Golden Gate—stands today a queen among sea-ports—industrious, mature, respectable. But perhaps she dreams of the queen city she was—splendid and sensuous, vulgar and magnificent—that perished suddenly with a cry still heard in the hearts of those who knew her.

—*"Preamble" from movie* San Francisco

Now there's a grown-up swinging town.

—Frank Sinatra

4

The Great Earthquake and the Great Recovery

POPULATION OF SAN FRANCISCO
1900: 342,783
1910: 415,912
1920: 506,676

There, thanks a lot. Gee, that was a whooper, huh!…Well, we certainly don't do things half-way in San Francisco, do we?

—*waiter being yanked from beneath the earthquake rubble by his boss Blackie Norton (Clark Gable),* San Francisco, *1936*

The first violent shaking lasts an agonizing sixty-five seconds. Then countless aftershocks rattle through the city. As structures collapse like matchstick houses, it triggers a perfect disaster—gas lines and water mains fracture simultaneously—spawning a conflagration that burns for three days. Surrounded by the Bay and the ocean, there is water everywhere, but nothing to spray. Stand along Van Ness Avenue and look north, east and west toward the Bay—virtually all is leveled. The Great Earthquake of 1906 hits on April 18 at 5:12 a.m., catching residents asleep. Modern science calculates a massive 8.3 trembler, the epicenter a mere two Pacific Ocean miles from San Francisco. Up to that point in history, no major city had been hit so close and directly by a high-magnitude earthquake.

A famous local author witnesses the event.

On Wednesday morning at a quarter past five came the earthquake. A minute later the flames were leaping upward in a dozen quarters. South of Market Street in the working class ghetto, and the in factories, fires started. There was no opposing the flames. There was no organization, no communication. All the cunning adjustments of the twentieth century city had been smashed by the earthquake. The streets were humped into ridges and depressions, and piled with debris of fallen walls. The steel raids were twisted into perpendicular and horizontal angles, the telephone and telegraph systems were disrupted and the great waters had burst all the shrewd contrivances and safeguards of man had thrown out of gear by thirty seconds' twitching of the earth's crust. An enumeration of the dead will never be made. All vestiges of them were destroyed by the fames. The number of victims of the earthquake will never be known.

—*Jack London, 1906*

The belief is firm that San Francisco will be totally destroyed.

—*the special* San Francisco Call-Chronicle-Examiner *combined newspaper, the day after the earthquake*

Darling Papa & Mamma & Sisters,
A terrible thing has happened. San Francisco is no more.

—*letter from a resident, April 20, 1906*

The event is regarded as the largest natural disaster in the nation's history until Hurricane Katrina in 2005. Quakes and fires destroy or severely damage some 28,000 buildings—almost two-thirds of the entire city. An astonishing 250,000 of the city's 400,000 residents are instant homeless refugees. It is also regarded as the largest natural disaster coverup in the nation's history. The Board of Supervisors quickly fixes the fatality count at 478. Despite widespread skepticism at the figure, it is generally accepted, even as contradictory stories emerge that there are countless victims impossible to recover under debris, makeshift graves abound, and numerous reports of more fatalities circulate.

The official figure remains unchallenged until one day in 1964 when Gladys Hansen, a research librarian at the San Francisco Public Library's Special Collections, is asked by a patron for an official list of the dead. She discovers that such a record does not exist. This revelation spurs a lifetime dedication to the pursuit of the truth and justice. One journalist describes her effort as "doing detective work for the bureau of missing persons." Hansen's exhaustive research eventually produces a dramatic revision of the death toll: at least three thousand…and counting. It is projected to climb to more than six thousand.

I met so many people who saw me as that kook from San Francisco on this vain search for the dead.

—*Gladys Hansen, 2005, reminiscing on her early days at the San Francisco Public Library. As her acclaim and credibility grows, she is appointed the first archivist of San Francisco by Mayor Joe Alioto in 1976. Letters addressed to "Death Lady of San Francisco" are automatically put on her desk. Upon retirement, Gladys Hansen is designated archivist emeritus; after her death in 2017, the position is left open.*

I shall never forget the scenes at the ferry-house. It was bedlam, pandemonium and hell rolled into one. There must have been 10,000 people try to get on that boat. Men fought like wild cats to push their way aboard....Women fainted, and there was no water at hand with which to revive them.

—George Musgrove, theatrical producer, 1906. *The removal of San Francisco residents to safe locations across the Bay is the largest evacuation of people over water until the massive withdrawal of British troops from the coastal town of Dunkirk, France, during World War I.*

As crowds frantically jostle at the Ferry Building to escape by boat in the midst of a citywide collapse of civil order that threatens looting, violence and mayhem, Brigadier General Frederick Funston orders troops stationed at the Presidio Army base to march into San Francisco—the only time those troops ever leave the enclave to enter civilian territory. It takes one step. Army and navy forces are joined the next day by city police, the California National Guard and motley bands of armed civilians in an effort to prevent and meet disorder. There is little coordination of effort. Without an effective organized center of control, various groups issue and follow contrasting orders, the most important of which comes from the mayor's office.

PROCLAMATION
BY THE MAYOR

The Federal Troops, the members of the Regular Police Force, and all Special Police Officers have been authorized to KILL any and all persons found engaged in looting or in the commission of any other crime.

I have directed all the Gas and Electric Lighting Companies not to turn on Gas or Electricity until I order them to do so; you may therefor expect the city to remain in darkness for an indefinite time.

I request all citizens to remain at home from darkness until daylight of every night until order is restored.

I Warn all citizens of the danger of fire from damaged or destroyed chimneys, broken or leaking gas pipes or fixtures, or any like cause.

E. E. SCHMITZ, Mayor.
Dated, April 18, 1906.

FACSIMILE OF MAYOR'S PROCLAMATION, ISSUED ON MORNING OF EARTHQUAKE

This is a government license to kill. Some who are not part of official law enforcement enthusiastically embrace the spirit and letter of the order. More disturbing, continual reports of military misconduct circulate, especially in the early, hectic, trigger-happy days. Residents complain of unnecessary and arbitrary evacuations and careless implementation of the official order to shoot criminals and looters. The army denies any involvement by its troops in illegal or violent actions, attributing the activity to other military or civilian armed units. This collateral damage has never figured prominently in any assessment of earthquake fatalities, at

least not explicitly. But Richard Hansen and David Fowler have documented, based on U.S. Army records, at least 514 people classified as "looters" and "criminals" killed. This is a far larger number than has been estimated by most historians. We will never know how many deaths occur as one rescuing his own possessions or helping a friend is mistaken for a looter.

Despite the meticulous effort of Gladys and Richard Hansen, we are left with Jack London's haunting words:

> *An enumeration of the dead will never be made....The number of victims of the earthquake will never be known.*

> *The damage to property was compounded by the way the dynamite squads went about their work. They lack good sense and judgment, or perhaps it may have that some incompetent officer gave orders....When the soldiers ran out of explosive, they had another cruder, method—legalized arson.*

> —*James G. Stetson, manager of the California Street Cable Railroad Company, 1906*

The firefighting practice of the time encourages firewalls to eliminate natural fuel that fires need to survive. In forests, you destroy living trees and brush in advance of the moving flames. In cities, the fuel is structures, and dynamite is the tool of choice. In 1906, this approach is less tested than in forests, and there are problems peculiar to urban applications. Defiant owners stand in front of properties with weapons, questioning the law or an official's judgment. Dynamiters, a few reported as inebriated, blow up the wrong buildings. Some explosions are larger than expected and take down nontargeted property. One overly enthusiastic contractor under explicit orders from Mayor Schmitz to concentrate on Chinatown is arrested for reckless mayhem; the mayor is spared the indignity. High winds in fires near water spawn a rare cyclone effect that blows embers every which way and start countless unintended blazes. In the chaos and later assessment, the decision to create firewalls is not officially debated. There is no evidence that the operation did more good than harm and considerable evidence to the contrary.

The earthquake is no respecter of class. Nob Hill is hit hard by the calamity. All "Big Four" transcontinental railroad barons' mansions are destroyed. On the site of the Stanford and Hopkins residences today are hotels bearing their names. The Huntington property becomes a public

park across the street from the Huntington Hotel built in 1922. The Crocker family gives its land to the Episcopal Church, which constructs Grace Cathedral on the spot.

The spirit of American institutions is obviously adverse to the quartering of troops in times of peace in large cities.

—General Greely, 1906, requesting that army responsibilities in post-earthquake San Francisco be transferred to local civil authorities and the Red Cross. He has endured nonstop criticism and controversy over the use of federal troops in San Francisco. The general is itching for a withdrawal. When granted the opportunity, he picks his time. The day after city saloons officially reopen on July 1—a thirsty two and half months after the earthquake—U.S. Army troops vacate San Francisco. In the meantime, saloons and liquor warehouses have suffered substantial damage. Fortunately, the largest distributor of whiskey, Anson Hotaling, has a sturdy brink building that survives largely intact and he recruits workers to move the precious inventory to secure (and hidden) spots along the piers. This inspires poet Charles K. Field to pose the question at the time:

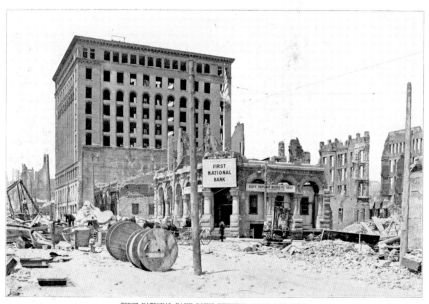

FIRST NATIONAL BANK DOING BUSINESS AMONG THE RUINS

If, as they say, God spanked the town
for being over frisky,
 Why did he burn the churches down?
 And save Hotaling's whisky?

It is one thing to have the product in a safe stockpile and another to have a safe place to drink it. Most saloons are declared off-limits until the city can make a thorough damage assessment. As eyes are focused on the immediate disaster, there is a below-the-radar public "calamity." If liquor is a mainstay of normal city life, is it not a dire necessity during a crisis? And in the midst of the devastation, where is the common man to slug a snifter? The dilemma inspires another poet:

> *...Before the glimmer of flames had died*
> *Me thought a Voice within the Tavern cried:*
> *"When all the bottles are set up within,*
> *Why lags the thirsty travel outside?"*
>
> *But no cork popped, and those who stood before*
> *The Tavern shouted, "Open, the door!"*
> *Yet the stern policeman barred the way,*
> *And still the thirsty refugees for chore...*
>
> *Would but this desert of the barroom yield*
> *One glimpse—if dimly, yet indeed revealed!*
> *But posted on the swinging door appears*
> *The Mayor's proclamation—unrepealed!...*

> —*Ralph E. Renaud, San Francisco newspaperman,*
> *"The Refugees' Rubaiyat," 1906*

The only commodity more important than liquor (for some) is food. Cooking requires chimneys to expel the smoke. Almost every Victorian home has one, and 95 percent are destroyed or damaged in the earthquake. Until they are repaired, the city decrees, the stoves cannot be used inside any structures. The prevailing response is simple and stoic: remain calm, move the stove to the street and carry on. San Franciscans do so in grand fashion.

There are hundreds of outdoor "earthquake" stoves all over the city. A group of displaced society woman publish the widely read *Refugees Cook Book* offering helpful recipes on to how prepare convenient gourmet "street" food.

Be ready to help people when they need it most.

—*Amadeo Peter Giannini, 1906*

In 1904, the enterprising son of Italian immigrants opens a modest bank located in a converted saloon. It is immediately labeled the "Dago Bank." The staid commercial banking establishment is shocked when the upstart becomes the first to advertise publicly for customers, appealing primarily to the working class.

As the earthquake is inflicting serious damage on the city's banks, Giannini rushes to his business. Fire racing toward him, the young man removes all his vault cash, hides it a vegetable wagon and, in the chaos and darkness of night, rides nervously but nonchalantly out of town to a secret location in San Mateo, eighteen miles south. Although many vaults survive the fire, the metal is so hot they cannot be opened immediately. Most big banks close for weeks. His place of business destroyed, Giannini sets up a temporary "bank" from a plank across two barrels in the street and secures loans on a handshake. As practically the only game in town, the young entrepreneur makes a small fortune during the "bank holiday." Years later, he recalls

that every loan is repaid. When branch banking is authorized by the state in 1909, Giannini jumps on the opportunity ahead of others, establishing these institutions throughout California. Eventually, the Bank of Italy has hundreds of branches. In 1931, he changes the name to Bank of America.

RUSH TO JUDGMENT: THE FATALITY TALLY AND THE COVER-UP

Everything you know about the 1906 Earthquake is wrong.

—James Dalessandro, *historian*

Uncounted bodies of dead men and women are lying in morgues and under uplifted walls. It is believed that nearly 1,000 lives were lost. The number cannot fall short of that, and it may prove to be much greater.

—San Francisco Chronicle, *April 18, 1906.*
The final and official Board of Supervisor fatality tally is 478.

How do you calculate the number of dead in such a widespread and complicated disaster, especially under pressure to deliver the figure quickly? There is mass dislocation and disrupted communication. Many bodies cannot be counted, much less rescued from the rubble of burned-out buildings, especially in Chinatown and the crowded South of Market hotels and boardinghouses. Adding to the confusion are unsettling reports, such as one in the *San Jose Mercury and Herald* that estimates over 150 fire victims in the vicinity of Telegraph Hill and Union Street are cut off from escape. This figure alone is almost one-third of the final estimate, and no one knows if those who compile the official list have any knowledge of the claim. Throughout the city, some victims are quickly buried in nearby open spaces. Unknown numbers are whisked to cemeteries and placed in improvised graves. Still others remain unnoticed or neglected in hasty and undocumented cleanups. Due to the lack of city hospitals to absorb such an emergency, uncounted injured are triaged in place and put on available railroad transportation to the nearest town with facilities to take them; most of those rescued in this way are unrecorded at point of origin

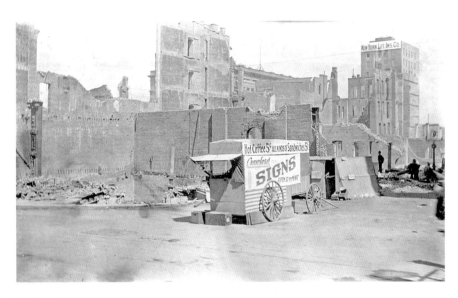

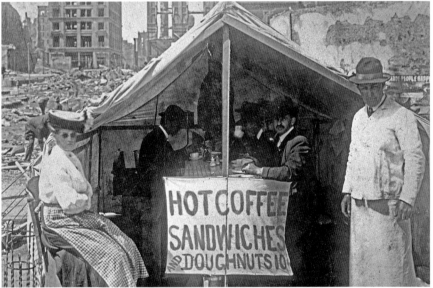

This page and next: Life goes on, spearheaded by resourceful refugee entrepreneurs.

or arrival, and there is no way to determine if they were moved again, survived or died.

Among the most serious flaws in the fatality count is the lack of any official effort to ascertain Chinatown casualties. The vast overcrowding and reluctance of the Chinese to interact with local officials has made

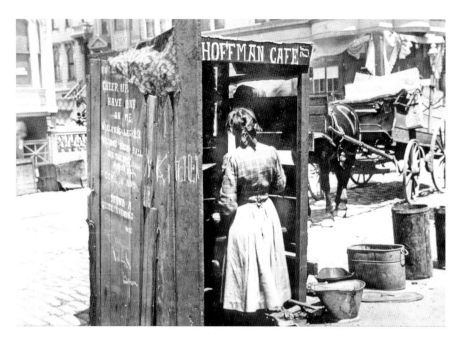

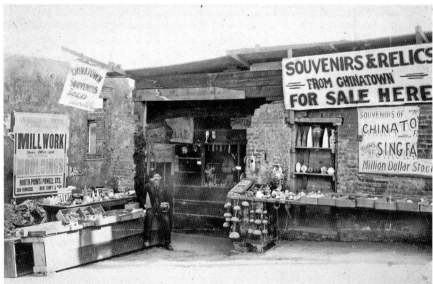

an accurate census impossible. As a result of anti-Chinese immigration laws and popular prejudice, that population is actually decreasing after 1890. At the time of the earthquake, there are estimated to be as many as 25,000 residents in a sardine-packed twelve-block region that suffers utter destruction. As late as 1984, Gladys Hansen can document only 22

Chinese deaths in an area that is dramatically less seismically sound than the rest of the city. Professor Yong Chen estimates 435 dead in Chinatown, 3,500 injured and 20,000 escaping to Oakland in the disaster. Historian James Dalessandro believes that at least as many as the official count of 478 perished in Chinatown alone. In general, the uncounted were more recent immigrants and poor—Italian longshoreman, Irish nannies and Asian laborers—concentrated in South of Market tenements and Chinatown.

To accurately ascertain the dead is a herculean task that demands patience and painstaking dedication, virtues that rattled city fathers cannot muster. Instead, there is a stampede to judgment orchestrated by civic and business leaders—a deliberate effort to manage the news. Today, we call this "spin control." The city must protect its civic reputation and formidable resources invested there. The Great Earthquake is regarded by local leaders as nothing less than an existential threat. There is an urgent need to reassure potential developers and future settlers that San Francisco remains a thriving urban area dedicated and able to sustain dynamic growth. The objective of this campaign is to reduce negative publicity by controlling how and what information is disseminated.

> *It was agreed by the San Francisco Real Estate Board that the calamity should be spoken of as "the great fire" and not as "the great earthquake."*
>
> —San Francisco Chronicle, *April 25, 1906*

Journalists especially are implored to describe the disaster as a fire. Banks and insurance companies will invest in a city that suffers a citywide conflagration, such as Chicago in 1871, but an earthquake is regarded as a different beast of nature—a capricious act of God that cannot be guarded against or controlled, much less understood. Given the ignorance and fear of earthquakes, it begs the question: what if San Francisco is an earthquake-prone region? The geological history is unsettling—some 250 events strong enough to have been recorded in newspaper and other accounts. In 1865 and 1868, more serious tremblers cause notable damage. In these cases, repairs are quickly executed and the news is downplayed. Before radio and television, out-of-town news arrives by telegraph wire to publications. Manipulation of information from San Francisco is all too easy. In 1906, as a confidence-boosting project, the city hires writers to craft positive stories, sometimes ignoring claims of human death and minimizing the connection between the earthquake and the fire. Due to its

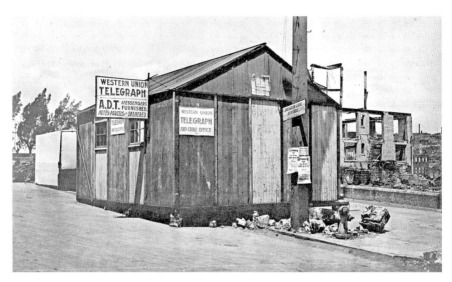

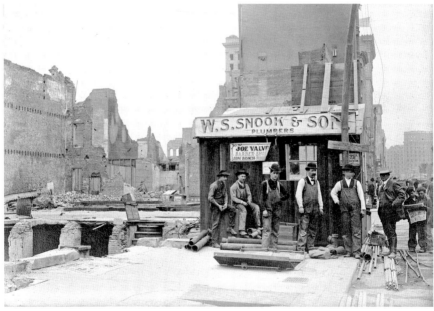

vast landholdings and hauling business in California and San Francisco, the Southern Pacific Railroad has a strong vested interest in softening the public perception of the crisis. *Sunset*, its monthly magazine, runs optimistic and misleading stories about the fire and recovery with hardly a mention of the earthquake itself.

Photography at the time was not the province of average people, so original pictures of the disaster and immediate aftermath are rare commodities. Insurance companies, newspapers, the Southern Pacific Railroad and private citizens—mostly owners of damaged property—acquire earthquake photos in order to destroy them. Some pictures are "photoshopped" to reveal less structural damage by hiring artists accomplished at retouching portrait photographs. There was another reason, both immediate and compelling, for the suppression of photographic evidence. Insurance companies generally compensated arson, but not earthquakes. The first two thousand insurance claims are all fire damage, a statistically unlikely result, and prima facie evidence of fraud. Partially destroyed structures are sometimes finished off with a match. Arson becomes a cottage industry. In 1906, the Board of Supervisors sets total property loss at $300 million (in today's dollars). That figure is derived carelessly and is underestimated as part of a larger effort to downplay the public perception of damage. Insurance was far less purchased then compared to modern times, and even among those that held coverage, it was common for an owner with multiple buildings not to insure all of them. The official city property loss statistic was likely based on insurance claims paid, which were only a portion of the actual filings. Historians Richard Hansen and David Fowler estimate the actual property damage could be as high as a staggering $5 billion.

As well as needing eastern banks to deliver sufficient construction loans, the city would also need insurance companies to cover its risks. A centralized depository of accounts and photographs that would serve as an endless stream of articles and books about the collapse and burning of buildings, not to mention the deaths of so many people, did not lend itself to the confidence and optimism that the city needed to go forward into the future. It would only serve to keep the dreadful past in the present.

—*Richard Hansen, historian*

San Francisco mayor Eugene Schmitz creates a committee to compile an earthquake report. Prominent banker John Humm is appointed chairman, and renowned University of California history professor Henry Morse Stephens joins the team. Solicitations in newspapers ask for personal accounts. Investigators conduct interviews with individuals ranging from ferry captains to housewives. Timelines and maps are carefully created.

The committee works full time for a year. No official report emerges from the voluminous material collected, and now virtually all that material has vanished. How does this happen? No one knows for certain. It might have been lost in the great 1923 Berkeley fire or gradually misplaced by staff assigned to classify and organize the mountain of materials. Professor Stephens dies in 1919 with no mention of the report in his estate records. The disappearance of the documentation feeds the conspiracy theory that it is deep-sixed by influential people who want to suppress evidence and facts about the disaster to protect the civic reputation and future progress of the city. There is at the very least a cabal of silence and accommodation, and it continues for many decades.

An enumeration of the buildings destroyed would be a directory of San Francisco.

—Jack London, 1906

On the centennial of the Great Earthquake, the San Francisco Board of Supervisors revises the official 1906 fatality figure of 478 by declaring the dead at "over 3,000." The occasion is commemorated at Cypress Lawn Cemetery with a special memorial dedicated by Gladys Hansen to the thousands of uncounted souls. To this day, it is only the formal tribute to those victims. A personal Gladys Hansen memorial is added to the spot in 2017 on the occasion of her passing.

I was married once—in San Francisco. I haven't seen her for many years. The great earthquake and fire in 1906 destroyed the marriage certificate. There's no legal proof. Which means that earthquakes aren't always bad.

—W.C. Fields

The past is wiped out in many ways. The formal record destruction of the 1906 earthquake is profound, which renders a determination of how many perished and many other research subjects obscure or impossible, such as immigration statistics. It creates an oriental puzzle box. The Chinese Exclusion Act of 1882 is intended to limit immigration by making only the Chinese relatives of documented male Chinese American citizens eligible for U.S. citizenship. This carefully crafted loophole unravels in a minute of nature's fury, thus enabling any Chinese man to assert citizenship since it is

impossible to refute the claim legally without records. And by declaring that right, Chinese men are legally granted the right to bring family members from China to the United States as citizens. Many of those claiming such citizenship are children and young adults, including many women. At that time, women represent only a small portion of Chinese residents, whose absence has hindered the society from developing along more traditional and holistic lines. Complications and controversies occur as this new immigration policy plays out in the following decades. But the eventual result is a demographic and cultural transformation that eventually integrates the San Francisco Chinese population into the city community.

BOOSTERISM AND THE SECOND INSTANT CITY

"You build a new San Francisco!"

—final scene from the movie San Francisco, *1936. Young man shouting to crowds camping on the city outskirts to escape the earthquake and fires— as they cheer and march triumphantly back upon hearing the long-awaited words from the breathless messenger: "The fires are out! The fires are out!"*

The great calamity…left no one with the impression that it amounted to an irrecoverable loss. This afternoon everyone is talking about it but no one is in the slightest downcast…..Nowhere is there any doubt but that San Francisco will rise again, bigger, better and after the very briefest of intervals.

—H.G. Wells, novelist, 1906

The "instant city" rebuilding of San Francisco has a price beyond the price. One is aesthetic. At the time of the earthquake, city movers and shakers are embracing a grand vision to remodel the metropolis into Paris of the Pacific. VIP Daniel Burnham, a distinguished urban designer and prominent developer of the 1893 World's Columbian Exhibition, has offered a Very Important Plan for a dramatic and ambitious makeover of San Francisco. Imagine tree-lined boulevards with axial streets radiating out to small village greens…a meticulously landscaped Twin Peaks urban oasis four times the size of Golden Gate Park and featuring a grand staircase from the now Castro

Building, Boosterism and Bustles.

district to an amphitheater flanked by a three-hundred-foot statue…city "vista points" surrounded by buildings with classical façades…elegant strolling boulevards ringing the old city. The Great Earthquake ends the Great Plan, which in the best of times will consume decades and incalculable revenue.

> [The people] *dropped the ideal plan in order to house themselves and rehabilitate their affairs. It was the worst time to talk about beautification. The people were thrown back to a consideration as to how again they would live and thrive.*
>
> *—former mayor James Phelan, 1918, recalling the fate of the proposed grand city makeover in the face of the earthquake of 1906*

Today, the Civic Center complex is the most notable Burnham-inspired Beaux-Arts footprint from the original grandiose blueprint. City Hall, the Main Library (part of which becomes the Asian Art Museum), Exposition Auditorium (renamed Bill Graham Civic Auditorium), the California State Building and the War Memorial Opera House compose the Civic Center Plaza. The widening of Nineteenth Avenue, expansion of Geary Boulevard and a redesign of what are now the Yacht Harbor and Aquatic Park along the Embarcadero are also completed, providing a hint of what might have happened in other parts of the city.

The more significant and serious consequence of the frantic reconstruction of San Francisco is the failure of civic leaders to conduct even a cursory review of how the earthquake affected various architectural structures in order to determine what San Francisco could learn from the disaster to make the city more seismically sound for the future. In a mad dash to restore San Francisco, most building codes are actually lowered, some by as much as 50 percent, which means that buildings and homes constructed after the earthquake are significantly less able to withstand another large disaster than those finished before it. Only in the 1980s is the full extent of this regrettable legacy realized and accepted. San Francisco still remains in catch-up mode.

> *San Francisco after the Great Earthquake was rebuilt on a foundation of deception.*
>
> *—public San Francisco television station KQED, 1989*

PHOENIX RISING FROM THE ASHES: PPIE IN THE SKY

For this city is one of those which have souls…This is a thing that we know, because we have had the land shake it as a terrier shakes a rat, until the form of the city is broken; it dissolved in smoke and flame. And then a polyp of the sea draws out of the fluent water form and perpetuity for itself, we saw our city drew back its shapes of wood and stone, and statelier, more befitting a spirit that has endured so much.

—Mary Austin, writer, circa 1910

The kudos for this remarkable recovery belong not simply to the movers and shakers who finance and profit from the endeavor, but to those who do the heavy lifting: heroic ordinary citizens who love the city and respond to the calls for rebuilding with perseverance and optimism, exhibiting that revered plucky old pioneer spirit.

Put me somewhere west of East Street where there's nothing left but dust,
And the boys are all a bustling and everything's gone bust,
And the buildings still left standing sort of blink and blindly stare
At the damnedest finest ruins ever gazed on anywhere.

Bully ruins, brick and wall, through the night I've heard you call
Sort of sorry for each other 'cause you had to burn and fall,
From the Ferry to Van Ness you're a God-forsaken mess,
But you're the damnedest finest ruins, nothing more and nothing less.

And the rubes who come a-rubbering, and hunting souvenirs,
And the fools who try to tell us it will take a hundred years
Before we've even started, and why don't we come to live
And build our homes in Oakland on the land they've got to give.

"Got to give!" Why, believe me on my soul, I would rather bore a hole
And live right in those ashes than to go to Oakland mole.
And if they gave me my pick of their buildings fine and slick
In those damnedest, finest ruins, I would rather be a brick!

—Larry Harris, a young city native, 1906, "The Damndest Finest Ruins"

San Francisco is among a dozen cities competing to host the upcoming 1915 Panama Pacific International Exposition (PPIE)—a national celebration of the long-awaited opening of the Panama Canal that promises to cut in half the time to travel or ship goods from the East Coast to the West. San Francisco is in the bidding early. When the United States begins canal work through the isthmus in 1904, the Merchants Association jumps in. What better way to showcase the "Paris of the Pacific" that visionaries and boosters have envisioned and promoted for half a century?

Alas, the Great Earthquake will surely sink those plans. Hardly. Just a bit more than a year after the disaster, the city's Panama-Pacific International Exposition Company is bankrolled by leading local financiers, businessmen and railroads. The state government pitches in with general issue bonds. The project now has a dual purpose—not just the promotion of the Panama Canal but also to tout and establish the city's grand comeback from the Great Earthquake. But could they rebuild an entire city from rubble and ruin to glory and grandeur in time?

> *Instead of fifty years, New San Francisco asks for fifty months to build here a Golden City. Fifty months to line her boulevards with the splendid structures which are promised by the money kings. Fifty months to grow, upon this new-made grave, a garden of beautiful homes, beautiful streets, beautiful offices and beautiful public buildings; to rear new the greatest city on the Pacific Coast.*

—New San Francisco Magazine, *May 1906*

> *Those who saw San Francisco immediately after the great fire of April, 1906 beheld a vast expanse of blackened landscape....Today, the scars of fire are all but obliterated....Well may they marvel that the hands of men could have done so much in a brief space of time.*

—Facts Regarding the City of Courage and Its Transition into the City of Destiny, *Phelan Building publication, 1909*

The upcoming Exposition becomes the symbol of the city's recovery and continued viability—the proverbial phoenix rising from the ashes—a coming-out party welcoming the world to the revitalized San Francisco. The earthquake fails to dampen the booster spirit—ironically, it generates the

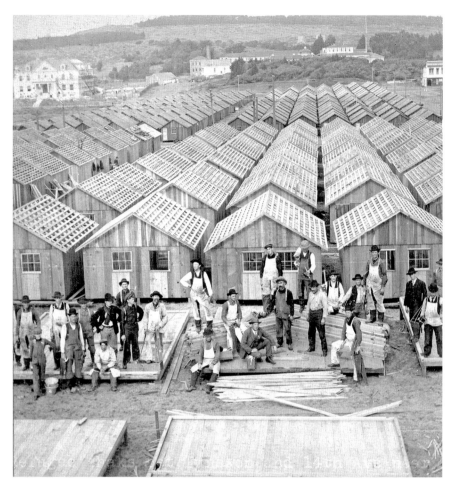

Earthquake "shacks" being built for refugees. Over 16,000 San Franciscans are housed in 5,610 of these tiny cottages spread out over 11 designated camps. When camps begin to close in 1907, refugees sometimes transport the structures to private lots and even cobble them together to form expanded "estate" residences. Of the 5,343 moved from the camps only a few are certified to still be standing.

gold rush "instant city" mentality all over again. San Francisco will not just rebuild. The new civic mantra becomes bigger and better than ever.

> *On April 18, 1906 we unwittingly pulled off the greatest advertising stunt before attempted. The dimmed eyes of the world were turned to us in sympathy. The world, or most of it, thought we had received our deathblow. They thought that at the least it would take a quarter of century to recover. It was predicted that it would take five years to remove the debris. And*

then the world was staggered by the heroic determination with which we commenced rebuilding before the bricks were cold.

Ye Gods, what an advertising opportunity. What glorious and convincing copy that never appeared. Men of San Francisco, it is up to you. What are you going to do about it?

—William Woodhead,
president of the Associated Advertising Clubs of America, 1909

By 1909, increasingly optimistic urban leaders are keen to demonstrate that the city is willing and now eminently able to hold the upcoming exposition. There is no time to lose. Selection of the host is mere two years away! What better way to grab national attention and toot the civic horn than to throw a grand party—a national dress rehearsal for the big exposition? City officials officially announce: "Whereas, the public-spirited citizens of San Francisco, in response to a general and spontaneous demand, have planned…a Festival, which shall at once commemorate the discovery of San Francisco Bay and afford opportunity for public rejoicing over the splendid present and the still more splendid future of the city."

Seizing on an obscure and never-before-recognized milestone—the 140th anniversary of the discovery of San Francisco Bay by Spanish explorer Gaspar de Portolá—a five-day movable Mardi Gras feast and festival is unveiled. The celebration turns out to be even bigger and grander than planned. Great energy goes into picking a queen for the festival—a search for "the most beautiful girl in California." Roofs across the city are painted red to welcome visitors. The first day features a larger-than-life Gaspar de Portolá entering the Golden Gate Strait to a "landing" at Pier 2, then parading with a large contingent of military troops from several countries, including el Comandante Portola's elite musket warriors, "dragoons" prancing on horses. Next day is another parade featuring twenty-five thousand marchers accompanied by waves of floats that start at the Ferry Building and travel though the Mission district. Both spectacles draw one million people, according to the *San Francisco Chronicle*. "Greatest Parade in History of the City" it headlines. The city population at the time is well less than half that total.

Packed into a wild Mediterranean-like wedding extravaganza lasting from October 19–24 are nonstop parties—formal dress balls, bands and music everywhere, fireworks galore, balloon races, swimming contests, tennis and golf tournaments, wrestling matches, an auto show with 1,600 decorated vehicles down Market Street followed by a racing event that draws 200,000

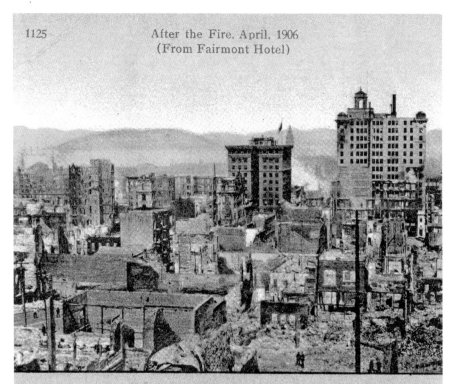

1125 After the Fire, April, 1906
 (From Fairmont Hotel)

A Portion of the New San Francisco, 1909
(Same view point)

to Oakland, exhibitions of airships and airplanes and 75,000 public visits to international war vessels docking in the Bay. Electricity will play an important role in the upcoming Panama Pacific Exposition, and San Francisco promises to rise to the occasion. An exhibit showcasing a brand-new city electric and power grid provides a dazzling lighting spectacle. An immense bell is suspended 125 feet in the air at Third and Market Streets and then illuminated, representing the largest single piece of electrical display ever attempted. The culmination of the festival is the Historic Pageant with floats moving along Market Street depicting historical events, surrounded by seas of costumed marchers.

> *San Francisco has twice become the Imperial City of the Pacific…the first time through the energy of a pioneer race…and the second after complete destruction by the greedy flames and in the face of insurmountable obstacles by a regeneration so rapid and complete as to be the wonder of the world.*
>
> *—President Taft, appearing in person and waxing grandiose in his opening toast to the Portola Festival, 1909*

After fierce national competition, the only serious rival for the Pan Pacific Exposition is New Orleans, the closest large port city to the Panama Canal, centrally located for easy travel from the largest American population centers. San Francisco is over twice the nautical distance from the canal and a three-thousand-mile train ride from New York City. In Congress, the argument seems to hinge on which city can put up the most money. San Francisco will not be denied. It is granted the honor of holding the biggest soiree in its history.

> *San Francisco is the city that knows how.*
>
> *—President Taft, 1911, shoveling the first scoop of dirt that will be the site for the Panama Pacific World Exposition Immediately, this quip becomes one of the city's enduring signature slogans. Was it a foregone conclusion? William Howard Taft anoints the Portola Festival and is still president when the city is chosen, and he presides over the groundbreaking Panama Pacific ceremonies in 1911. Was the "fix" established or at least the San Francisco prejudice already baked into the exposition loaf?*

After rejecting Golden Gate Park as the site of the exposition, the Board of Supervisors votes to create a new 635-acre expanse to host the extravaganza. The land is reclaimed from a largely uninhabited area of tidal pools, swamps, marshlands and sand dunes dotted with wharves and small industrial plants. Rubble from the 1906 earthquake serves as landfill, but most comes from dredging mud and sand from the bottom of the Bay. Master landscape designer and superintendent of Golden Gate Park John McLaren, greatly relieved that the exposition will not invade his domain, enthusiastically decorates the land with a 25,000 yellow pansies, 200,000 daffodils, 200,000 tulips, 50,000 begonias and a forest of olives trees. Tall, graceful palms along the walkways welcome guests into the fantasy world. Mature evergreens towering up to sixty feet decorate the outer perimeter like an elegant fortress wall. The international event is a man-made heaven of earthly delights far from the maddening crowds.

> *The exposition—what a wonderful thing to see.... The colors—I could not see them but do you know I believe since I was at the exposition I know how color feels. It cannot be any more beautiful to your eyes than it was to my mind.*
>
> *—Helen Keller, April 1915. Blind and deaf, Keller is a now worldwide celebrity, one of a multitude of celebrities to visit the fair. Her life story is celebrated in the 1956 movie* The Miracle Worker, *starring Patty Duke and Anne Bancroft. One ad for the exposition features Helen Keller and Houdini on the same bill.*

A splendid courtyard at the Panama Pacific Exposition.

Panama Pacific Exposition on the verge of its opening.

THE GIANT TYPEWRITER, WEIGHT 28,000 POUNDS.
Writing Daily at the UNDERWOOD EXHIBIT,
PALACE OF LIBERAL ARTS,
PANAMA-PACIFIC INTERNATIONAL EXPOSITION, SAN FRANCISCO, CAL.

GRAND PRIZE, HIGHEST HONOR
PANAMA PACIFIC INTERNATIONAL
EXPOSITION, AWARDED TO THE
UNDERWOOD TYPEWRITER

"The Machine You Will Eventually Buy

Almost twenty million attend, ten times the draw of the 1894 San Francisco Midwinter Fair two decades earlier. After the exposition, the land is sold to developers who dismantle virtually all the grand structures and open the area to residential development—the present-day Marina District. The only major structure to survive sits on its original site. The Palace of Fine Arts is designed to exhibit fine works of art. A victim of age and saltwater breezes, the ruin is rebuilt in 1965; renovation of the lagoon and walkways plus a seismic retrofit are finished later. It is popular spot for tourists and locals, often serving as a backdrop for weddings. A miniature replica sits in Disney's Anaheim California Adventure.

The Pan Pacific International Exposition re-announced, reintroduced, reinserted San Francisco into the roll call of significant American cities.

—*Kevin Starr, California historian*

SEVEN WONDERS OF THE (WORLD) EXPOSITION

THE AEROSCOPE

For twenty-five cents one can ride in a 120-seat passenger car connected to the end of a giant steel beam that slowly lifts the entourage to dizzy 235 feet above for a once-in-a-lifetime ten-minute view of the exposition grounds and city.

AIRPLANES

At the time of the fair, most Americans have never witnessed an actual airplane fly. Now they are treated to the best daring young men in their flying machines. For the more adventuresome guest, you get to soar on a thrilling ten-minute hydroplane flight over San Francisco Bay. The most celebrated of the new death-defying aeronauts, San Francisco native Lincoln Beachey, is killed just after his twenty-eighth birthday when the wings snap during his famous "dive of death" and he plummets into the Bay in front of a horrified seventy thousand spectators. This tragedy hardly interrupts the stunt shows, which include nighttime aerobatics featuring phosphorous flares attached to wings that produce spectacular luminous trails in the darkness.

DAYTON FLOOD

Two years before the fair's opening, a devastating flood hits Dayton—to this day the greatest natural disaster in Ohio history. San Francisco is now familiar with great natural disasters. An exhibit re-creates the momentous deluge. You enter through a marquee depicting a colossal giant struggling to hold back massive waters surging from floodgates. Inside, visitors listen to the dramatic disaster tale as torrents of water race from a hole and inundate a scale model of the Ohio city, igniting the diorama.

FORD ASSEMBLY LINE

The average Tony, who might well own a Ford, gets to see just how his magic four-wheeled carpet is manufactured on a real assembly line that produces a new automobile every ten minutes, right there, as workers add parts, engines

and interiors to the vehicles, which are then driven from the fairgrounds to local Ford distributors.

PANAMA CANAL MODEL

The fair is the celebration of the Panama Canal, so it is very fitting to have a working model of the modern engineering marvel. Occupying the equivalent of five football fields complete with miniature trains and lighthouses, scale model ships pass through lock systems as visitors gaze down and listen to commentary from one of 150 tramcars circling the show on elevated tracks.

TELEPHONE GOES TRANSCONTINENTAL

In 1889, Alexander Graham Bell makes the first successful telephone call to an assistant on the other side of a wall. It takes a generation before the inventor makes another historic call to the same Mr. Watson over a two-mile wire between Cambridge and Boston. It is the first long-distance wire conversation. But just as there are problems penetrating the wall, there are problems expanding the two-mile feat. Voices weaken as they travel along the line. A major technological breakthrough is announced just before the exposition. Visitors there can listen to a recording of the first transcontinental phone call held a month prior and then hear a voice in real time from New York City read newspaper headlines and describe the weather.

TOWER OF JEWELS

In 1915, the tallest structure in San Francisco is the imposing forty-three-story architectual focal point of the exposition. Aptly named the Tower of Jewels, it is adorned with 100,000 pieces of polished crystal and colored glass backed with tiny mirrors. Dangling by hooks, they sway and shimmer a rainbow of opalescence in the gentle ocean breezes. When struck by the sun, the tower glistens and gleams like rubies and emeralds. At night, forty-eight gigantic beams of concentrated colored light illuminate the tower, turning it into a monumental jewel, earning the fairgrounds its moniker—the Jewel City.

HONORABLE MENTION: STELLA

There are plenty of nude statues and paintings on display at the exposition's Palace of Fines Arts, representing an enlightened cultural history to be appreciated by all who value elegance and imagination. But in San Francisco, Stella outdraws Aphrodite. For a dime, visitors can buy two heart-racing minutes to stare close up at a voluptuous saloon nude painting named Stella who, thanks to a clever lighting trick, appears to be taking deep, sensuous breaths. The gal is a stand-in-long-lines attraction, collecting $15 million in today's dollars.

<p style="text-align:center">5</p>

Between the Wars

<p style="text-align:center">Population of San Francisco

1920: 506,676

1930: 634,394

1940: 634,536</p>

Bottom's Up in San Francisco

On Jan 17, 1920, American's most wide-open city ran headfirst in American's most puritanical law.

—*public television KQED documentary,* San Francisco in the 1920s

Prohibition may have had less effect in San Francisco under Mayor James Rolph than any in any major city in the country.

—*Jerry Flamm,* Hometown San Francisco

The newly reelected mayor proclaims San Francisco as the party-and-convention playground of the West in 1920. It is an open secret that the national ban on alcohol enacted in that year will likely be ignored in the city. The first test arrives quickly. The Democratic Party national convention is held in San Francisco just five months after Prohibition.

The Democrats arrived in San Francisco full of miserable forebodings. What a surprise awaited them! The moment they got to their hotels they were waited upon by small committees of refined and well-dressed ladies, and asked to state their desire.…Within a few hours the glad word was everywhere. No matter what a delegate ordered, he got Bourbon…Bourbon of really ultra and super quality. It came in quart bottles on the very heels of the committee of ladies—and there was no bill attached. It was offered to the visitors with the compliments of Mayor James Rolph.…Day by day they swam in delight.

—H.L. Mencken, journalist

What made the San Francisco situation so painfully shocking to the dry's was the ready connivance of the San Francisco government in the blatant nullification of the law.

—*Gilman Ostrander*, The History of Prohibition in California

San Francisco regards Prohibition as a small-town, native-born Midwest plot to foist its values on the rest of the nation. Almost two-thirds of the city's 1920 residents are foreign-born or have at least one immigrant parent. Major ethnic groups—Irish, German, Italians and Jews—come from cultures where ritual and recreational drinking is traditional. At the time Prohibition is enacted, San Francisco has a drinking establishment for every ninety residents—the highest per capita of any U.S. city.

San Francisco during the 1920s did not have the gangster element like Chicago or New York. There was a general feeling in San Francisco that vice be home grown, that vice in San Francisco belong to the locals.

—*Kenneth Rose, historian*

There are reports that Al Capone abandons plans to expand his operations here in face of local Prohibition-busting cabals that appear resistant to outsiders. A special detective unit of the local police keeps a keen eye on who enters the pre-bridge geographically isolated city by scouring train stations and the Ferry Terminal for wanted criminals and "undesirables." Guided by local politicians, law enforcement develops an unwritten understanding with residents on just how the city will flaunt Prohibition. In 1926, the Board of

Supervisors instructs local police not to cooperate with national Prohibition enforcement agents. The well-heeled and connected are not the only ones who may grab a recreational drink. In the heart of the city or on the edge of the Pacific accessible by streetcar are establishments such as Roberts-at-the-Beach, where ordinary patrons can bring their own bathtub gin and order fruit juice. Dinners are available, and the three-dollar cover charge includes a dance band. To keep the place wholesome, women have to be escorted. At the traditional ham-and-eggs Billows restaurant in Playland at the Beach, you can sip the finest French Champagne and illegal whiskey from Canada. To keep up appearances, coffee mugs are used when dining. Federal agents are known to accept bribes. Local police become concerned only if an owner has more than one speakeasy—an effort to keep crime from "organizing."

An irony of morality legislation is the unintended consequences. Before Prohibition, no respectable woman will be caught drinking in a bar. Suddenly, speakeasies become fashionable. To disguise the transgression, they often locate in San Francisco "family" restaurant settings that further encourage women to drink in public, a new custom that survives Prohibition.

Even in the depths of the Depression, sin city keeps up a thriving nightclub life that cavorts till dawn. It attracts out-of-town partygoers, most notably from Hollywood; its late-night establishments and restaurants cannot compete with those of Wild West San Francisco, always reliable for an uninterrupted flow of liquor and the entertainment that accompanies it.

One thing was certain in those days: San Francisco was an open town, and the people were happy about it. Like Rolph said, pleasure wasn't prevented; it was regulated.... This particular period of permissiveness lasted for more than thirty years. Nothing lasts that long unless the people are willing that it should.

—Sally Stanford, eventually to be a fabled madam, on her arrival in San Francisco in the early 1920s

It needs another quake, another whiff of fire, and more than all else, a steady trade-wind of grape-shot.... It is a moral penal colony. It is the worst of all the Sodoms and Gomorrahs in our modern world.

—Ambrose Bierce, journalist and editor of the satirical Wasp *magazine, 1922*

A Big City Grows Bigger and Better

The chief business of the American people is business.

—President Calvin Coolidge, 1925

Prosperity for the business man…means prosperity for all.

—San Francisco mayor Jim Rolph, 1925

I think every great city needs an embodiment of what it can be at its best. For Athens it was Pericles, for Florence it was Lorenzo the Magnificent, and for San Francisco that person was James Rolph, Jr., "Sunny Jim."

—Gary Brechin, historian, daring to compare a modern urban machine politician to the exalted ancient and Renaissance urban machine politicians. The most popular mayor in San Francisco history wins a remarkable nine straight elections from 1912 to 1931

San Francisco's Sky Line from the Bay.

The robust 1920s ferry traffic heading to a modern San Francisco skyline.

San Francisco is the most roaring city of the Roaring Twenties. Growth and prosperity reign. Golden Gate Park is finally the Central Park of the West. New, taller buildings sprout from the downtown cityscape. A world-class Legion of Honor Museum opens in 1925, joining the acclaimed de Young Museum. Tourists adore the city. Fisherman's Wharf is becoming an attraction for visitors and locals as street fish vendors become more established and restaurants begin to appear. The section of Lombard Street known as the "crookedest street in the world" is originally straight and features an exhilarating 27 percent grade, a challenge that cars of the era have trouble negotiating. S curves are added for safety in 1922, eventually turning it into one of the most popular San Francisco tourist attractions. At a time before bridges connect San Francisco to Marin to the north and Oakland to the east, people navigate the Bay by individual or automobile-load via the world's largest ferryboat system. In 1930 alone, fifty million passages across the Bay are recorded.

San Francisco may be freed from the standing menace of Chinatown.

—Merchants' Association Review, *1906, contemplating the opportunities for change wrought by the Great Earthquake*

Fire has reclaimed to civilization and cleanliness the Chinese ghetto, and no Chinatown will be permitted in the borders of the city.

—*The* Overland Monthly, *1906*

The dense twelve square blocks of San Francisco's Chinatown are utterly destroyed by the earthquake. The rebuilding and transformation of Chinatown is breathtaking—and ironic. Devastation of this tiny enclave in 1906 accomplishes in single minute what many leaders and ordinary citizens have advocated for half a century—an opportunity to relocate the area from its valuable adjacent-to-downtown location to a remote part of the city. But the long-maligned minority fights to remain in its present boundaries. Chinese community leaders warn that a move to Oakland that would mean the loss of valuable tax revenue. To complicate the matter, the evacuation of the Chinese might be an embarrassing international incident, the Chinese Consulate counsels. And that consulate in Chinatown is likely unmovable because of its legal status as property of the Chinese government.

Relenting, city fathers insist that the new Chinatown must be a radical revision of the drab, improvisational structures honeycombed by narrow dark alleyways and layered subterranean basements. Enter wealthy American businessman Look Tin Eli. He offers to replace and revamp old Chinatown with a tourist-friendly and family appeal. Securing a loan from Hong Kong bankers, he hires Caucasian architects to create an Asian village as imagined by the Western world. Chinatown, as in the fabled San Francisco phoenix, rises quickly from the ashes with a new look, resembling a Hollywood stage set that, like chop suey and the fortune cookie, does not exist in the real China.

The illusion created a masterful design solution, unique and indigenous, for it is neither East nor West but decidedly San Francisco.

—*Philip P. Choy, historian*

City residents are nudging across the western urban desert to the Pacific Ocean, spurred on by the expansion of Golden Gate Park, improved public transportation and new roads for the burgeoning automobile traffic. The trauma and relocation of the 1906 earthquake make the relatively untouched Outside Lands (Glen Park, Twin Peaks, the Richmond and Sunset Districts) more inviting. Residents and tourists can whisk to a thriving Pacific coastline

Looking up Market Street from Ferry Building, Twin Peaks in the distance.

The dynamic downtown of the most dynamic metropolis west of the Mississippi.

entertainment complex anchored by the Sutro Baths Pleasure Palace, Playland at the Beach amusement park and the restaurant-bar-ballroom Ocean Beach Pavilion.

Downtown remains the premier attraction. The area is quickly reconstructed from ruin to new glory. The first municipal railroad in the nation connects isolated parts of the metropolis to the glittering city center, where grand movie houses and theaters are being built. The largest of these entertainment palaces, the Fox, holds no fewer than 4,651 patrons with balconies ascending nine stories above the orchestra. Opening night for the Fox is one of the great gala Hollywood events of the decade, attended by a galaxy of movie stars.

BARBARY COAST BITES THE DUST, AND ALL THAT JAZZ

It is a San Francisco fixture and nemesis from the earliest gold rush days. The city's old red-light district dominates Pacific Street (now Avenue) between Montgomery and Stockton and serves as the main drag of the nine-block area of saloons and dance halls known as the "strip of joy." Sailors christen the spot in the 1860s, borrowing from the North African Barbary Coast, home port of pirates.

At the turn of the twentieth century, city fathers are anxious to find a permanent solution to what is regarded as an embarrassing vice slum in the heart of a world-class city. As with Chinatown, the 1906 earthquake provides a golden opportunity. When most buildings on the Barbary Coast are destroyed, politicians and businessmen jump at the chance to transform it into a more inviting area for tourists and locals. Almost overnight, physically and culturally reconstructed dance halls and bars are open for business on the block of Pacific between Kearny and Montgomery. The area becomes a traditional San Francisco vice transformation project—an elaborate charade with the convivial connivance of politicians, police and business owners. The grand idea is to tame the Barbary Coast but keep its edgy ambiance, at least in appearance. Newspapers refer to the establishments as "resorts."

I can remember the time you could come across San Francisco Bay on the ferryboat and you could pick out that blaze of electric lights on Pacific Street. There wasn't any neon in them days; just millions of electric

lights.... You could see all the lights from them for miles in any direction. I've seen good times on Terrific Street when the street was so crowded with people nobody could go through there in an automobile, and I remember the night the officers of the law came in and closed everything down.

—*Sid LeProtti, jazz pianist and band leader*

The plan is to draw affluent middle-class adventurers who crave the thrills of the old Barbary Coast but without real danger—a Barbary Coast Lite. New customers are called "slummers"—the bourgeois who venture to the rough side of town to see how the other half lives while spending money for the voyeuristic thrills. The shows are terrific. Which is why the area becomes known unofficially as Terrific Street, dubbed so by musicians to describe innovative sounds and dances that burst onto the scene. Black talent from New Orleans introduces ragtime, blues, boogie-woogie and jazz. Jelly Roll Morton and a young Sophie Tucker perform in clubs. Even Sarah Bernhardt and Al Jolson show up. The first published use of the word *jazz* appears in a San Francisco newspaper at the time. Soon to be national dances crazes— the Cake Walk, the Texas Tommy and the Turkey Trot—are San Francisco inventions. Locals and tourists flock to the clubs to drink and dance night away. These new moves are harbingers of the soon-to-be jitterbug and rock 'n' roll hijinks. The backlash then resembled the hysterical reaction of 1950s parents to the new music and dance.

Make San Francisco Clean for Clean People, Let Healthy Gayety and Pleasure Abound. But No Vulgarity.

—San Francisco Examiner *headline, 1913*

The newly reelected mayor moves to reform the Barbary Coast even further. Powerful forces are pushing Jim Rolph. Along with a Board of Supervisors fresh from a purge of corrupt politicians, he is egged on by William Randolph Hearst, who urges in *San Francisco Examiner* editorials that the Barbary Coast be "wiped out." Mayor Rolph, described by one historian as a "reluctant dragon" in the crusade, can tolerate such an initiative, at least officially and if it does not interfere with the city's discreet and fashionable underground vice. Pressured further by a resurgent and well-coordinated San Francisco church-based virtue campaign, the Police Commission announces in 1913:

- No dancing to be allowed in any establishment of the (Barbary Coast) district that offers alcohol
- No women—employees or patrons—are permitted in any saloon of the district
- Electric signs are forbidden

Under this edict, some establishments are pushed from the district to "off Union Square" or the outskirts of the "Tenderloin." Most of the larger dance halls relocate to other districts and manage to survive by masquerading as "dance academies" where girls are paid to promenade with customers on salary. Patrons pay ten cents for a two-minute flirt. The practice becomes known as "taxi dancing." A few bars fire their female employees. Others shutter. Many musicians move to Oakland or Los Angeles or perform at Oakland's Seventh Street jazz scene. Shops take over some of the former badlands. The remaining brothels are guillotined by enforcing the 1917 state Red Light Abatement Act. By that time, all the excitement of Terrific Street has vanished. The final blow, which eviscerates the entertainment scene, comes in 1921 when taxi dancing is forbidden. Insult is added to injury. Prohibition is enforced in the Barbary Coast as upscale brothels and bars elsewhere are left untouched and thrive.

WORLD'S OLDEST PROFESSION: MORE PROFESSIONAL THAN EVER

San Francisco had become an adult playground, not just for the local men but also for the tourists who flocked to the city because of its reputation tolerating loose morals and the unconventional.

—*Charles Lockwood, historian,*
describing San Francisco at the turn of the twentieth century

The erotic trade thrives here, continuing a tradition born in the gold rush. The per capita "ladies of the night" is, as with liquor, the highest in the nation—before, during and after Prohibition. This can happen only with the cooperation of the government and police force.

We were informed this investigation was not intended to be a moral crusade in the sense that it should bring about the closing of unlawful business, as such a course was contrary to the desires of the great majority of San Franciscans....We were aware that the bulk of the people wanted a so-called "open town" and that the history of San Francisco reflected a public attitude of broadmindedness, liberality and tolerance, comparable probably to only two other American cities, names, New York and New Orleans.

—From the Atherton Report, *commissioned by the city to investigate police corruption in 1937. The focus is deliberately set on gambling and other "rackets," rather than prostitution.*

Many of the 135 upper-end sex establishments noted in the *Atherton Report* are concentrated in small areas, at least a dozen of those businesses within three blocks of the Hall of Justice. In one North Beach section, beleaguered homeowners place signs that identify their residences as "private," a practice that continues until the end of World War II. A San Francisco house owned by Mayor Rolph nicknamed the "entertainment hideout" is conveniently/inconveniently located a couple of miles away.

The district got its name from a crooked New York cop named Alexander Williams. When he was transferred from an area in New York of low dives to a district of expensive vice—and big payoffs—he supposedly said, "I've been living on chuck steak for a long time, and now I'm going to get a little of the tenderloin." Pretty soon, the newspapers started calling entertainment and vice districts "tenderloins." The first reference to the Tenderloin in San Francisco was in 1891.

—Carl Nolte, journalist, offering a theory on the origins of the infamous Tenderloin district where much of the brothel activity of the time is located

A Mad City with Perfectly Insane People...Redux

One characteristic had not changed during the city's rise to world eminence: the quixotic and unpredictable character of its people. San Francisco's ability to produce unusual and memorable personages

remained undiminished to this day. The pioneer spirit that pushed some of its citizens to the far edge was unabated.

—Charles Adams, historian, 1998

Many of these unusual and memorable personages are madams.

I shot him, 'cause I love him, God Damn Him!

—Tessie Wall, 1917, standing over the body of her ex-husband with the smoking gun gripped tightly in her large, determined hand

Blonde bombshell Tessie Wall, born Irish Catholic, operates a three-story house at 377 O'Farrell, infamous and celebrated as the finest of the city's pleasure palaces, replete with a lavish ballroom, fine art and antique European furniture. The sensational and violent incident in Tessie's early career proves to be only a minor road bump. Yes, the scorned lady discharges a few wild shots at the political boss/professional gambler and ne'er-do-well/womanizer Frank Daroux after he wins a newspaper feeding-frenzy divorce trial against her in 1917. But immediately remorseful, she offers to donate blood to save her victim. And immediately forgiving, he gallantly refuses and declines to press charges. All's well that ends well. Daroux survives, and who needs another public trial in a town with such a salacious press?

So well liked and connected and generous to San Francisco's law enforcement, Tessie is chosen as the (unofficial) queen of the annual Policeman's Ball. Throughout the 1920s, she enters with and joins Mayor Rolph for the Grand March and traditional first dance at the Civic Auditorium. When the grand dame passes in 1932, the largest floral wreath in the history of the cemetery is signed by every member of the police department. Her will is a surprise and…not a surprise. Ten living relatives are well provided for, but the bulk of the estate goes to police captain J. O'Meara, who is appointed executor.

If every man was as true to his country as he is to his wife—God help the USA.

—needlepoint hanging above entrance to Tessie's receiving room

The Queen is Dead. Long Live the Queen. After Tessie's passing, her San Francisco social position is quickly assumed by an ambitious and enterprising lady who relishes and lives life to the hilt in the San Francisco luck-and-pluck entrepreneurial tradition.

His attitudes were the significant thing about him. First and foremost, he was for Live and Let Live, Let Sleeping Dogs Lie, and Don't Stir Up Muddy Waters. Also, If You Haven't Tried It Don't Knock It.

—Sally Stanford, referring to Mayor Jim Rolph, in her autobiography. Mabel Busby arrives in San Francisco in 1924 with a third-grade education, a rap sheet, and experience as a speakeasy proprietor. Eventually, she becomes the most famous and celebrated of modern Bay Area madams, hosting politicians, business moguls and the rich and famous such as Errol Flynn, Marlon Brando, Bing Crosby, Frank Sinatra, Humphrey Bogart and San Francisco labor leader Harry Bridges. In 1972, Sally Stanford, long retired, is elected mayor of Sausalito, an upscale town just north of San Francisco in Marin County. The best-selling Sally Stanford autobiography, The Lady of the House, *becomes a TV movie in 1978. The lady is a sultry Dyan Cannon. Famed San Francisco lawyer Melvin "King of the Torts" Belli plays a perfect Mayor "Sunny Jim" Rolph.*

They were a wonderful set of burglars, the people who were runnning San Francisco when I first came to town in 1923. Wonderful because, if they werer stealing, they were doing it with class and style. When they turned City Hall and the Hall of Justide into a pair of stores with bargains for all, they did with charm, finesse, and all the French "savioir-fiare."

—Sally Stanford

Sally Stanford, a famous Madame, had a huge house on Russian Hill and her girls were like socialites and junior leaguers, they wore dusters and feather boas, they wore corsages and they acted like ladies. And it was even on the Gray Line Tour for a while. You could drop in and meet Sally's girls.

—Herb Caen, San Francisco columnist, reminiscing about the good old days

The grand pleasure salons of Tessie Wall and Sally Stanford mask a more sinister and disturbing feature of San Francisco's libertine character. If there are, as Sally Stanford estimates, some 580 houses of ill repute in 1940 San Francisco, very few are elite establishments that attract independent, entrepreneurial women of free will, as she describes her employees. Most of the professional ladies in the city are marginalized in dangerous and unsavory plights under the control of pimps. In Chinatown, the conditions are more dire and typically involve young girls as victims of human trafficking. The responsibility for this spectacle rests with the local Chinese gangsters who organize the import slave trade and the white politicians who tolerate and promote it.

"Go West, Young Man"

The phrase attributed to *New York Tribune* editor Horace Greeley in 1868 becomes a battle cry in turn-of-the-century San Francisco. On this occasion, the arduous journey from civilization to the Pacific Ocean covers about three miles. The new focus is due in part to the earthquake as residents begin to contemplate other parts of the metropolis for the first time—areas that had been neglected, underutilized and sometimes even ridiculed as unlivable. The earthquake has spared most land north and west of Van Ness Avenue. Suddenly, Bernal Heights, Glen Park, the Richard District and even the wild and untamed Sunset look more attractive.

One obstacle to development are relics of San Francisco's past, namely thousands of dead buried on suddenly valuable land. In the first part of the twentieth century, the city gradually banishes public and private cemeteries to create room for commercial and residential expansion—the only metropolis in American history to evict all of its dead. The sprawling public City Cemetery, located on the edge of the Pacific Ocean and filled in large part by pauper graves, is controlled by the will of the government. More problematic are the four private cemeteries that comprise some 65 square city blocks (165 acres) on prime real estate in the center of the small city. Through a variety of resistance that includes referendums and lawsuits, an official eviction order by the city in 1913 takes almost twenty-five years to fully implement. Eventually, over 130,000 remains there are disinterred between the world wars to make room for housing, hospitals, offices, university expansion and retail stores. The Richmond District is no longer up-and-coming; it has arrived.

There is plenty of San Francisco terrain left to develop after World War I. The Sunset District remains a desert. Lake Merced is on the right. Fleishhacker Pool, one of the largest heated outdoor swimming facilities in the world, is at the lower left next to the Pacific Ocean.

Hardly a generation earlier, both public and private cemeteries are promoted in areas regarded as undevelopable. But conditions and ideas can change fast in an "instant city" milieu. City Cemetery area is transformed into the Legion of Honor Museum, spacious Lincoln Park Golf Course and the western end of Golden Gate Park. The approximately twenty thousand bodies buried in City Cemetery are ordered disinterred. Done with haste and a lack of planning, no one can say for certain how many are actually removed and relocated, but the majority of the remains remain today under the living pleasure grounds. The Presidio Army base military cemetery along the Pacific coast is spared only because it is federal land.

The private cemeteries are gradually relocated to Colma, a necropolis of seventeen separate burial grounds. The grandest is modeled after the classic East Coast garden cemeteries of the early nineteenth century, featuring rolling hills and wide roads in arboretum settings that also serve as public parks before such amenities exist. Cypress Lawn hosts many of the most prominent leaders of early California, some removed from San Francisco.

134

Tours are available. The 1,500 living residents of the necropolis adopts this phrase as its motto: "It's great to be alive in Colma."

Even in the 1920s and 1930s, it is hard to imagine that the far western section of the city approaching the Pacific, called the Sunset District—a virtual desert stretching to the Pacific Ocean—can ever be part of a thriving metropolis. The 1921 Hollywood blockbuster movie *White Sands* adopts that inhospitable terrain to double for the Sahara Desert. Early residents there see themselves as pioneers, venturing bravely into unforgiving terrain. They report swirling sand cyclones blowing through thresholds and covering yards and cars. There are few local amenities. The Point Lobos toll road to the Pacific Ocean—later called Geary Boulevard—is still straddled in the 1920s by chicken farms, dairy ranches, orphanages and hastily constructed homes and businesses that are sometimes cobbled together from decommissioned cable cars. The 1930s Depression years provide little improvement.

The automobile, made accessible to everyman at this time, eventually transforms the terrain. Today, Sunset Boulevard is a six-lane divided thoroughfare lined with stately homes. When introduced in 1931, it is surrounded by high, rugged sand dunes.

FUN AT THE END OF THE WORLD

After a backbreaking workweek that could stretch to sixty hours, residents can enjoy a leisurely Sabbath. How about a swim, a bath or just a spectator getaway at the Sutro Bath Pleasure Palace? Or a dance and dinner at the nearby Grand Pavilion? Prohibition is *shhh*...a wink and nod makes the liquor more fun (by Christmas 1933, it is legal again). Earlier, the city paves the Great Highway along the ocean and builds boardwalks that connect the beach to city streets. The area begs for more entertainment. Send in the clowns. Playland-at-the-Beach becomes a mega attraction in 1913, expands with the times and remains a favorite spot until an urban progress army of bulldozers plows it over for residential development in 1972.

What is Playland? More food concessions than you can count or eat your way through, ten fun-filled rides, some that propel your heart into your mouth, and one of the most popular thrills in amusement park history— Shoot-the-Shoots, where daring patrons board small boats for an ascent to the "summit," glimpse the far-off Farallon Islands and then descend in a screaming wet flash to a lagoon. There is the Funhouse with wacky mirrors

A lot of action squeezed into a compact space. Note the crowded parking at the edge of the sand.

Fun is what Playland is all about, circa 1940.

and the larger-than-life crazy Laughing Sal figure (who now has a second life in the Musée Méchanique at Fisherman's Wharf). The park opens at noon and goes til midnight. It is a great escape, especially during the Great Depression when many have no job to report to in the morning. Until the 1940s, most of the guests are adults.

Playland assaulted the senses. Activity and lights were everywhere. It sparkled with scenic vistas of every sort: rides flashing by, colorfully lighted exhibited, couples walking arm in arm and flocks of girls and guys stealing glances at each other. Machine vibrations rumbled up through your soles, thrumming against your chest, and the rides put your gut in your throat. The smells of fried chicken, cotton candy, kludge, grilled onions, popcorn, taffy, steamed dogs, tamales and caramel overwhelmed any sense of propriety in diet.

—*James Smith,* Playland at the Beach, The Early Years

Here are Pleasures to Rival Any to Be Found at Coney [Island]

—San Francisco Chronicle *headline, 1929*

FUN IN THE OLD CITY: FISHERMAN'S WHARF

The name Fisherman's Wharf is derived from the rush of Italian and Chinese immigrants to fish and feed the rush of early miners. Initially, they operate from the foot of Vallejo and Union. In 1900, the area between Taylor and Leavenworth streets along the Bay waterfront is designated for commercial fishing boats, relocating from the older harbor area.

Since the earliest days, fishermen sell parts of the catch directly from their sailing crafts to housewives and other retail customers. Some set up stalls on the piers to develop a regular market. By the mid-1920s, these outdoor venues, often including benches and tables, have become a staple of the Fisherman Wharf experience. Nunzio Alioto's fish stand Number 8 is booming, so in 1932 the Sicilian immigrant decides to open a countertop eatery to sell Dungeness crab and shrimp cocktail—the first restaurant establishment at Fisherman's Wharf. After Nunzio's death, his wife and three children debut the larger Alioto's 8 in 1938 with a full kitchen. Legend

has it that wife Rose creates cioppino, the city's iconic tomato-based fish stew. When the 1939 World's Fair officially declares Fisherman's Wharf as a tourist attraction, it brings the outside world to the restaurant, which is still thriving today.

The first outdoor vendor to install benches and tables to his fish stand, Tom Castagnola, in a moment of divine inspiration, devises a new seafood cocktail dish by adding a sauce he concocts using Thousand Island dressing to the Dungeness crab staple. The famed Crab Louie is born and morphs into the Crab Louie Salad, soon to be a signature Wharf dish; there are competing claims, some as far away as Seattle, for the invention of the Crab Louie Salad. At the very least, it first becomes a famed staple for the masses at Fisherman's Wharf. The other great historical Wharf treat is clam chowder in a hollowed-out sourdough bowl. The original and still the best of this delight can be found at Boudin Bakery at the Wharf, the first major commercial bakery to sell sourdough bread to the gold miners.

Each day in the early morning before the sun rises, the fishing boats rush for the catch and then race back to land to be the first to sell their fresh sea treasure.

Fisherman's Wharf is a colorful spot. A descent down the west slope of Telegraph Hill, to the foot of Taylor Street leads one to a bit of Neapolitan atmosphere....Both sides of Taylor are lined with fish stands of various sizes and architectural design. In front of each stands stand is stationed a strong-voiced barker, who extols the delights of his fish wares to the passer-by....Friday is the busiest day on Fisherman's Wharf....Hundreds of conscientious housewives drive their cars to the wharf to personally select crab, meat oysters, tempting strips of sole tenderloin and gifts of the sea for hungry husbands and children....Italians from all over America eventually find their way to San Francisco....For it is here that they find, as many have told us—"da sun, she is warmer, ju-ust likka inna da olda countree!"

—*Henriette Horak*, San Francisco Chronicle, *1935*

What eventually becomes the Red and White Fleet at Fisherman's Wharf begins maritime operation in 1892, taking goods and workers across the Bay. Enterprising young Thomas Crowley expands his operations with gas-powered vessels and moves into the tugboat business. His maritime fleet plays an important role in the 1906 earthquake recovery. During the 1915 Panama Pacific International Exposition, Crowley offers excursions on the

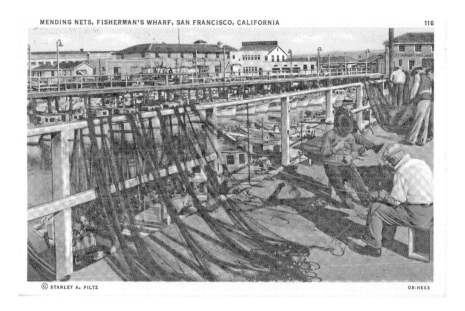

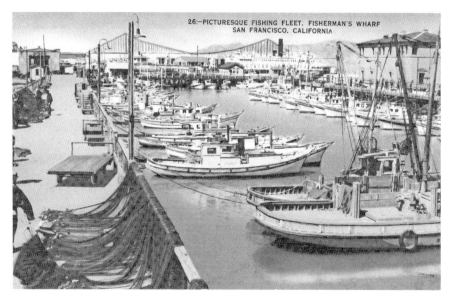

These romantic 1930s views of Fisherman's Wharf are not very different from the present-day romance of the same little spot.

San Francisco Bay to visitors—the first established sightseeing water venues. By the 1930s, a regular tourist touring tradition has developed, enhanced by the Bay bridges and the Treasure Island Fair. This is the origin of the Red and White Fleet's popular Golden Gate Bay Cruise.

TALE OF TWO BRIDGES

The long-imagined vision of concrete thoroughfares connecting San Francisco to the East Bay and Marin is completed in the mid-1930s during the worst of economic times, financed by bridge bonds issued by the State of California. Many California bankers are hesitant to take the risk. A.P. Giannini's Bank of American leads the rescue.

> *The Golden Gate Bridge is a global icon, a triumph of engineering, and a work of art....Like the Pantheon, the Golden Gate Bridge seems Platonic in its perfections...a natural, even an inevitable, entity as well, like the final movement of Beethoven's Ninth. In its American context, taken historically, the Bridge aligns with the thoughts of Jonathan Edwards, Ralph Waldo Emerson, and other transcendentalists in presenting an icon of transcendence: a defiance of time pointing to more elusive realities...a fusion of material and trans-material forces, held in delicate equipoise.*
>
> —*Kevin Starr, California historian, waxing poetic*

> *The Golden Gate Bridge's daily strip tease from enveloping stoles of mist to full frontal glory is the most provocative show in town.*
>
> —*Mary Moore Mason, travel journalist, waxing lusty*

Marin and the major counties to the north—Napa, Sonoma and Mendocino comprise the budding wine-producing regions—are sparsely populated with no major highway leading to the enclaves. Property owners and businesspeople lobby long and hard for a Bay crossing that is sometimes called the "Golden Goose" Bridge for the imagined riches that will flow when decent roads inspired by the bridge reach the vineyards and towns of the northern counties. But not all share that vision.

4,200 feet between towers the Golden Gate Bridge presents the world's longest span.

When you have one of the most romantic approaches in all geography why spoil it? Let the landowners of lovely Marin stew in their own juice. Make the Sausalito ferry a "floating place," beguile the half-hour journey with every vulgar pleasure; subsidize the communities if necessary, but in the interest of your own uniqueness, dear San Francisco, do not bridge the Golden Gate.

—*Katherine Gerould, writer, circa 1930*

DID YOU KNOW? GOLDEN GATE BRIDGE FACTS

- Just three months before the opening of the Golden Gate Bridge, ten men are killed when a large piece of scaffolding breaks and the safety net below collapses from the weight. Only one other worker loses his life in the four-plus years of construction. However, nineteen men at various times plummet from the bridge but are caught by the safety nets. These daredevils organize an exclusive group: The Half Way to Hell Club.
- The U.S. War Department wants the bridge painted in yellow and black stripes to increase its visibility to ships. U.S. Air Corps

asked for red and white stripes. Bridge architect Irving Morrow prevails, and the distinctive orange remains to this day.

- You are not allowed to cross the bridge on horseback.
- Fitness guru Jack LaLanne swims the length of the bridge in 1954 with 140 pounds of equipment strapped to his back.
- Three babies are born on the bridge…and counting.
- In 1987, 50,000 people are anticipated for the bridge's fiftieth anniversary celebration. About 800,000 show up, causing the bridge to sag ten feet and sway. It is the largest load ever put on the span and almost leads to mass panic.
- For being the one-billionth car to cross the bridge in 1985, a local dentist receives a case of champagne and a hard hat.
- When built, it is the longest single-span suspension bridge in the world. The Golden Gate Bridge currently ranks as number nine.

The idea of a Bay bridge connecting San Francisco to Oakland has been entertained since the gold rush.

Mad Emperor Norton laid down his check for $3.5 million and ordered the Mayor of San Francisco: "Build the bay bridge." San Francisco grinned at the madman's command.

—Mrs. Fremont Older, writer and wife of Fremont Older, San Francisco journalist. Emperor Norton is a popular and celebrated San Francisco "street" eccentric who is the self-proclaimed emperor of the United States and protector of Mexico.

WHEREAS, we issued our decree ordering the citizens of San Francisco and Oakland to appropriate funds for the survey of a suspension bridge from Oakland Point; also for a tunnel; and to ascertain which is the best project; and whereas the said citizens have hitherto neglected to notice our said decree; and whereas we are determined our authority shall be fully respected; now, therefore, we do hereby command the arrest by the army of both the Boards of City Fathers if they persist in neglecting our decrees.

Given under our royal hand and seal at San Francisco, this 17th day of September, 1872.

—official proclamation of Emperor Norton

Bay Bridge in progress.

No less significant but not as celebrated, the much longer Bay Bridge spans eight miles connecting the city to the already well-populated east and serves many times the traffic volume of the Golden Gate Bridge. At the time, the sea highway to Oakland traverses the deepest body of water yet spanned and calls for the deepest foundations ever built.

> [The Bay Bridge] *was the greatest expenditure of funds ever used for the construction a single structure in the history of man.*
>
> —*Father John McGloin, historian*

> *This marks the physical beginning of the greatest bridge ever erected by the human race.*
>
> —*former president Herbert Hoover, a civil engineer by training, 1933, on the effort to build the Bay Bridge*

TALE OF THREE ISLANDS

To a certain extent the loss of the paperwork for immigration in San Francisco in April 1906 represented a kind of wholesale amnesty for the Chinese.

—*Kevin Starr, historian*

ANGEL ISLAND

Angel Island, three miles off the San Francisco coast, is designated as a military preserve in 1850. In 1910, part of the island begins to serve another purpose. Hostility to the Chinese in California pushes Congress in 1882 to pass the Chinese Exclusion Act, which allows entry only to those who have been born in the United States or have husbands or fathers who are currently citizens. Some Chinese residing here are deported as a result of the new law.

When the 1906 earthquake destroys virtually all the city immigration records, most Chinese men in San Francisco assert citizenship—now impossible to refute legally—and send for their relatives in China. A steady stream of mainland Chinese begins a migration to the city, claiming automatic citizenship under the provisions of the Chinese Exclusion Act, a consequence that is the opposite of its intention. Proving paternal linage can be complex, often requiring numerous documents. This is the origin of the phrases *paper sons* and *paper families*. To compound the issue, some enter with contrived documents and coaching books to negotiate grueling interviews. When American immigration authorities uncover that ruse, and the number trying to enter mushrooms, the immigration station is moved from a ramshackle set of buildings in the city to the more isolated and spacious station on Angel Island.

Eventually, more than 175,000 Chinese immigrant prospects are processed there. The island compound houses large dormitories and a five-hundred-bed hospital. Average detention is two weeks; the longest on record is twenty months. Conditions on Angel Island are harsh. Families are isolated, separated and interrogated in great detail. Until 1940, every immigrant from Asia is brought to Angel Island. People arrive from eighty-four different countries. Chinese immigrants constitute the single largest ethnic group until 1915, when they are outnumbered by Japanese; overall, more than 70 percent of the immigrants detained on Angel Island are Chinese. The

Chinese Exclusion Act is repealed in 1943, when China becomes a U.S. ally in World War II. Today, Angel Island is a popular destination for locals and tourists. In 1955, the California State Parks Commission purchases thirty-eight acres, and Angel Island State Park is established for biking, picnicking, camping and hiking.

ALCATRAZ ISLAND

It is called America's "Devil Island." A twenty-two-acre patch barely a mile offshore of San Francisco is originally an American military fortress, then a military prison; in 1934, it is redesigned as a super maximum-security escape-proof federal facility. Nicknamed "The Rock," it houses what are considered the worst of the worst—notorious bank robbers and murderers, including Al Capone, "Machine Gun" Kelly and "Baby Face" Nelson. Although he could never be convicted for more than income tax evasion, it is enough to get Al Capone off the streets. Bad guys are never sentenced directly to Alcatraz but rather have to "earn" their way onto the island through bad behavior at another federal institution.

Alcatraz Island in the picturesque good old pre–Alcatraz Penitentiary days. It is always a garrison/prison in some form.

At most American maximum-security prisons at the time, there is one guard per twenty-five inmates. At Alcatraz, the ratio is one guard per three. For the first six years of Alcatraz, the new warden, proving his steel, forbids any communication among prisoners. Solitary confinement in the Hole, consisting of an unlit room with no cot, is an oft-practiced punishment.

> *Alcatraz is not like any other prison in the United States. Here, every inmate is confined ALONE....to an individual cell. Unlike my predecessors, Wardens Johnson and Blackwell, I don't have good conduct programs, I do not have inmate counsels. Inmates here have no say in what they do; they do as they're told. You're not permitted to have newspapers or magazines carrying news; knowledge of the outside world is, ah, what we tell you. From this day on, your world will be everything that happens in this building...Alcatraz was built to keep all the rotten eggs in one basket, and I was specially chosen to make sure that the stink from the basket does not escape.*
>
> —*Paul J. Madigan, last warden of Alcatraz, circa 1960*

ALCATRAZ: BY THE NUMBERS

14: escape attempts
36: total prisoners who attempt to escape
23: caught alive during escape
6: shot and killed during escape
5: missing or presumed drowned during escape
2: convicts who dared twice
2: convicts drowned and recovered

Although San Francisco Bay does have sharks, the majority are small species such as the Brown Smooth Hound and Leopard varieties that average only a few feet in length and almost never attack people. Alcatraz guards and other personnel later admit to deliberately exaggerating the human threat from sharks in the Bay to inhibit prison breaks. More subtle methods to discourage escape are implemented. Federal prisons typically mandate inmates a two-thousand-calorie daily diet; Alcatraz permits almost twice that amount. The ration for hot water at federal prisons is relaxed; in fact, only hot water is allowed, and long showers are tolerated. There

is logic to the benevolence—pudgy, out-of-shape inmates unaccustomed to frigid Bay water temperatures are less likely to make it to shore in any escape attempts.

During Alcatraz's twenty-nine years of operation, penitentiary officials maintain that no prisoner successfully escapes. However, three of the "missing and presumed drowned" might well have lived to tell the tale. On a summer night in 1962, Frank Lee Morris and brothers John and Clarence Anglin slip off the island in a makeshift dinghy. Though the prisoners are never captured, officials report that they are presumed dead—no remains are uncovered. The caper is enshrined in a book and later the Clint Eastwood movie *Escape from Alcatraz*.

> *A New York newspaper back in town to do a Sunday supplement about last year's Alcatraz escape, received this confidential word from an official: "At this point we have no alternative but to assume that all three made it."... Actor Sterling Hayden, who lives in nearby Belvedere, got so excited over the trios derring-do that every night for a week he left his Volkswagen parked on the pier nearest Alcatraz with the keys in the car and peanut butter sandwiches on the seat.*
>
> —Herb Caen, 1963

On May 2, 1946, a prisoner grabs a gun from a guard, takes twenty more guards hostage and then flips a master switch that springs all the prison cell doors. Hellish chaos erupts, and the Battle of Alcatraz begins. Fearing a mass escape, additional guards and eighty-five marines armed with rifle grenades are rushed to the island. Under a relentless barrage of ordinance, prisoners surrender—but only after five days of hunkering resistance. Big crowds gather along at Fishermen's Wharf to watch the reality show. Two guards and three prisoners are killed in the incident. The astonishing array of ammunition holes pockmarking the walls and ceiling is a popular feature of present-day Alcatraz tours.

TREASURE ISLAND

It was a kind of movie set a la Shangri-La as Busby Berkeley might have seen it. The highlights were grandly named: the Statue of Pacifica, the

Court of the Moon, the Tower of Sun, and ninety-foot Arch of Triumph symbolizing who knew what?

—Tom Coles, San Francisco historian

These architectural colors and style drawn from all Pacific continents freely adapted and generously flavored with Art Deco and other tastes of the decade, resulted in a Fair that was madly eclectic.

—Patricia Carpenter and Paul Totha, historians

Remember Treasure Island fondly—not as the drab naval base that it later became, but as the a veritable "fairy land of lights," as it was during the Golden Gate International Exposition.

—Herb Caen

It is more carnival than exposition. Unlike the 1915 Panama Pacific International Exposition that is aesthetically elegant and makes money as it proclaims the momentous opening of Panama Canal, the grandiosely named Golden Gate International Exposition is a rambling hodgepodge of exhibitions, finishes in the red and competes with the more acclaimed 1939 New York World's Fair. The event celebrates as its official theme a vague Pacific Unity that does not exist and explodes into World War II in the midst of the exposition, causing some countries to close their exhibitions. It should be noted that the same fate hits the Panama Pacific Exhibition when the world marches to war in 1914. The 1939–40 exposition does showcase the opening of two local "wonders of the world," the Golden Gate and Bay Bridges but, with all due respect, they fall short of the international gravitas of the Panama Canal.

So-called Treasure Island is a monumental project—the creation of separate landmass adjacent to Yerba Buena Island. Transported to the four-hundred-acre site are 4,800 full-grown palm trees and over a million flowers. Its Madison Avenue name is invented from the claim that soil pumped from the Bay to fill the island contains original 1849 Mother Lode gold washed down from the Sierra streams. Early publicity photos show miners panning for gold on the brand-new island.

The Treasure Island Fair is sometimes regarded as a glorified "girlee show." The main midway is named "The Gayway," which in those bygone days connotes a red-light district. Barkers entice patrons to famed fan dancer Sally Rand's "Nude Ranch." The *Follies Bergeres*, which needs little barking, features female dancers in various forms of undress, including totally nude; the Follies 3,500-seat venue is sold out every night. At an "educational" exhibit, patrons can observe artists painting naked models. The most popular and moneymaking show is the Billy Rose Aquacade, boasting a cast of 250 with the spotlight on a voluptuous eighteen-year-old Esther Williams teaming with Johnny Weissmuller aka Tarzan in a sensuous duet swimming display surrounded by bathing suit–clad young ladies gyrating to music. The event structure holds 16,000. People are turned away every night.

> *Maybe he took that jungle character a little too seriously....He was always right behind me, that big smile on his face, those groping hands—three shows a day, six days a week.*
>
> —*Esther Williams, soon to be a Hollywood star, reminiscing on her Treasure Island Fair days with Weissmuller, who is twice her age and weight.*

> *Whenever business started slacking* [at the Nude Ranch] *there would be another big raid....The police would roar up and everybody on the whole Island would come rushing over to see what was going on. The police would close the place down, and it would be in the papers that Sally was busted. The next morning it was business as usual. In fact, more business than usual.*
>
> —*Kathryn Ayres, historian*

Sally's girls begin as topless, but after complaints, they are covered by skimpy bandanas around the neck. The *Follies Bergeres* shows even more, but this was "French" and thus acceptable. In the first six days of operation, the Nude Ranch draws 63,449 customers.

The new island will be the San Francisco International Airport following the exposition, officials proclaim. When the Japanese attack Pearl Harbor, the city promptly sells the property to the U.S. Navy for one dollar. It remains federal property until 1997, when the federal government deeds

SAN FRANCISCO BAY BRIDGE SHOWING TREASURE ISLAND, SAN FRANCISCO, CALIF.—8

Treasure Island, conjured up for the San Francisco World's Fair in 1939, is slated to be the site of the new city airport until World War II scuttles those plans. Today, it is a "frontier settlement" of some 3,500 and growing with great expectations.

it back to the city. It is slowly being developed for mixed residential and commercial use.

THE GREAT DEPRESSION

San Francisco is partially cushioned from hard times in the 1930s by substantial jobs programs for the Golden Gate and Bay Bridges, as well as employment opportunities at the Treasure Island Fair. Additional young men are put to work in the massive removal of some seventy-five thousand bodies from old San Francisco burial grounds to Holy Cross and Cypress Lawn Cemeteries in Colma, nine miles to the south. Coit Tower, another project that contributes to local pockets, is built in 1933 from funds willed "to beautify the city I love" by heiress and firefighter aficionado Lillie Hitchcock Coit. The task falls to celebrated architect and friend Albert Brown, who also designs her mausoleum and is buried next to "Firebelle Lil" at Cypress Lawn Cemetery. The 210-foot monument in the shape of a fire hose capped by a nozzle can be ascended by stairs. Dozens of federally funded artists, inspired by renowned Mexican muralist Diego Rivera, decorate the walls with depictions of the working class.

In 1934, one of largest and most significant labor events of the decade ignites on San Francisco docks and spreads like wildfire up and down the Pacific coast, turning into the largest maritime strike in American history to that time. It is violent. On July 5, thousands of angry workers confront strikebreakers and the police. When the tear gas clears, two strikers are dead and sixty-four wounded. The day goes down in history as "Bloody Thursday." In response, the unions declare a general strike, paralyzing the city. Even before the call, over thirty thousand workers walk out, including teamsters, butchers, laundry workers and more. An arbitrated agreement ends the action a few days later. Labor has flexed its muscle and achieves most of its goals.

THE INTERNMENT

Yesterday, December 7, 1941—a date which will live in infamy—the United States of America was suddenly and deliberately attacked by naval and air forces of the Empire of Japan. The United States was at peace with that nation.

—President Franklin Roosevelt's address to Congress on December 8, 1941, declaring war on Japan

The massive Japanese assault on Pearl Harbor virtually destroys the American Pacific naval fleet. But it is hardly the start of war preparations in San Francisco. There is clear fear of an "Asian front" for at last a year before what the president characterizes in his address as an "unprovoked and dastardly attack." Pearl Harbor ignites the smoldering tinderbox.

You people do not seem to realize we are at war. So get this: last night there were planes over this community! They were enemy planes—I mean Japanese planes.

—Lieutenant General John DeWitt, Western Reserve commander, December 8, 1941, to San Francisco mayor Angelo Rossi. One of the army's few three-star generals, DeWitt is the senior commander in the West—the person responsible for the defense of the 1,300-mile coastal territory of Pacific states plus the six-thousand-plus-mile coastline of

the territory of Alaska. On the same day, San Francisco establishes a Civilian Defense Council, and the first air raid practice and blackout are conducted.

An Enemy Will Attack the Golden Gate Bridge

—San Francisco Chronicle *article headline, November 28, 1941, eight days before Pearl Harbor*

There is concern, verging on hysteria, that a Japanese fifth column residing on the West Coast could be part of such an attack by providing information and sabotage. Germany has cultivated fifth-column movements for invasions of surrounding countries, where locals sympathetic to Nazis have aided and abetted the takeover of their lands. In retrospect, the momentous decision to remove all Japanese residing on the West Coast to interior internment camps is widely criticized, but it is less controversial at the time. The drumbeat begins before Pearl Harbor.

Three days after Pearl Harbor, U.S. Treasury agents report that an estimated 20,000 Japanese in the San Francisco metropolitan area "were ready for organized action." There are an estimated 120,000 Japanese living along the West Coast.

In the war in which we are now engaged, racial affinities are not severed by migration [to the United States]. *Sabotage, naval action and air raids will be assisted by enemy agents signaled from the coastline.*

—General DeWitt to the U.S. War Department, February 14, 1942

In his final report on the evacuation/internment in 1943, he contends that thousands of American-born Japanese have recently traveled to Japan, where they receive indoctrination and then return to the United States with the intention to help their ancestral land. The general is regarded as a key figure in the military strategy in California. Before Pearl Harbor, he advocates a more moderate posture against Japanese sabotage on the West Coast, but the shock of December 7 pushes him to embrace wholesale internment.

Many Americans voice opposition to such a comprehensive approach. But elected officials, with whatever reluctance, generally endorse the plan. Public opinion after Pearl Harbor jumps on board.

We recommend the immediate evacuation of all persons of Japanese lineage and all others, aliens and citizens alike, whose presence shall be deemed dangerous or inimical to the defense of the United States from all strategic areas.

—*every member of Congress from California, Oregon and Washington in a letter to President Roosevelt, February 14, 1942. California governor Culbert Olson concurs.*

On February 19, 1942, the president signs the order that authorizes the secretary of war to designate military war zones "from which any or all personnel may be excluded." The first Greyhound bus transporting Japanese from the city arrives at the Tanforan Racetrack in San Bruno, twelve miles south of San Francisco, on April 27, 1942. The camp is at capacity (7,816) two weeks later, but it takes almost six months to transport the detainees to interior relocation camps. Conditions at Tanforan are makeshift at best. The living quarters are converted horse stables. The food, furnishings and sanitary facilities are generally described as inadequate, sometimes dismal.

It is fair and reasonable to ask if such a national defense position should have taken a more moderate, nuanced and balanced approach rather than an indiscriminate dragnet of suspicion. Many argue against mass relocation at the time, recommending instead increased surveillance on already suspected individuals, a focus on alien Japanese rather than citizens and an exemption for all under the age of fourteen. No less a patriot than J. Edgar Hoover, director of the FBI, describes General DeWitt's plan as "hysteria and lacking of judgment." Francis Biddle, FDR's attorney general, lobbies hard against evacuation. But moderate voices are drowned out by fear of the first war on American territory since 1812. Public opinion after Pearl Harbor, fed by historic anti-Asian sentiment, supports radical action.

Prominent figures at the time veered all over the spectrum on the issue, often changing or nuancing their positions, as well as contradicting what one might have expected from them. It is a strange historical moment that "tries men's souls" and produces "odd bedfellows." An opinion that has one of the greatest effects on the debate comes from a highly respected journalist regarded as the voice of responsibility and liberalism. He is neither a politician nor a military figure and has the ear of President Franklin Roosevelt.

The Pacific Coast is in imminent danger of a combined attack from within and without....There is the assumption that if the rights of a citizen are abridged anywhere they have been everywhere.....Nobody's constitutional right include the right to reside and do business on a battlefield.

—*Walter Lippmann, February 13, 1942*

You've got to realize they bombed Pearl Harbor, so we thought there might be battleships coming over here and airplanes carriers, and all of our ships were destroyed at Pearl Harbor. We were afraid that the next bombing could be San Francisco or Los Angeles. It was a very frightening period. We weren't mobilized for the war, weren't prepared in any way, shape or form.

—*Pat Brown, former governor of California, reminiscing on the early war days, 1987*

In the end, 120,313 people of Japanese ancestry are forcibly removed from California, Washington and Oregon to interior locations. Approximately two-thirds were U.S. citizens.

<p style="text-align:center">6</p>

A Place Like No Other

Tell me why does San Francisco
Just like a lover's kiss go
Straight to my brain?

—*Carmen McRae,* I'm Always Drunk in San Francisco

The United Nations was founded at Sally Stanford's whorehouse.

—*Herb Caen, 1946. The* San Francisco Chronicle *columnist wins fame and a Pulitzer Prize. Frances Ford Coppola calls him "the voice and soul of San Francisco." San Francisco is chosen as the host for the founding of the United Nations in 1945. Delegates and some 2,500 journalists stream in from all over the world for the three-month event. From 1940*

to 1949, Sally Stanford is madam of a swank and celebrated Nob Hill bordello at 1144 Pine Street.

I was determined to have the most beautiful, elegant, grand temple of love....I appealed to every taste....Every room and every floor was different. One whole floor was designed and decorated as an exclusive hunting lodge. The Pompeian Court with its fountain, fireplace and pools has been described as breathtaking. The Oriental, Italian, French Provincial, and Venetian Renaissance rooms were decorated with the finest antiques, glorious and plush draperies and carpets....Soft music was piped throughout. Food, prepared exquisitely and served with fabulous vintage wines, was the order of the day.

—Sally Stanford

It is no wonder that some United Nations delegates in the still patriarchal mid-twentieth century, many from Old World cultures, feel at home in the luxurious milieu. One can converse more frankly and comfortably there than in more institutional settings, especially when loosened up by one-hundred-year-old cognac.

Russian, Chinese, Czech, English, Norwegian, and Mexican delegates found their way and felt very much at home. But it was the Arabians, Hindus, Egyptians and the Pakistani that were the attention grabbers. What a colorful bunch of stallions these!

—Sally Stanford

Every man should be allowed to love two cities, his own and San Francisco.

—Gene Fowler, journalist, circa 1950

San Francisco is a city where people are never anymore abroad than when they are at home.

—Benjamin Taylor, journalist, 1875

I'm just mad for San Francisco. It looks like London and Paris all stacked on top of each other.

—Twiggy, international model, 1965

San Francisco is one of the cultural plateaus of the world, one of the really urbane communities in the United States...a truly cosmopolitan place—and for many, many years, it always had a warm welcome for human beings from all over the world.

—Duke Ellington, jazz musician

We're crazy 'bout this city. Los Angeles? That's just a big parking lot where you buy a hamburger for the trip to San Francisco.

—John Lennon, visiting the city with Yoko Ono in 1972. They rave about the beauty of San Francisco, the ambiance of the neighborhoods and how "at home" they feel here. Young journalist Geraldo Rivera reports on the trip.

Anyone who doesn't have a great time in San Francisco is pretty much dead to me. You go there as a snarky New Yorker thinking it's politically correct, it's crunchy granola, it's vegetarianism, and it surprises you every time. It's a two-fisted drinking town, a carnivorous meat-eating town, it's dirty and nasty and wonderful.

—Anthony Bourdain, television travel food host

If you're not alive, San Francisco will bring you to life. You may be a fool for a week or two, but nobody will notice since everybody else has been a fool too, and is likely to be a fool again. San Francisco is a world to explore. It is a place where the heart can go on a delightful adventure. It is a city in which the spirit can know refreshment every day.

—William Saroyan, novelist and playwright, 1985

Cities are like gentlemen, they are born, not made. You are either a city or you are not, size has nothing to do with it. I bet San Francisco was a city from the very first time it had a dozen settlers. New York is "Yokel," but San Francisco is a "City at Heart."

—*Will Rogers, satirist, circa 1930*

Two days in this city is worth two months in New York.

—*Robert Menzies, prime minister of Australia, 1965*

I love this city. If I am elected, I'll move the White House to San Francisco.

—*Robert Kennedy, 1963*

Leaving San Francisco is like saying goodbye to an old sweetheart. You want to linger as long as possible.

—*Walter Cronkite, circa 1980*

It has the quality of a fairy tale.

—*Elizabeth Bowen, British novelist, circa 1960*

THE CITY LOVED AROUND THE WORLD

THE Pride of the West!
The Gem of the Sea!
The City that Is!
The City to Be!
Where the ship "Content" her sails has furled;
The City Loved Around the World!
San Francisco!

JAMES HENRY MacLAFFERTY

COPYRIGHT APPLIED FOR.

An ode to the city, circa 1910.

In 1965, the largest tourist attraction in the western United States is San Francisco. Disneyland is second.

Then there is the famous San Francisco weather.

AVERAGE HIGH-LOW MONTHLY TEMPERATURES IN SAN FRANCISCO

January: 57/46
February: 60/48
March: 62/49
April: 63/49
May: 64/51
June: 66/53
July: 67/54
August: 68/55
September: 70/55
October: 69/54
November 63/50
December: 57/46

The coldest winter I ever spent was a summer in San Francisco.

—Mark Twain often gets credit for this witticism, but he never actually penned those words.

To a Traveler paying his first visit, it has the interest of a new planet. It ignores meteorological laws which govern the rest of the world.

—Fitz Hugh Ludlow, travel writer, circa 1960

Ah, San Francisco. Whenever we start getting perfect football weather… you can tell that baseball season is about to begin.

—Herb Caen

There is on earth nothing exactly like the fog of San Francisco Bay…the damndest finest fog in the world.…While it sometimes chills the bones of

thinly-clad summer tourists, San Franciscans love the fog because it keeps the city cool during the summer....San Franciscans are temperamentally and constitutionally not acclimated to hot weather. When the mercury hits 80, the natives begin to wilt. If it stays, they get mad.

—Bernard Averbuch, San Francisco writer, 1973

Whosoever after due and proper warning shall be heard to utter the abominable word "Frisco," which has no linguistic or other warrant, shall be deemed guilty of a High Misdemeanor, and shall pay into the Imperial Treasury as penalty the sum of twenty-five dollars.

—Emperor Norton, the quintessential San Francisco eccentric, circa 1870

May I boil in oil
And fry in Crisco
If I ever call
San Francisco 'Frisco

—Ogden Nash, poet, 1940

When I was a child growing up in Salinas we called San Francisco "the City." Of course it was the only city we knew, but I still think of it as the City, and so does everyone else who has ever associated with it. A strange and exclusive work is "city." Besides San Francisco, only small sections of London and Rome stay in the mind as the City. New Yorkers say they are going to town. Paris has no title but Paris. Mexico City is the Capital.... In a way I felt I owned the City as much as it owned me.

—John Steinbeck, novelist, 1937

San Francisco is the only heavily populated area from the Canadian border to the Mexican border that is known as "The City."

—Chester MacPhee, member of the Board of Supervisors and chief executive officer of San Francisco, circa 1960

Even in adolescence, San Francisco is a tourist mecca. By the 1870s, this tiny ink spot on a distant coast has cobbled together a stable population and unparalleled amenities. Its reputation as the great and only place to re-create in the West becomes legendary. American TV Westerns of the 1950s portray the early city as an accessible luxury. From cowboys and criminals to dandies and dance hall girls, there is constant chatter under the cactus about coming from or going to a San Francisco of riches, glamour and escape from the endless mundane where the chuck wagon and antelope roam.

But until the mid-twentieth century, the destination remains relatively remote and isolated from most of the country. Commercial aviation is still in its infancy and for the hoity toity. It takes five days and nights to travel by rail from the East Coast. The modern national highway system is yet to be built, and before 1936, no bridges connect San Francisco to the north or east. World War II transforms that reality as quickly as the gold rush. There are 101,000 wage earners in the city in 1941; two years later, that number almost triples. New shipyards blossom around the Bay. Tiny Sausalito, three miles north of the San Francisco, welcomes an astonishing 90,000 workers at its Marin facility. Through aggressive advertising, Hunters Point Naval Shipyard in San Francisco attracts thousands of new employees, many of them African Americans who have never been outside the South.

SAN FRANCISCO-OAKLAND BAY BRIDGE, SAN FRANCISCO, CALIF. EAST BAY SHORE IN DISTANCE

© STANLEY A. PILTZ

Everything's up to date in San Francisco. The modern cosmopolitan skyline in the 1950s.

The city was changing [in 1946]. *It used to be like an island sort of cut off from reality, cut off from the world. Before the bridges were built and it was a foggy night it really felt like you were out in the ocean and only a ferryboat could connect you to the mainland. The bridges changed that and then the war changed it even more by bringing thousands of people through the city who never realized what a lovely little secret we had here, so back they came by the thousands.*

—*Herb Caen, 1946*

REBEL WITH A CAUSE: 1950s

San Francisco's raucous and radical character in the 1960s and beyond is developing its "sea legs" in the buttoned-down 1950s.

I know there are strong sentimental reasons for this old, ingenious and novel mode of transportation....The fact remains that the sentimentalists do not have to pay the bills.

—*San Francisco mayor Roger Lapham, 1947, announcing the retirement of the historic cable car system that began operation seven decades earlier*

As soon as the city moves to modernize its transportation by replacing the noisy rattle of crumbling, inefficient cable cars with state-of-the-art diesel buses, spirited opposition and street demonstrations erupt. It begins in the most benign and aristocratic manner when one Friedel Klussmann, a member of San Francisco society, respectfully forms the Committee to Save the Cable Cars and the San Francisco Beautiful movements in 1947. Ultimately, the rebellion results in three of the original eight cable car lines remaining in operation to this day.

Anyone attempting to fool with the cable cars in any shape or form is apt to be run out of town on a spike.

—*Mayor George Moscone, 1976*

When Klussmann dies at age ninety, cable cars are appropriately decorated in black in her memory. Later, the city dedicates the turntable at the terminal of the Powell-Hyde line to the unlikely activist.

The cable car revolt coincides with the freeway revolt. President Eisenhower promotes a grand interlocking national highway system to connect the continent. The audacious plan will facilitate commerce, promote suburban development, decongest traffic-clogged cities, enhance tourism and energize the economy with jobs. What's not to like? Large urban areas jump on the bandwagon. The San Francisco Planning Department announces a bold design for ten freeways crisscrossing the city. The two recently built bridges connecting the city to Oakland and Marin are to be accessed via a freeway along the Embarcadero waterfront. Similar thoroughfares will extend into the middle and western parts of the city—the Richmond and Sunset neighborhoods—and smack down the middle of the Golden Gate Panhandle to an eight-lane "Great Highway" colossus flowing into another freeway along the Pacific shore. The project plans to cut the Sunset in half and eliminate Junipero Serra Boulevard. Some hundreds of homes must be displaced for the greater good. The "Crosstown Freeway" will transverse through the Glen Park neighborhood, removing about 120 homes and businesses as it "re-landscapes" the rural Glen Canyon oasis. Most of Mission Street is to be converted to freeway use. Again, numerous structures are scheduled for removal.

Governor Pat Brown, a native San Franciscan, turns the idea into a personal crusade. Some natives call him a "traitor."

While the asphalt jungle is cheered by most local civic and business leaders, the proposals are vigorously criticized by a broad coalition of local interests. As with the cable car, the resistance is initially led by society women.

> *Come and learn how Glen Park District will be destroyed.*
>
> —*Hermini "Minnie" Straub Baxter, lifelong Glen Park resident, in a flyer inviting residents to an anti-freeway meeting in 1958*

> *It was the first opposition to the post–World War II national consensus on automobiles, freeways, and suburbanization.*
>
> —*Chris Carlsson, historian, on the local reaction to the San Francisco new urban master strategy*

The less controversial parts of the plan are quickly completed—the Bayshore (101) and Southern Freeways (280). But then the opposition flexes its muscle, especially against projects that will extend north of Market Street and into their backyards. In 1959, neighborhood petitions are piled on Board of Supervisors' desks to cancel seven of the proposed ten freeways. One petition requires the halt of the Embarcadero in mid-track, for which over a mile of construction is complete. The Board of Supervisors votes on the issue presented in various forms three times in seven years. All the votes are close but all in favor of protestors' positions. Even fear of losing several hundred millions in dollars in federal financing for the city's highways is pushed aside in a concession to neighborhood activists. The Department of Highways and the state government are aghast. The stopped-in-construction Embarcadero Freeway juts out like a concrete ruin until it meets a generally welcome and ignoble demise in the 1989 Loma Prieta earthquake that weakens enough of the span to warrant demolishment. It leads to the "open space" Embarcadero we enjoy today. Herb Caen, always the wordsmith, calls the downtown waterfront freeway the "Damnbarcadero."

The rejection of the freeways goes hand-in-hand for support of the BART (Bay Area Rapid Transit System) project that debuts in 1972.

There will be a freeway on the moon before we get one in San Francisco.

—*San Francisco mayor John Shelley, 1966*

A MAD CITY WITH PERFECTLY INSANE PEOPLE...REDUX...REDUX

San Francisco is forty-nine square miles surrounded by reality.

—*Paul Kantner, founder of the San Francisco rock band*
Jefferson Airplane

On its surface San Francisco evokes a genteel, aristocratic image; underground, it breeds the volatile rebelliousness than has given birth to the most revolutionary social and cultural movements of the past two generations.

—*Thomas Albright,* Art in the San Francisco Bay Area: 1945–
1980, *describing what he calls the "split personality" of the city*

*The Bay Area seems to give people permission to experiment, to go crazy, try
something new, then the ideas get packaged by the media in New York and
are sent as myths to the rest of the country.*

—*Jerry Rubin, 1960s anti-establishment leader who rejoins the
mainstream as a successful stockbroker, 1987*

*It is very easy to believe that everyone you meet there is also a space traveler.
Starting a new religion for you is just their way of saying "hi." Until
you've settled in and got the hang of the place it's best to say "no" to three
questions out of any given four anyone may ask you, because there are some
very strange things going on there, some of which an unsuspecting alien
could die of.*

—*Douglas Adams, author of* Hitchhiker's Guide to the Galaxy,
circa 1980

*San Francisco is a complex town that lets you be yourself, that accepts you
even if your family doesn't. No matter how uncomfortable your own skin
feels, you can move to this city, discover who you really are, and plant your
feet on the ground.*

—*Jack Boulware, writer, circa 1980*

San Francisco is one of the most obscene cities in the United States.

—*Reverend O.G. Armstrong, speaking at the Baptist Convention in
Springfield, Ohio, 1965*

THE BEAT GOES ON

I saw the best minds of my generation destroyed by madness...

—*Allen Ginsberg, opening line of the poem* Howl, *1955,*
first read in San Francisco

While some are tilting against buses and freeways, others focus on larger issues like existential angst and the condition of Western Civilization. Mass culture, crass materialism and boorish conformity are the symptoms. Capitalism is the culprit, and the United States is the root of the problem. The disaffected gravitate to North Beach. How did this tiny Italian enclave, surrounded by Fisherman's Wharf, Chinatown and the Financial District come to harbor so much rebellious energy and significance? Some 1950s devotees are natives, but many are East Coast transplants attracted to San Francisco by its bohemian traditions. New York's Greenwich Village thrives as well, but the so-called Left Coast is smaller and easier to negotiate and influence—and like everyone, from the homeless to rich aristocrats to starving artists, everyone digs the weather here.

It was still the last frontier when I arrived in 1951. It was a wide-open city. You could come here and just start anything you wanted, because, in New York City, it would have been impossible to start a bookstore unless you had lots of money.

—*Lawrence Ferlinghetti, 2015. The renowned Beat poet co-founds City Lights Bookseller & Publishers in 1951, still standing along with the poet who recently published his first novel at 101 years young. The store becomes famous when Ferlinghetti is tried on obscenity charges for publishing Allen Ginsberg's* Howl and Other Poems. *The jury finds the book has "redeeming social value," and he is acquitted. Located at 261 Columbus Avenue at the nexus of North Beach and Chinatown, City Lights is designated an official historic landmark in 2001. Ferlinghetti is best known for* Coney Island of the Mind *(1958), a collection of poems that has been translated into nine languages with sales of more than one million copies.*

So-called beatniks are not always good at making fun of themselves. This is an **exception** in front of the famed beatnik mecca watering hole, Vesuvio, located next to City Lights **Book** Store. Jack Kerouac Alley is just to the right. All these locations still thrive.

It was the end of the continent; nobody gave a damn.

—*Jack Kerouac, author of* On the Road, *1957,*
describing San Francisco

The Beat generation bursts onto the social scene as an angry, disaffected literary movement that draws inspiration from European intellectuals and writers grappling with the gloomy devastation of the Great Depression and World War II. They demand a radical rethinking of Western Civilization. Hardly a significant movement in terms of devotees, its cultural impact far outweighs its numbers. All aspects of bourgeois culture are denounced. Jazz is heralded over traditional, square music; formal verse is abandoned for free-form poetry. Uptight fashion is rejected in place of de rigueur turtlenecks, berets and funky attire. Finger snapping replaces rude applause in coffee houses. Don't keep up with the Joneses, pity them. Its language is "hip" and esoteric, drawing heavily from Harlem jazz lexicon. However political the message may have appeared, Beats tend to look inward for personal transformation rather than direct social activism.

How and when do the Beats get their moniker? Most credit Jack Kerouac, author of *On the Road* (1957). The Afro-American colloquial meaning "tired or beaten down" is appropriated and elevated to "beatific" and "on the beat." The present may be bad vibes, brother, but the future can be hip, blessed in beatitudes. The word *beatnik* is coined by *San Francisco Chronicle* columnist Herb Caen. Beat generation has already appeared in print and speech, and he adds the Russian suffix -nik soon after the launch of Sputnik in 1957. Caen is not fond of beatniks, and the name is a slap at their criticism of traditional American values. Allen Ginsberg calls the term "foul."

By 1958, I realized I couldn't stay in North Beach anymore. It was filled with tourists coming to look at people like us. We became an industry.

—*Michael McClure, North Beach poet*

The Beats beat a cultural retreat to obscurity, if not insignificance. Some persist or move on to the next revolution; others return to the mainstream. But their fierce independence, anti-materialism and iconoclastic attitude set the stage for the tumultuous social upheavals waiting in the wings. There is a

Beat Museum in San Francisco at 540 Broadway. When it reopens after the pandemic, come see the best minds of the generation go stark raving mad from 10:00 a.m. to 7:00 p.m. daily.

COUNTERCULTURE

What is the connection between beatniks and hippies? Beatniks are born in the 1920s and 1930s and become the hipster royalty of the 1950s. Their eclectic cocktail of anti-establishment resistance and flirtation with Afro-American culture and Eastern religions appeals to baby boomer counterculture rebels. Beatniks are hip, a word salvaged and reinvented from 1920s Harlem. Youngsters in the late 1950s and '60s who admire and strive to emulate the Beats are seen by those elders as "junior" or "wannabe" hipsters—like tadpoles or hippies. The word floats around hipster circles and catches on in the mainstream, as usual, inspired by journalists.

The counterculture is born and thrives well before the famous 1967 San Francisco Summer of Love, which in retrospect may represent the apogee of Hippie America. Young, disaffected rebels are streaming into the Haight-Ashbury neighborhood in 1960s, known for its low-rent, dilapidated Victorian houses that attract buyers looking to relocate on a dime. By 1967, there are as many as twenty thousand there who identify as hippies. The new music scene is thriving by the Summer of Love. San Francisco plays a significant role with locally based, nationally prominent cutting-edge bands that are promoted by a savvy New York transplant to the city, Bill Graham. His contribution to the local music culture is regarded as so significant that the historic San Francisco Civic Auditorium is renamed the Bill Graham Civic Auditorium after his death.

For those who want a birth date for the Summer of Love, it is January 14, 1967, the Human-Be-In at Golden Gate Park. It is very hippie—no beginning, no end, no planning, no squares. Just a "happening" that keeps on happening. How groovy is that? It is there that the Pied Piper of psychedelics, Tim Leary, first urges youth to "turn on, tune in, drop out." Allen Ginsberg leads the Gathering of the Tribes in a final benediction—a collective "OM."

Let the Summer of Love games begin! There is free music, free food, free drugs, free medical care and with a little luck you could get lucky—free love. Riffs of Jefferson Airplane, Grateful Dead and Family Dog—all living in or around the city—waft free through the air, mixing with pungent clouds of marijuana smoke. You can get stoned by strolling, and the contact

high is born. LSD is readily available, supplied by Hells Angels who are always ready to profit from and partake of any party action. Day by day the crowds swell. The world's first major rock concert, the nearby Monterey Pop Festival, draws sixty thousand. The word goes out: "Boogie up north to San Francisco and check it out." Traditional spring breakers looking for a change of pace and curious about hippie chicks also stream into Haight-Ashbury. Soldiers from nearby military bases, ready to have fun, join the throngs and tongs. The scene becomes a tourist attraction. Gray Line tour buses snake through narrow streets streaming with tie-died fashionistas and braless, even topless, young ladies.

> *You will note that many of the natives bears a resemblance with the mountain boys and also have a bit of shyness. The favorite pastimes of the hippies besides demonstrations, taking drugs, and partying are seminars and groups of discussions. They take many trips and the trip of the hippie is generally an unusual thing.*

> —*from a Gray Line bus driver tour script*

It does not take long for the little neighborhood to be overwhelmed by the 100,000 revelers. Eventually, the celebration deteriorates into street people, drug overdoses, hunger, disease, fights and crime. Still, the good vibrations prevail for most. The summer decompresses more than concludes. Kids have to get back to school, some run out of money or their minds, voyeurs grow bored and the tourist season is winding down. On October 7, those remaining there stage a mock funeral, "The Death of the Hippie," to symbolize the end of the adventure. The historic Irish working-class Haight-Ashbury neighborhood is forever transformed by the experience. To this day, it remains a bohemian mecca, a home for whatever countercultures are currently in vogue.

At the fortieth anniversary of the Summer, there is a one-day reunion in San Francisco that draws over thirty thousand and includes some of the original musicians who played there in 1967. Mayor Gavin Newsom, a newborn when the Summer erupts, proclaims an official day commemorating the heady times, declaring, "Whereas, The Summer of Love in San Francisco is internationally recognized as the birthplace of the 60s revolution that ignited a spiritual awakening that swept the world…"

THE SEXUAL REVOLUTION

If the Board of Supervisors sends me a bill to outlaw topless dancing, I'll sign it. Immediately.

—*Mayor Joseph Alioto, 1969*

In the same year as the Summer of Love, the Condor Club in San Francisco becomes the first topless dance bar in America, featuring a larger-than-life attraction—Carol Doda. Within days of her debut, all the strip joints on the North Beach strip are bursting to keep up with the Dodas. Before Carol is a topless dance phenom, she tries her luck at as a prune picker, file clerk and cocktail waitress. Then comes the transformation from a modest 34-23-36 to a bodacious 44-22-36. One of the first to use the new silicon enhancement technique, Carol has, coincidently, a total of forty-four injections sans complications. In 1969, Carol Doda takes the next logical step and sheds the bottom. Again, she is the first in the nation and again, North Beach clubs scramble to keep up with less. The femme fatale celebrates completely au naturel until the California Alcoholic Beverages Commission rules in 1972 that completely au naturel is prohibited in establishments that serve alcohol. That's a deal breaker. It's back to panties, however sheer and tiny.

Mix labor activism and sexual permissiveness and you get the first unionized U.S. sex business in 1997—the Lusty Lady Strip Club in San Francisco. Toss progressivism into the mix, and six years later you produce the first worker cooperative sex business. The sexual toy industry is founded in San Francisco and Los Angeles at about the same time. Doc Johnsons in Southern California opens as a wholesaler in 1976; Good Vibrations debuts in 1977 at 1210 Valencia Street as an "antique vibrator museum" but quickly transforms into a clean, well-lighted retail emporium featuring the latest vibrators, lubrications, instructional books and sex-related videos. In San Francisco sex industry tradition, it turns into a worker's cooperative in 1992, and branch stores are opened. It is owned and operated by women.

San Francisco birthed this entire industry.

—*film documentary maker Michael Stabile, on the development of the 1970s X-rated adult film revolution, 2011*

They are the original odd couple. And they are brothers. Artie and Jim Mitchell, always the showmen, pick July 4, 1970, to open the O'Farrell Theatre in a converted old Pontiac showroom in a gritty district near downtown. There they make and show short X-rated movies, surviving dozens of arrests in the early years. In 1972, the brothers catch lightning in a bottle when they produce the first feature-length adult film in the United States designed for mainstream audiences. When revealed that *Behind the Green Door* star Marilyn Chambers is the idyllic mother holding the idyllic baby on the Ivory Soap box featuring the logo "99/100 pure," the film becomes a gold mine. For Marilyn, a career door closes, a career door opens. A $60,000 investment for the brothers eventually turns into $50 million.

The development of the videocassette and rental shop outlets in the 1970s puts a serious crimp in the original X-rated movie business. So the enterprising Mitchell brothers concoct another erotic revolution—the "consumer contact" business model strip club. Throughout the 1980s, Jim and Artie face the same routine of raids and criminal prosecution as in the X film industry days, this time over so-called lap dancing and other types of physical intimacy. Again, the brothers prevail in the court of law and largely in the court of local public opinion.

The personal story ends tragically in 1991 when Jim Mitchell fatally shoots Artie. Jim is convicted of voluntary manslaughter when he convinces a jury that Artie became psychotic from drugs and was lethally dangerous. He goes on to establish the Artie Fund to raise money for drug-abuse prevention and is released from prison after serving three years.

It's the Carnegie Hall of public sex in America.

—Hunter Thompson, 1985. The "gonzo journalist,"
author of Fear and Loathing in Las Vegas,
briefly finds honest work with the Mitchell brothers.

When septuagenarian burlesque star Tempest Storm dances at the thirtieth anniversary of the O'Farrell Theatre in 1999, San Francisco mayor Willie Brown declares a "Tempest Storm Day" in her honor. When Marilyn Chambers returns to perform there a few days later, the mayor announces a "Marilyn Chambers Day." By then, all of this erotic display is regarded as "old pasties"—at least in San Francisco. In 1980, the first annual Exotic Erotic Ball debuts in San Francisco. Held around Halloween every year until 2010, the event is described in Wikipedia as "a combination of Adult-themed Halloween

Festival, Musical Festival, Burlesque show, Lingerie party, Masquerade ball, Fetish club, Swinger's party and Adult Industry Trade show." It is hard to imagine such spectacle in any other city. It is even harder to imagine that two San Francisco mayors issue official "Exotic Erotic Ball Day" proclamations.

San Francisco's historic social tolerance benefits gay men from the earliest days of the gold rush. In the mad dash to riches amid a wildly diverse population, few pay attention to personal behavior or regard it as a serious cause for concern. Young men streaming into San Francisco from all over the world without the company of women for months or even years might well indulge in same-sex behavior, which has been recorded in the earliest narratives of humankind. Some eleven thousand Australians are part of the early gold rush. The country is a British male penal colony, and that influx undoubtedly helps to kindle a local gay populace. Even as the city consolidates and organizes into a stable metropolis, the traditional "live-and-let-live" attitude thrives—tolerating excesses, eccentricity and "aberrations." When celebrated English writer Oscar Wilde is drummed out of Great Britain in the 1890s as a consequence of his outing as homosexual, he finds a new home and acclaim in America, first and most notably in San Francisco. Major events that draw people into San Francisco add to the gay presence. During the 1898 Spanish-American War in the Philippines, the city is the primary port of arrival and embarkation to thousands of soldiers from all over the country. This is the first time that gay bars (and police raids) are reported in local newspapers. At the 1915 Panama Pacific International Exposition, which attracts some eighteen million tourists, gay drinking establishments and gathering places again invade the local news. The U.S. military conducts concentrated dishonorable discharge operations of suspected gay servicemen during World War II. Many who are forced to disembark at the convenient port of San Francisco chose to stay in a place more gay-friendly than whence they came.

By the '50s, California was the one state whose courts upheld the right of homosexuals to congregate in bars and other public establishments, giving homosexuals a modicum of security, despite the continual police harassment....In the mid-50s, the bohemian literary scene in North began attracting national attention. Many of the central figures of San Francisco's beat subculture were gay men....The hippies flocking to the Haight-Ashbury district in the summer of 1967 also no doubt contributed to the development of the San Francisco lesbian and gay subculture.

—*Jim Van Buskirk, historian*

In 1964, *Life* magazine proclaims "San Francisco the Gay Capital of the U.S." At that point, the relatively small openly gay population is concentrated in the Tenderloin and Polk Street areas. The Summer of Love three years later draws thousands of rebellious youngsters, including gay revelers and those open to experimentation of all sorts. When the summer ends and the neighborhood dissolves into drugs and disorder, many eye the nearby Castro District—a "Eureka Valley" neighborhood in transition as the children of working-class Irish, German and Scandinavian residents move to the suburbs or the rapidly developing outer Sunset District. They abandon aging housing and commercial real estate that lingers without demand at the time. Nature abhors a vacuum, and a historic migration ensues. Stores are transformed into gay bars, businesses and restaurants, stimulating more migration to what is quickly becoming a gay mecca. In the mid-1970s, real estate values are skyrocketing, and the modern Castro blooms. Ten years later, the city's gay male population is estimated to be 70,000 (10 percent of the population). Two-thirds are under the age of thirty-nine. In 1976, the Gay Freedom march for the first time surpasses that of New York City in sheer numbers, which has ten times the population. By the early 1990s, residents in the Castro area alone have grown to over 120,000. The LGBT (lesbian, gay, bisexual, transgender) citywide community is becoming a major political force. In part, these demographics lead to the smallest share of children under eighteen of any major U.S. city.

> *It is increasingly obvious that San Francisco has become to the gay community what Rome is to Catholics.*
>
> —*Michael Svanevik, historian*

Harvey Milk is the only openly declared gay elected official in the United States when he wins a seat on the San Francisco Board of Supervisors in 1977. He quickly introduces a then pioneering and radical bill banning discrimination in public accommodations, housing and employment on the basis of sexual orientation. It passes 11–1 and signed into law by Mayor George Moscone.

In the 1978 city elections, conservative young Dan White is chosen to the Board of Supervisors and then impulsively resigns to pursue other business matters. Before a replacement can be chosen, he has a change of heart and requests the job back. The mayor declines. Convinced that he is a victim of

a progressive cabal, an unhinged White sneaks into city hall and assassinates Moscone and Milk. In a mind-boggling decision, a jury declares that White has consumed enough Twinkies to develop a sugar-induced psychosis, triggering depression and an inability to distinguish right from wrong at the moment of the crime. He is sentenced to seven years in prison, which is reduced to five. Released in 1983 to a closely guarded secret location, White takes his own life two years later. The verdict sparks outrage in San Francisco, resulting in angry and at times violent protests. Police cars around city hall are set on fire, and the nearby Castro District becomes a police-resident battleground.

The lethal disease AIDS is detected in 1981 and spreads quickly in gay communities across the United States. Almost 10 percent of the national cases are recorded in San Francisco alone. By the late 1990s, various treatments and safe sex practices are effectively curtailing or restraining the virus.

THE BEAT GOES ON: THE "LEFT" COAST

The San Francisco Bay Area is the caldron of West Coast political activism in the 1960s and 1970s.

In 1960, the House Un-American Activities Committee, which has seen little protest since its creation in 1938, abruptly confronts organized resistance in San Francisco when it announces a local investigation of "communist subversion" among local college professors, politicians, labor leaders and social activists. Denied access to packed meetings, raucous protestors face high-pressure water hoses and forcible eviction down the steps of the city hall rotunda. In the chaos, sixty-four people are arrested. Some five thousand protestors show up for the final day of hearings. Dramatic national press coverage of the "riot" puts San Francisco in the spotlight.

The Free Speech Movement also produces national headlines. Born and nurtured at the University of California, ten miles from San Francisco, the Berkeley campus becomes the stage for a prolonged protest campaign that demands the right to advocate and recruit for outside political causes on campus—at the time strictly forbidden by university rules. San Francisco sympathizers are deeply involved in the movement. The 1964 school year opens with demonstrations, rallies, marches, occupations and dramatic arrests. After tumultuous months, the protests culminate in victory for the

Free Speech Movement to conduct political operations on campus. Some of those now-seasoned activists will go on to participate in and lead "New Left" and antiwar groups.

On strike! Shut it down!

> *—for five months, like clockwork, these words ring out daily at noon on the campus of San Francisco State. After an accompanying rally, striking students march again and again on the administration building.*

San Francisco State is among the most dramatic battlegrounds of students versus authorities in this period. Throughout 1968, tensions between the administration and the Black Student Union intensify. Demands are denied for an overhaul in admissions policy and the creation of a Third World Studies Department controlled by student groups. A long and at times violent student/faculty strike, supported by substantial numbers of non-Black students and other allies, leads to police occupation of the campus. The five-and-a-half-month closure remains the longest in a U.S. academic institution.

Throughout the 1960s, San Francisco is the scene of anti-Vietnam rallies and other assorted causes.

> *We, the native Americans, re-claim the land known as Alcatraz Island in the name of all American Indians by right of discovery....We will purchase said Alcatraz Island for twenty-four dollars ($24) in glass beads and red cloth, a precedent set by the white man's purchase of a similar island about 300 years ago....We will give to the inhabitants of this island a portion of that land for their own....We offer this treaty in good faith and wish to be fair and honorable in our dealings with all white men.*

> *—proclamation delivered on November 20, 1969, by eighty-nine Native Americans who seize control of Alcatraz Island by occupation. Alcatraz penitentiary has been shuttered for over six years when a group of young American Indians activists invade and occupy the island just before Thanksgiving, 1969. Under a nineteenth-century treaty, they claim, all surplus federal land should revert to the native people who once lived there. Local and national headlines announce the invasion. Headlines continue to cover the adventure over its tumultuous nineteen-month span, especially when the occupation swells to some four hundred activists and includes celebrity sympathizers like Marlon Brando. He will later be a no-show*

and decline the 1973 Best Actor Award for The Godfather *to protest the treatment of Native Americans. Since Alcatraz is federal property, President Nixon is thrust into the midst of the political thicket. Negotiations with the White House continue for over a year. In May 1970, Washington orders a termination of electricity and telephone service to the island. A month later, a suspicious fire destroys some buildings. Faced with a crisis of resources and diminishing public support, the number of activists dwindles. When federal forces land on Alcatraz in June 1971, only fifteen people are left to remove. During most of the occupation there are derring-do scrimmages between a navy blockade and resourceful amateur blockade-runner boats navigating choppy waters in the dark of night to bring food and other necessities to remote parts of the island, which must then be hauled up a long ladder.*

Many ideas are floated for the transformation of Alcatraz Island, ranging from a casino-resort to a global peace and creative arts center.

Under no circumstances should anyone be allowed to use the island to glorify the criminal acts which brought men to Alcatraz or exploit the human misery associated with crime.

—the Alcatraz Island Commission recommending a monument to honor the 1945 founding of the United Nations in San Francisco. It remains today an abandoned prison and a top tourist attraction glorifying its criminal past.

SLOW GROWTH MOVEMENT

San Francisco is a city with assets of a metropolis without the disadvantages of size and industry.

—Jack Kenny, American actor, circa 1960

San Francisco is the last great metropolitan village.

—Herbert Gold, poet and novelist, circa 1980

AEROPLANE VIEW OF BUSINESS DISTRICT LOOKING TOWARDS TWIN PEAKS. SAN FRANCISCO, CAL.

©G. E. Russell, San Francisco.

The "metropolitan village" before the Great Tech Invasion.

Manhattanization is the buzzword for the Slow Growth Movement, a cause that begins in San Francisco and inspires other cities to raise the battle cry. San Francisco is changing physically and demographically. A provincial, relaxed European ethos is surrendering to a faster-paced, more uniform urbanization accompanied by rising buildings and rising rents. This transformation is led in the 1960s by a new breed of resident attracted to the Bay Area's early "tech revolution" that is creating soon-to-be behemoth Silicon Valley. Startups sprout everywhere. Creative tweaking of regulatory laws opens the floodgates for building development in San Francisco, which becomes a chip off the new computer block, providing banking, legal and technical expertise for the entire region.

> *I recommend San Francisco as the goal of every person in their 30s with a good education, a splendid wine collection and who drives a Volvo.*
>
> —*David Savegeau, travel writer, 1981*

> *The tech revolution has brought more power and money to San Francisco. But folks still frequent sidewalk cafes.*

—Joe Flower, musician, circa 1975. The only difference almost fifty years later: the cappuccino is now ten dollars and can be accompanied by twelve-dollar organic avocado spread on a slice of gluten-free non-GMO toast. Plus a 5 percent surcharge as some establishments openly admit "for the cost of doing business in San Francisco." Then there is the tip. Anything less than 20 percent is regarded as rude and, even worse, politically incorrect. If you don't like the venue, be patient. It will go broke and be replaced with next great urban hope.

Financial district skyscrapers rise at a pace never before seen or imagined, and the boom includes high-rise condominiums in adjacent residential neighborhoods. San Francisco is quickly morphing into a global city led by financial and corporate elites with a master plan to replace traditional port, warehouse and industrial enterprises with technology-based companies, luxury supportive housing and entertainment venues. Another instant city is emerging that some dare compare to the 1849 gold rush instant city. Hotels are built at a frantic pace. In 1959, there are 3,300 hotel rooms. By the turn of the century, a vibrant convention and tourist business can boast almost ten times as many. Office space explodes. Between 1965 and 1982, the official compact downtown planning district more than doubles that capacity. This economic progress affects all aspects of life, from where you live to where you shop. An opposition movement, caught off-guard, scrambles to gain traction.

By the Numbers

1930–1958: one major office building is constructed in downtown San Francisco.

1959–1972: Fifty-two major office buildings rise in the downtown area, culminating in the 853-foot Transamerica Pyramid building on Montgomery Street. Like the Eiffel Tower in Paris, it is at first criticized, even ridiculed, but quickly turns into the symbol of the city.

In 1954, the tallest builiidng in San Francisco is a modest 435 feet. The six-year period from 1966 to 1972 experiences a frenzy of construction as thirty-two of the structures are built. Witness plentiful white- and blue-collar employment, wealth concentration, residential relocation and traffic snarls.

SAN FRANCISCO'S DOWNTOWN DISTRICT, GOLDEN GATE BRIDGE

© STANLEY A. PILTZ SPANNING THE GOLDEN GATE ENTRANCE TO SAN FRANCISCO

The old city for which Herb Caen always yearned.

The vertical earthquake of the 1970s and 1980s destroyed what was left of a tradition and covered it with a new city that bears no resemblance to what had gone before. The pile drivers were singing the song of the big buck.

—*Herb Caen, "The Vertical Earthquake," 1993*

Enough already! declare beleaguered critics. The Slow Growth movement of the 1970s seeks to curb downtown expansion vertically and horizontally, which it blames for traffic congestion and rising rents. And not only in the historic downtown. It is also blamed for a ripple effect in adjacent neighborhoods—and potentially all over the city—that are succumbing to chain stores and what is criticized as tacky modern residential construction occupied by people who don't know or care about historic San Francisco. Residents are grumpy and ready to rebel. When U.S. Steel announces its plan to construct a 550-foot high-rise on the water near the Bay Bridge in 1970, it ignites waves of protest that leads to the High Rise Revolt. Looking at the present San Francisco skyline, imagine a ballot measure in 1971 to limit heights on new buildings in all neighborhoods, including downtown, to a mere 72 feet—about seven stories. The effort fails, but city officials do impose height limits in the neighborhoods.

The whole idea was that the city was controlled by developers. We said, is this the future you want? Is this where you want to raise your kids? It's lost its livability for people who aren't devoted just to making money, its livability for people who want to do creative things in the arts....It's over for me. It's a different city.

—*Alvin Duskin, who leads the 1970s High Rise Revolt, in a* New York Times *2018 interview. The clothing entrepreneur waxes nostalgic for the good old days when affordable rents attract artists and writers from all over the country. He reminisces about hanging out at local cafés where friends like Lenny Bruce or Dick Gregory would stop by to chat. Duskin escaped to the Marin County hinterland.*

Most of the newer houses throughout the city are totally without the verve and vigor of the buildings they are replacing. Take a walk through the eastern end of Pacific Heights where turreted and gabled old Queen Anne houses, stone mansions, Tudor, Spanish, Renaissance and colonial homes are being replaced by stark, bland apartments...on the whole, the new dwellings appear utterly lacking in character and interest; monotonous, box-like, mass produced products of an age of conformity.

—*Harold Gilliam, San Francisco writer and environmentalist, 1971. He also bemoans that old homes on Telegraph and Russian Hills are surrendering picturesque views of the city to tall new high-rise buildings: "The ultimate result will to turn San Francisco into a counterpart of Manhattan Island, its hills disappearing behind a wall of skyscrapers."*

San Francisco is celebrated for weaving a delicate balance of financial and tech industries alongside distinct, quaint neighborhoods. No other city, it is said, manages to combine cosmopolitanism—serving as headquarters for some the largest banking, insurance, real estate, brokerage and technology firms—so thoroughly with provincialism: a commitment to preserve diverse residential enclaves integrated with unique enterprises in place of chain stores.

The passage of historic Proposition M in 1986 codifies the slow growth vision by establishing new oversight for high-rise construction downtown while curbing demolition of historic architecture. Regarded as revolutionary in terms of neighborhood protections and city center

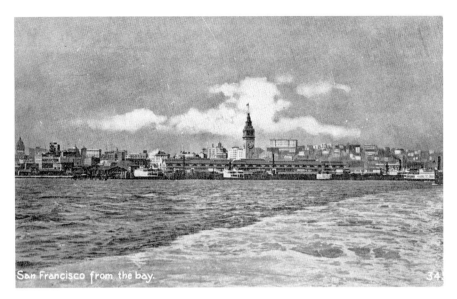

San Francisco from the bay.

This San Francisco was gone forever by the 1960s.

growth prohibitions, which limits new downtown office space every year to the square foot equivalent of the Transamerica Pyramid, it represents the most comprehensive set of development regulations adopted by public vote initiative in a major urban area.

Soon you may have to go to San Jose to get your shoes repaired.

—Pro-M statement in the official San Francisco Voters Election Guide, 1986. Opposition to chain stores is closely linked to the slow-growth movement. Advocates blame the spillover effect of downtown development to accelerating housing prices and store rents that give large formula franchise operations an advantage over local shops. The end result is…Phoenix?… San Diego?…or, oh no! Los Angeles? The issue continues to this day.

Chain store bans fallout
Critics blame them for vacancies—backers say they keep San Francisco's flavor

San Francisco is home to some of fashion's biggest names: Levi Strauss & Co., Gap and Old Navy. But in three neighborhoods—North Beach,

Chinatown and Hayes Valley—those local companies are banned from opening new stores.

That's because the city forbids chains, defined as having more than 11 locations globally, in those areas. The bans passed starting in 2004, after residents fought the encroachment of large corporations into neighborhood retail districts. Other areas require additional permits for such stores, also known as formula retail.

—San Francisco Chronicle, *July 7, 2019*

I don't know why people call it the Sunset district. I've never actually seen the sun, much less seen it set.

—anonymous

There's an old saying about the city and county of San Francisco. The part where everything happens—North Beach, Chinatown, Nob Hill, the Mission, the Castro, South of Market, that's the city. *The rest— all those places on the other side of Twin Peaks and out by the beach, that's the county.*

—*Carl Nolte,* San Francisco Chronicle *writer, 2019*

As the Sunset District gradually turns into residential neighborhoods, there is growing criticism of the assembly line methods producing cookie-cutter rows of nearly identical houses. A few appear in the late 1920s, but it takes post–World War II prosperity and G.I. loans for returning servicemen to spread asphalt over the city's infamous western desert to the "end of the world" Pacific Ocean. Developer Henry Doelger offers the American Dream to "Mr. and Mrs. Average San Franciscan." Splashy display ads in the late 1940s dangle a $4,350 home for only $450 down and $27.50 a month payment. Real estate update: The current price of that early bargain is currently about $1.4 million. And the demographic has changed. In the mid-1960s, the Sunset residents are largely Caucasian. Today, about 50 percent of the district is Asian, mainly Chinese, but also Vietnamese, Thai, Cambodians, Tibetans, South Pacific Islanders and Japanese. San Francisco's famed diversity lives on.

The Sunset District—or Doelger Row—is the victim of more snide remarks in the past few years than other section of town.…There's something vaguely amusing about those blocks of wedding-cake house and FHA loans, all looking alike, smelling alike, and costing alike.

The gags about the Sunset are all alike as well. You can't drive a nail into your wall to hang picture without checking with the guy next door to make sure he has a picture to hang on the other end. In the morning, when your wife asks you: "How do you want your eggs, dear?" a husband seven houses down answers, "Scrambled." And so on."

—*Herb Caen,* Baghdad by the Bay, *1949*

So who wins the battle between slow growth and the corporate behemoth? On the surface, the behemoth. But some resisters take consolation from new mixed-use areas that retain more low/moderate income presence than other cities. Yerba Buena—an eighty-seven-acre downtown urban redevelopment enclave that encompasses the Museum of Modern Art, Moscone Convention Center, entertainment complexes, residential housing and parks—is touted an example of such a compromise. Others insist that progressive ideas have been lost in the rush to gentrification in spite of the enactment of far-reaching rent control and eviction protections for tenants.

San Francisco is the only City I can think of that can survive all the things you people are doing to it and still look beautiful.

—*Frank Lloyd Wright, 1953, often quoted by critics of Manhattanization*

The 1989 Loma Prieta earthquake strikes on the same San Andreas fault line as the 1906 Great Earthquake, but the epicenter is near Santa Cruz, seventy-five miles south of San Francisco. Registering a formidable 7.1, it kills 62 people and injures some 3,700. Of those fatalities, 42 occur in Oakland when the upper deck of a freeway collapses, pancaking cars on the lower level as it causes deadly crashes above. In the city itself, five people perish in the collapse of a brick wall. There is extensive damage in the Marina district of the city, which is an "instant city" created on landfall for the 1915 Panama Pacific International Exposition and then converted to residential use. When the earthquake hits, the third game of the 1989 "Bay" World Series (Oakland versus Francisco) is minutes away from first

pitch. Thousands have left work early or are staying late for afterwork group viewings and parties. Normally crowded commuter freeways contain unusually light traffic. Initial media reports fail to access the game's effect on the commute, and the death estimate of 300 is soon corrected. Even an earthquake cannot save the San Francisco Giants that year. They lose the World Series in four games.

MODERN TIMES

In 1986, Proposition M puts the brakes on downtown and residential expansion. But, in reality, it is short-lived. The rules are cumbersome and overly bureaucratic, critics complain, and impede reasonable growth. Change is coming.

> *Mayors are known for what they build and not anything else, and I intend to cover every inch of the ground that isn't open space.*
>
> —*Mayor Willie Brown, 1997*

> *In 1995, San Francisco was a great city in danger of losing its way. Over the last four years, we have worked together and successfully to get San Francisco moving forward.*
>
> —*Mayor Willie Brown, State of City address, 1999*

Perhaps no one could have accomplished what he does. The first African American to occupy the San Francisco Mayor's Office is elected by an eclectic and novel coalition of gay residents, racial minorities, progressive groups, business leaders, developers and organized labor. Brown finds loopholes and exemptions in existing laws. Projects stalled for years are fast-tracked, including the new San Francisco Giants ballpark. During two terms, Brown becomes a virtual planning czar, using all his skills, charisma and power broker experience from a legislative career that takes him to Speaker of the California Assembly, then back to mayor of his hometown. "Mayor Bricks-and-Mortar" is determined to build not just office space but research-and-development complexes, housing, shopping malls and entertainment centers.

This expanded urban vision is enhanced by the 1990s tech boom that welcomes an invasion of entrepreneurs, computer software engineers and marketing professionals to the city. The inevitable result: more gentrification that displaces existing and often longtime residents and businesses in a tide of rising rents and new building construction. Between 1993 and 2000, there is a jump in residential rental rates of as much as 300 percent. Much of this development takes place south of Market, continuing the transformation of the area from industrial shops, working-class neighborhoods and low-income residential hotels.

At the same time, the city's northern waterfront was being transformed in a different way. In 1951, the beautiful Art Deco Aquatic Park bathhouse was turned into a maritim museum, and a few years later a fleet of historic vessels docked at the old Hyde Street ferry pier. By 1988, the collection had been turned into the San Francisco Maritime National Historic Park, dedicated to bringing the city's maritime heritage to life.

There were bigger changes as well. In 1972, the National Park Service acquired most of the region's military land and turned it into the Golden Gate National Recreation Area. And in 1996, the Park Service acquired the U.S. Army's crown jewel—the Presidio of San Francisco. The Presidio had been a military post since it was established by the Spanish in 1776. Now it became the centerpiece of a huge national park.

Bust! The national dot-com bubble implodes in 1999, and for a few painful years San Francisco suffers a population exodus and office vacancies. Rents decline from impossible to ridiculous. Boom! By 2004, the economic picture is brighter. Ironically, the recession has exacerbated the gentrification problem by prompting city officials to relax even more of the arcane building restrictions of Prop. M. It ushers in another wave of Manhattanization, especially in the form of tall residential downtown condominiums. Recent heights have climbed beyond the dreams and nightmares of the previous generation.

A large, new, innovative Transbay Transit Center serves as the city bus terminal and projected rail terminal. Known as the Salesforce Transit Center, it is adjacent to 1,070-foot Salesforce Tower that dominates the current San Francisco skyline.

The modern Mission Bay area of the city, on land that had been a Southern Pacific Railway Yard south of Market and a mile from the main business district, gets an initial shot in the arm with a $3 billion initiative passed in 2004 for a stem cell biotech research center. It remains the largest development in the history of city at 303 acres complete with 6,000 housing

units, retail facilities, 51 acres of park and a second campus of the University of California medical school. The new Golden Gate Warriors Arena joined the party there. This neighborhood is hardly more than a gargantuan Barry Bonds home run to the San Francisco Giants Oracle Park, another special development area in a former waterfront industrial and warehouse space called China Basin, which lures residents with new apartments, converted warehouse lofts, clubs, stores and restaurants. In addition, the baseball team will convert 28 acres of its parking lots into 1,200 residential units and up to 1.4 million square of office space.

San Francisco is currently bursting at the seams with a record population of 885,000, not including a floating homeless population of some 8,000. In 1940, the official population is tallied at a tad over 634,000. Where did the city put everyone? On landfill. In nooks and crannies. On parking lots. On abandoned rail yards and factories. By demolishing and rebuilding. And, of course, reaching higher and higher—the final frontier.

Today, the Presidio Trust manages rental homes and apartments—refurbished buildings left over from its days as a military base—that contain some four thousand people, all official San Francisco residents. Some two hundred diverse organizations occupy office space.

Treasure Island, the man-made creation for the 1939 World's Fair, is currently home to about 3,200 residents—and an official part of San Francisco. There are plans for large-scale development that could place 25,000 additional residents there by 2035. Enhanced ferryboat service is planned to divert additional auto traffic away from the Bay Bridge. Yerba Buena Island, the rocky outcropping that rises from the Bay next to Treasure Island and serves as the spot where the Bay Bridge touches land in its span to the city, is home to a Coast Guard station, a marina, 145 species of plants and 21 types of birds. Tourists and locals love to bike, hike, picnic and explore. Soon it will welcome a species that until now has not inhabited the island. The plan is to keep the ambiance while allowing the encroachment of civilization. The 226 units now open to occupancy are a collection of flats, townhouses and a five-story apartment building tucked into a hillside surrounded by 72 acres of hiking trails, beaches and landscaped parks.

Notwithstanding additional space, the growth of residents since 1940 and in the future has and will be in the same tiny geographic area. San Francisco is forever confined to forty-nine square miles surrounded by water on three sides. More density can lead to more inequality as residents compete for resources and public services. In one consequence of this issue, critics gripe that highly paid tech workers, such as those from Google and Facebook,

board luxury buses using public transit space to commute in comfort to jobs in Silicon Valley and then return to exorbitantly priced San Francisco flats that have pushed working folks to the hinterland.

A new brand of dot-com millionaires and Silicon Valley money have moved into San Francisco with bags full of cash and no manners.

—*Lawrence Ferlinghetti, poet, 2015*

Is San Francisco losing its soul? The big paychecks of the tech boom are changing the City by the Bay as Twitter and Google millionaires take over its bohemian haunts. Could this be the end of the city as we know it?

—*The* Guardian *(American edition) 2014*

Tech Boom Forces a Ruthless Gentrification in San Francisco

—Newsweek, *2014*

San Francisco's guerrilla protest at Google buses swells into revolt.

—*The* Observer *(American edition), 2014*

SF protesters say no to "techsploitation," block buses with scooters.

—Mission Local website, *2014*

The Heart of the City group stages a six-month confrontational protest in 2015 against "technological privilege" and gentrification in general. Activists block buses and shout complaints into bullhorns. One in particular is addressed: tech buses are using urban infrastructure for free. In 2015, the city regulates the routes and sizes of those buses, which includes a fee for every public bus stop they use.

Is the graying of San Francisco yet another sign of gentrification? This is an issue of house color not hair tint. In the extroverted, self-expressive 1960s and '70s, city residences explode in an array of hues, leading to the celebrated *Painted Ladies* phenomenon and bestselling book. According to authors Elizabeth Pomada and Michael Larsen, the breakout of vibrant

hues is nothing short of a revolution: "To people feeling increasingly like helpless victims of big corporations, big government and jobs which are not means to productive ends, painting their homes is a satisfying form of self-expression." But as the nouveau riche young corporate techies invade the city, a creeping gray enters, a color that German artist Gerhard Richter calls "an ideal color for indifference, fence-sitting, keeping quiet." Also the ideal color for increasing real estate value. Zillow, the Internet home-selling site, advises that a shade of gray will up the retail price by some $3,500. Some believe that the gray wave of conformity touches on existential issues and the debate over San Francisco's true identity.

Now, it, seems, it's not about gray buildings. Or gray houses or gray cars, but about a growing grey-ness.

—*Annie Vainshtein,* San Francisco Chronicle, *2019*

By economic logic, increasing density should lower residential housing and rental prices, but San Francisco, like other popular job destinations, does not fit that logic because new "pioneers" continue to arrive who can afford the tab. Gentrification has affected every neighborhood but most dramatically South of Market, Mission and Haight-Ashbury as less prosperous residents are nudged or forced out.

"Build affordable housing" becomes a San Francisco mantra. Can the city ever come up with enough supply to satisfy demand and stabilize prices? It is the most contentious and complex issue of the time. Ironically, Proposition M, passed in 1986, serves as a protection for neighborhoods from city and state politicians looking to construct more, usually high-rise, infrastructure. Locals want to preserve their domains from new residential/commercial invasion. "Not in my backyard" (NIMBY, for short) is another San Francisco mantra. One example: smack dab in the middle of the city—eleven acres of the University of California Laurel Heights Campus in the Richmond District—is to be transformed in a 744-unit housing/retail/open space complex. "Too big and out of place for our quaint neighborhood!" protest the residents. Redevelopment of the Balboa Reservoir with 1,100 new homes and the reuse of the Balboa Power Plant with another 26,00 units is another proposal. "Too big and out of place for our quaint neighborhood!" protest the residents.

Time is incredibly detrimental to projects. Just the fact of appending the lawsuit has the effect of stalling our projects. Opponents know how to play the time game to their advantage.

—*attorney Tim Tosca,* San Francisco Chronicle, *November 15, 2019*

Then there is homelessness—a combination of progressive politics, great weather, sky-high residence prices and a NIMBY resistance to shelters and treatment facilities.

SAN FRANCISCO

Average rent: (2 bedroom): $4,597
Average home price: $1.7 million
Average price of a gallon of gas: $4.24

The longer it takes to build something, the more expensive it becomes.

—*William Ibbs, professor of construction management at University of California–Berkeley, 2013*

When the 1989 Loma Prieta earthquake collapses a part of the Bay Bridge, the city moves quickly to restore the section. All agree it is a temporary fix. The eastern span—the section from Oakland to Yerba Buena Island—needs to be retrofitted for the next big one. Here is what happened on the road to retrofitting that 2.2 miles. In 1998, the California Department of Transportation (Caltrans) finally announces a plan that will take six years and cost $1.5 billion, consisting of a simple skyway without adornment. It is a baby that only a mother can love.

It was just a plain vanilla type of structure. What was called "the viaduct" or what some of our elected officials disparagingly referred to as "the freeway on stilts."

—*William Ibbs, 2013*

Years of haggling over various ideas ensue. There are too many chefs for this nuts and bolts stew, including the governments of Oakland, San

Francisco, the State of California, the U.S. Navy and Coast Guard, the Metropolitan Transportation Division and Caltrans. Each time a new plan is proposed, the completion time is longer and the cost soars. By 2004, the bill is $5.6 billion; a year later, it is $6.3 billion. Construction finally begins. The picturesque span you see today finally opens in 2013.

TODAY, FISHERMAN'S WHARF BEGINS officially at Pier 39. You can indulge in a leisurely Bubba Gump's Dumb Luck Coconut Shrimp Sunday brunch at Pier 39 and hours later wander into the Buena Vista Café for an original Irish coffee nightcap—all packed in a one-and-a-half-mile stroll with intriguing diversions at every step. The continued popularity of Fisherman's Wharf is that it has changed and not changed. The Fisherman's Wharf Merchants association is founded in 1946. Despite its redevelopment into a tourist attraction during the 1970s and 1980s, the area is still home to many active fishermen and their fleets. Efforts are made to save the working part of Fisherman's Wharf from being overrun by "commercialism" while at the same time encouraging tourism to offset the loss of shipping dock revenues.

Pier 39 is a family-oriented mega mall of shops and attractions that prospers from opening day in 1978. *USA Today* names it the third-most visited venue in the country. Year after year, Pier 39 is ranked the top tourist destination in the city by the San Francisco Travel Association. The most popular attraction there is an unexpected gift from nature. In January 1990, sea lions—a cross between a walrus and a seal, to whom they are related— begin arriving in droves. The invasion is a national and international sensation. California sea lions have long been a part of the Bay, but the Pier 39 colony is unique. How to explain this unique gift? The creatures follow the food, and some thirty years ago the feeding inexplicably gets more plentiful there. Natural predators like white sharks and orcas seldom hunt in the Bay. And docks are more comfortable and protected from storms than rocky beaches. There was one problem. In 1990, those docks are already occupied—by humans and their boats. After anguished deliberations, the humans surrender to the mammals and the vessels relocate. Then a weightier problem develops. The average male scales in at 660 pounds, and there can be six-hundred-plus creatures depending on the season. The docks are slowly sinking under the collective tons. Pier 39 comes up with a simple, creative solution: a flotilla of flat ten-by-twelve-foot docks moored to the area. Thus, the Sea Lion Hotel & Spa is born.

It is impossible to miss the attraction. Just follow your ears and nose. You will hear and smell the colony well before you see it. Nothing can be done about their incessant chatter, but the smell, especially during in the summer when the mammal population has a baby boom, would be a deal breaker. The Pier 39 Marina Crew periodically douses the "hotel" docks with high-pressure fresh water from the Bay. The Marine Mammal Center also serves as a sea lion hospital, rescuing the sick and injured when possible. Notice: It is illegal in the United States to feed or harass wild marine mammals. Gawking is permitted. An effort to bellow back to a sea lion in its own language is not regarded as harassment.

Other popular attractions at the Wharf are Alcatraz, Boudin at the Wharf, the Maritime Museum, Musée Méchanique, a World War II submarine (*Pompanito*) and a World War II Liberty ship (*Jeremiah O'Brien*). In the late 1940s, Thomas Crowley, who introduces the Bay Cruise as a tourist attraction, repaints the fleet—red and white—and officially christens it the Red and White Fleet. Today, the company, situated in the heart of Fisherman's Wharf at Pier 43½—a stone's throw behind Boudin at the Wharf—is operated by Thomas Crowley's grandson Tom Escher, a third-generation owner. The Blue and Gold Fleet also provides Bay Tours as well as ferry service to Angel Island, Sausalito, Tiburon, Vallejo, South San Francisco, Harbor Bay, Alameda, Oakland, Richmond and the Giants Ballpark on game days.

So, what is San Francisco in the twenty-first century?

The more things change, the more they remain the same.

—*Jean-Baptiste Alphonse Karr, French writer, circa 1850*

It is the best of times, it is the worst of times.

—*Charles Dickens, 1859,* Tale of Two Cities

Today's San Francisco has a decidedly Manhattan profile and demographic—a source of criticism and praise. In spite of these changes, distinct neighborhoods, unique small stores and innovative art continue to invigorate the city, including downtown. Moreover, what Carl Nolte calls the "county" of San Francisco—Twin Peaks and the Richmond and Sunset

districts—has, even in the face of rising residential and commercial prices, hardly been taken over by large housing developments and residential high rises. Some say that charming old San Francisco is gone forever and in its place is a dense, gentrified, globally oriented megalopolis. But it is in the eye of the beholder.

The death of San Francisco is an illusion, and it always has been....As seen by the vocal cynic, the soul of San Francisco is always just one tall building or comedy club closure or homemade ravioli shortage from arbitrary point of no return....What we're missing, as this skewed picture becomes national news, is equal time for sense of joy and wonder and creativity and allure that continues to exist in the city.

—*Peter Hartlaub,* San Francisco Chronicle, *2019*

Sure, San Francisco has changed—more in the last five years than at any time since 1906....San Francisco will never be the same again.... [Those critics] *were right yesterday and they'll be right tomorrow and the next year....*

The march of times has become a gallop and changes have come very fast to the city, growth with which we could not cope, inflation that alters our standards....All our dizzying changes stem from two things—a sudden excess of people and of money.

These changes of today aren't permanent either. Some will pass, some will become part of our city's evolution. They won't remain, any more than anything else remains static in a modern, moving metropolis.

—*"My S.F., How You've Changed!"* San Francisco News, *1946*

Unique San Francisco Food and Spirits

Chop Suey

Don't try to order chop suey in China. Early Chinese immigrants to San Francisco are culinary pioneers. One of the inexpensive menu mainstays is quickly dubbed *chop suey*—translated as "bits and pieces." These leftovers from vegetables and other ingredients used during the day, augmented with tasty broth, deliver a filling and nutritious meal anytime.

Fortune Cookie

This oddly folded wafer with a paper fortune tucked inside is not invented in China or even San Francisco's Chinatown but at the Japanese Tea Garden during the city's 1894 Midwinter Fair. Eventually, it becomes a de rigueur complimentary after-dinner treat at American Chinese restaurants, appearing as far away as Taiwan. The Original Fortune Cookie Factory still turns out the goodie at 56 Ross Alley in San Francisco. Open every day 9:00 a.m.–6:00 p.m. Entrance is free. Yes, cookies are for sale there, individually and in bulk.

IRISH COFFEE

The problem with Irish Coffee is that it ruins three good drinks: coffee, cream, and whiskey.

—Carl Nolte, San Francisco journalist

A travel writer for the *San Francisco Chronicle*, Stanton Delaplane, introduces Irish coffee to America in 1952 after tasting it at the Shannon Airport in Dublin, Ireland. He conspires with the Buena Vista bar owners to re-create the Irish method for floating cream on top of the coffee—a delicate and tricky task. San Francisco mayor and dairy owner George Christopher comes to the rescue. He suggests that cream aged at least forty-eight hours would be more apt to float. Delaplane popularizes the drink through his travel column. By 2000, the Buena Vista Café in Fisherman's Wharf is making two thousand Irish coffees a day. The establishment has served—by its hazy estimation—more than forty million of the drinks…and counting. Open every day until 2:00 a.m. Scientific studies point to coffee as an antidote for liquor toxins in the liver, making Irish coffee the perfect elixir: a drink that can satisfy a craving and mitigate its effect in the same swallow.

IT'S-IT

George Whitney comes up with the idea while on vacation in the central coast of California. Visiting a small market in Morro Bay that sells ice cream and fresh baked cookies, he notices regulars requesting the two be served as a sandwich. For forty-five years, until Playland at the Beach is demolished in 1972, IT'S-IT is available only at Whitney's shop located there. Two years later, a company in Burlingame, a dozen miles south of San Francisco, buys the name and continues the tradition.

MAI TAI

San Francisco–born Victor Bergeron creates a drink in 1934 at his across-the-Bay Oakland Trader Vic's restaurant for friends visiting from Tahiti.

Upon tasting the concoction, one declares "Maita'i roa ae!," meaning "Excellent! Out of this world. The best!" A star is born and the Mai Tai quickly becomes the signature drink at tiki-themed restaurants and bars. It is featured in the Elvis Presley movie *Blue Hawaii*. Trader Vic's Restaurant chain today hosts small establishments called Mai Tai Bars that feature cocktails and pupus (Hawaiian appetizers).

MARTINI

Late nineteenth-century bartending manuals usually list the martini. The most famous of such books is written by Jerry Thomas of the Occidental Hotel in San Francisco. Many historians believe the drink originates there, dubbed "Martinez" because of the numerous patrons heading to nearby Martinez, and the moniker eventually morphs into martini. Martinez claims it is the other way around—that miners first taste the concoction in that town, named the "Martinez Special," and have to instruct bartenders in San Francisco how to make it. The so-called Court of Historical Review in San Francisco has determined that the drink is invented in San Francisco. Case closed. Or not.

PISCO PUNCH

Widely served during the gold rush, Pisco Punch is so potent that one writer of the day remarks: "It tastes like lemonade but comes back with the kick of a roped steer." Another says: "it makes a gnat fight an elephant." Imagine this drink served at bars where every patron is typically armed to the teeth. Pisco is a late sixteenth-century brandy made from Peruvian grapes. Available in San Francisco since the 1830s when rawhide and tallow traders bring the potent libation via ship, it is the first distilled spirit made in the New World. At the opening of the city's legendary Bank Exchange & Billiard Saloon in 1853, pisco is on the menu. Several such punches using the Central America firewater are concocted over a succession of owners. Prohibition forces the final proprietor, Duncan Nicol, to shut the doors permanently. Pisco punch gains fame worldwide thanks to accolades penned by travelers including Mark Twain and Harold

Ross, founder of the *New Yorker* magazine. Resting on Nicol's crypt shelf at Cypress Lawn Cemetery in Colma—a necropolis of seventeen cemeteries nine miles south of San Francisco—sit a pair of modern inscribed pisco punch drinking vessels from the recent renaissance of the cocktail. His secret recipe (taken to the grave) uses pisco brandy, pineapple, lime juice, sugar, gum Arabic and distilled water.

Rice-A-Roni: The San Francisco Treat

When Domenici "Charlie" DeDomenico moves to San Francisco in 1895, he sets up a company to produce and deliver fresh pasta to Italian stores and restaurants. For his family only, he creates a unique spiced recipe of rice and macaroni. In 1958, son Vince takes the private dish public and develops Rice-A-Roni by adding chicken soup to the mix. Because of its origins, it is merchandised as the "San Francisco Treat."

Sourdough Bread

Sourdough bread is not invented. It is discovered in the unique San Francisco microclimate. Yeast is the substance that makes bread rise. Mix flour, water and salt and set the substance on a surface to ferment, whereby it captures the spores and bacteria from the air and transforms the mixture into a leavening agent. Add that agent to flour, water and salt—and lo and behold, bread rises. Ancient Egyptians developed the process some five thousand years ago. The vast majority of the world's yeast delivers a slightly sweet flavor. When the French bakers come to San Francisco to make their staple product, it has a sour tang. *Mon Dieu! Mais pourquoi?* Yeast takes on the character of the local spores and bacteria, and the confined Yerba Buena microclimate produces this unusual zest—offbeat and a bit biting, just like the city itself. Quickly, the rough-and-tumble miners embrace the taste and even demand it. The piquancy is so confined to San Francisco that bakers have to row across the Bay to Oakland to concoct the yeast for traditional "sweet" baguettes. As French sourdough becomes coveted beyond San Francisco, bakers in other places try to replicate the flavor of the starter, which often loses its character over

time. Many add a souring agent, like vinegar or peppers, but this is sour bread—not sourdough—and discerning palates can detect the difference. Boudin Bakery is the most prominent commercial venue to make original French sourdough in San Francisco and remains the premier location to savor it at Fisherman's Wharf.

Bibliography

Ackley, Laura A. *San Francisco's Jewel City: The Panama Pacific International Exposition of 1915*. Berkeley, CA: Heyday, 2015.

Adams, Charles. *The Magnificent Rouges of San Francisco*. Sanger, CA: The Write Thought, Inc., 1998.

Albright, Thomas. *Art in the San Francisco Bay Area, 1945–1980: An Illustrated History*. Berkeley: University of California Press, 1985.

Asbury, Herbert. *The Barbary Coast*. New York: Alfred A. Knopf, 1933.

Atherton, Gertrude. *California, An Intimate History*. New York: Harper & Brothers Publishers, 1914.

Averbuch, Bernard. *Crab Is King: The Colorful Story of Fisherman's Wharf in San Francisco*. San Francisco: Mabuhay Publishing Company, 1973.

Bancroft, Hubert Howe. *Some Cities and San Francisco*. Resurgam, New York: Bancroft, 1907.

Banks, Charles E. *The History of the San Francisco Disaster and Mount Vesuvius Horror*. San Francisco: C.E. Thomas, 1906.

Barker, Malcolm E. *Bummer & Lazarus: San Francisco's Famous Dogs*. San Francisco: Londonborn Publications, 2001.

———. *More San Francisco Memoirs: 1852–1899*. San Francisco: Londonborn Publications, 1996.

———. *San Francisco Memoirs, 1835–1851: Eyewitness Accounts of the Birth of a City*. San Francisco: Londonborn Publishers, 1994.

———. *Three Fearful Days: San Francisco Memoirs of the 1906 Earthquake and Fire*. San Francisco: Londonborn Publishers, 1998.

Barth, Gunter. *Instant Cities*. New York: Oxford University Press, 1975.

Boorstin, Daniel J. *The Americans: The National Experience*. New York: Random House, 1965.

Brechin, Gray. *Imperial San Francisco*. Berkeley: University of California Press, 2006.

Bronson, William. *The Earth Shook, The Sky Burned*. Garden City, New York, 1959.

Brooks, James, Chris Carlsson and Nancy J. Peters. *Reclaiming San Francisco: History, Politics, Culture*. San Francisco: City Lights Books, 1998.

Browning, Peter, ed. *Yerba Buena San Francisco: From the Beginning to the Gold Rush, 1769–1949*. Lafayette, CA: Great Western Books, 1988.

Bruno, Lee. *Misfits, Merchants & Mayhem: 1849–1934*. Petaluma, CA: Cameron + Company, 2018.

Burns, John F., and Richard J. Orsi, eds. *Taming the Elephant: Politics, Government, and Law in Pioneer California*. Berkeley: University of California Press. 2003.

Caen, Herb. *Baghdad by the Bay*. Garden City, NY: Doubleday, 1953.

Carpenter, Patricia, and Paul Totah, eds. *The San Francisco Fair: Treasure Island: 1939–1940*. San Francisco: Shotwell Associates, 1989.

Chandler, Arthur. *Old Tales of San Francisco*. Dubuque, IA: Kendall/Hunt, 1977.

Chang, Iris. *The Chinese in America*. New York: Penguin Books, 2004.

Chase, Marilyn. *The Barbary Plague: The Black Death in Victorian San Francisco*. New York: Random House, 2003.

Chen, Young. *Chinese San Francisco: 1850–1943*. Palo Alto, CA: Stanford University Press, 2000.

Clary, Raymond, H. *The Making of Golden Gate Park*. San Francisco: California Books, 1980.

Conrad, Barnaby, ed. *The World of Herb Caen: San Francisco, 1938–1997*. San Francisco: Chronicle Books, 1997.

Covert, Adrian. *Taverns of the American Revolution*: San Rafael, CA: Insight Editions, 2016.

De Tocqueville, Alexis. *Democracy in America*. London: Saunders & Otley, 1838.

Dicksen, Samuel. *Tales of San Francisco*. Palo Alto, CA: Stanford University Press, 1947.

Egan, Ferol. *Last Bonanza Kings: The Bourns of San Francisco*. Reno: University of Nevada Press, 1998.

Ehrlich, Cindy. *Cypress Lawn: Guardians of California's Heritage*. Colma, CA: Cypress Lawn Memorial Park, 1996.

Evanosky, Dennis, and Eric J. Kos. *Lost San Francisco*. London: Pavilion Books, 2011.

Flamm, Jerry. *Hometown San Francisco: Sunny Jim, Phat Willie, and Dave*. San Francisco: Scottwall Associates, 1994.

Gentry, Curt. *The Madams of San Francisco*. Garden City, NY: Doubleday & Company, Inc., 1964.

Gould, Milton, S. *A Cast of Hawks: A Rowdy Tales of Scandal and Power Politics in Early San Francisco*. La Jolla, CA: Copley Press, Inc., 1985.

Hansen, Gladys, and Emmet Condon. *Denial of Disaster: The Untold Story and Photographs of the San Francisco Earthquake and Fire of 1906*. San Francisco: Condon and Company, 1989.

Hansen, Gladys, Richard Hansen and Dr. William Blaisdell. *Earthquake, Fire & Epidemic: Personal Accounts of the 1906 Disaster*. San Francisco: Untreed Reads Publishing, 2013.

Helper, Hinton, edited by Lucius Beebe and Charles M. Clegg. *Dreadful California*. New York: Bobbs-Merrill Company, 1948.

Hittell, John. *A History of the City of San Francisco*. San Francisco: Bancroft, 1878.

Holdredge, Helen. *Firebelle Lillie: The Life and Times Lillie Coit of San Francisco*. New York: Meredith Press, 1967.

———. *Mammy Pleasant*. New York: G.P. Putnam's Sons, 1953.

Holliday, J.S. *The World Rushed In: The California Gold Rush Experience*. Norman: University of Oklahoma Press, 1981.

Johnson. Robin C. *Enchantress, Sorceress, Madwoman: The True Story of Sarah Althea Hill, Adventuress of Old San Francisco*. California Venture Books, 2014.

Kamiya, Gary. *Cool Gray City of Love*. New York: Bloomsbury, 2013.

Lavender, David. *Nothing Seemed Impossible: William C. Ralston and Early San Francisco*. Palo Alto, CA: American West Publishing Company, 1975.

Lloyd, B.E. *Lights and Shades in San Francisco*. San Francisco: A.L. Bancroft, 1876.

Lockwood, Charles. *Suddenly San Francisco: The Early Years of an Instant City*. San Francisco: San Francisco Examiner, 1978.

Lotchin, Roger W. *San Francisco, 1846–1856: From Hamlet to City*. New York: Oxford University Press, 1974.

Martini, John A. *Fortress Alcatraz: Guardian of the Golden Gate*. Emeryville, CA: Ten Speed Press, 2004.

McGloin, John Bernard. *San Francisco: The Story of a City*. San Rafael, CA: Presidio Press, 1978.

McWilliams, Cary. *California: The Great Exception*. Berkeley: University of California Press, 1949.

Moffat, Francis. *Dancing on the Brink of the World: The Rise and Fall of San Francisco Society*. New York: G.P. Putnam's Sons, 1977.

Morris, Charles. *The San Francisco Calamity by Earthquake and Fire*. Facsimile edition of 1906 book. Secaucus, NJ: Citadel Press, 1986.

Mullin, Kevin J. *The Toughest Gang in Town: Police Stories from Old San Francisco*. Novato, CA: Noir Publications, 2005.

Muscatine, Doris. *Old San Francisco: The Biography of a City from Early Days to Earthquake*. New York: G.P. Putnam's Sons, 1975.

Neider, Charles, ed. *Life as I Find It: A Treasury of Mark Twain Rarities*. Garden City, NY: Cooper Square Press, 1961.

Nasaw, David. *The Chief: The Life of William Hearst*. London: Gibson Square Books, 2003.

Older, Cora Miranda. *San Francisco: Magic City*. New York: Longmans, Green & Company, 1961.

Purdy, Helen Throop. *San Francisco As It Was, As It Is, and How to See It*. San Francisco: Paul Elder, 1912.

Rawls, James J., and Richard A. Orsi, eds. *A Golden State: Mining and Development in Gold Rush California*. Berkeley: University of California Press, 1998.

Reeves, Richard. *Infamy: The Shocking Story of the Japanese American Internment in World War II*. New York: Henry Holt and Company, 2015.

Richards, Rand. *Mud Blood and Gold: San Francisco in 1849*. San Francisco: Heritage House Publishers, 2009.

San Francisco and Its Municipal Administration. San Francisco: City of San Francisco, 1902–4.

Saxton, Alexander P. *The Indispensible Enemy: Labor and the Anti-Chinese Movement in California*. Berkeley: University of California Press, 1971.

Scharlach, Bernice. *Big Alma: San Francisco's Alma Spreckels*. San Francisco: Shotwell Associates, 1990.

Smith, Dennis. *San Francisco Is Burning: The Untold Story of the 1906 Earthquake and Fires*. New York: Viking Press, 2005.

Smith, James. *San Francisco's Playland at the Beach: The Golden Years*. Fresno, CA: Craven Street Books, 2010.

Soule, Frank, John H. Gihon and James Nisbet,. *Annals of San Francisco*. New York: Appleton & Company, 1854.

Sparks, Edith. *Capital Intentions: Female Proprietors in San Francisco, 1850–1920*. Chapel Hill: University of North Carolina Press, 2006.

Stanford, Sally. *The Lady of the House*. New York: G.P. Putnam's Sons, 1966.

Starr, Kevin. *California: A History*. New York: Random House, 2005.

————. *Golden Gate: The Life and Times of America's Greatest Bridge*. New York: Bloomsbury, 2010.

Starr, Kevin, and Richard J. Orsi, eds. *Rooted in Barbarous Soil: People Culture and Community in Gold Rush California*. Berkeley: University of California Press, 2000.

Steffens, Lincoln. *Upbuilders*. New York: Doubleday & Page, 1905.

Stewart, Robert, Jr., and M.F. Stewart. *Adolph Sutro: A Biography*. Berkeley, CA: Howell-North, 1962.

Stoddard, Tom. *Jazz on the Barbary Coast*. Berkeley, CA: Heyday Books, 1982.

Tarnoff, Ben. *The Bohemians*. New York: Penguin Books, 2014.

Taylor, Bernard. *Eldorado; or, Adventures in the Path of Empire*. New York: C.W. Benedict, 1850.

Thomas, Gordon, and Morgan Max Witts. *The San Francisco Earthquake*. New York: Stein and Day, 1971.

Trobits, Monika. *Antebellum and Civil War San Francisco: A Western Theatre for Northern and Southern Politics*. Charleston, SC: The History Press, 2014.

————. *Bay Area Coffee: A Stimulating History*. Charleston, SC: The History Press, 2019.

Ungaretti, Lorri. *San Francisco's Sunset District*. Charleston, SC: The History Press, 2011.

————. *Stories in the Sand: San Francisco's Sunset District, 1847–1964*. San Francisco: Balangero Books, 2012.

Valente, Francesca. *A.P. Giannini: The People's Banker*. Temple City, CA: Barbera Foundation, 2017.

Valentine, Alan. *Vigilante Justice*. New York: Reynal, 1986.

Walsh, James P. *The San Francisco Irish: 1850–1976*. San Francisco: Smith McKay, 1978.

About the Authors

TERRY HAMBURG was trained as a historian, completing graduate studies at the University of Michigan and Cambridge University in England. After a brief foray as a hippie and political activist, he settled into a career as an antiques dealer in San Francisco, where over the years he opened stores on Market, Lombard and Sixteenth Streets. Terry finally found his forever vocation near San Francisco as the director of the Heritage Foundation at Cypress Lawn Cemetery, a place rich in California history and art. There he oversees and conducts tours and lectures, plans special events and writes a newsletter and blog articles. He is the author of *Grand Entrances*, which features artistic San Francisco storefronts and their histories.

For over fifty years, RICHARD HANSEN has been researching and documenting San Francisco and California history. His love of history, photography, science—and the preservation of history—has led him to create, direct and be a member of dozens of organizations with the same goals. And in collaboration with his mother, one-time city archivist Gladys Hansen, they became world-renowned experts on the 1906 San Francisco

earthquake, fire and epidemic—especially on those who died during the disasters—yes, disasters plural.

Today, Richard remains active in many of the premier historical organizations—sharing his knowledge, stories and photographs of San Francisco and California history while contributing and guiding historians in the San Francisco Bay Area and around the world.

Richard is the founder and driving force behind the virtual museum www.sfmuseum.org, created in 1988.